DRAWING
AND
PAINTING
IN
COLOR

DRAWING
— AND —
PAINTING
— IN —
COLOR

HOW TO UNDERSTAND COLOR
AND MAKE IT WORK FOR YOU

JEREMY GALTON AND JUDY MARTIN

CHARTWELL
BOOKS, INC.

A QUINTET BOOK

Published by Chartwell Books
A Division of Book Sales, Inc.
PO Box 7100
Edison, New Jersey 08818-7100

This edition produced for sale in the U.S.A., its
territories and dependencies only.

ISBN 0-7858-0240-1

This book was designed and produced by
Quintet Publishing Limited
6 Blundell Street
London N7 9BH

Creative Director: Richard Dewing
Designer: James Lawrence
Editor: Sean Connolly

Typeset in Great Britain by
Central Southern Typesetters, Eastbourne
Manufactured by Colour Scan Sdn. Bhd. (Malaysia)
Printed by Star Standard Industries (Pte) Ltd, Singapore

Material in this book previously appeared in *Drawing with Colour* by
Judy Martin, and *Choosing and Mixing Colour for Painting* by Jeremy Galton.

CONTENTS

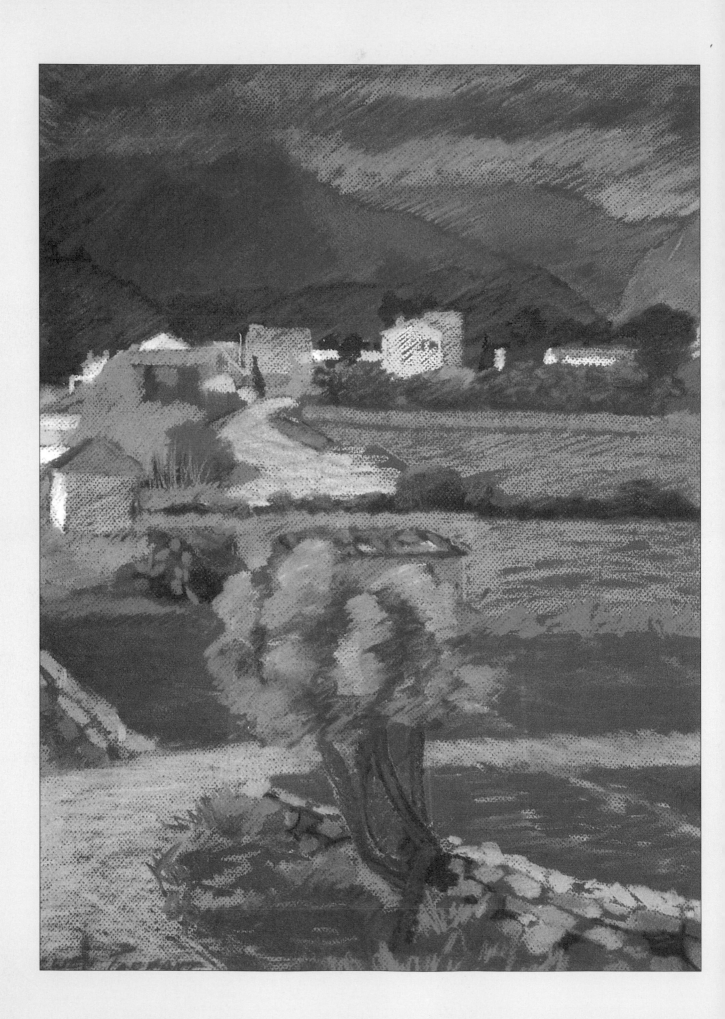

INTRODUCTION

Two things have changed the way color is used in both drawing and painting. One is the idea of beginning with color, rather than structure in the form of line and tone, and making it one of the essential themes of an image. This was a concept which only began to be explored fully in the late nineteenth century, but since that time, color has been acknowledged as a basic element in image-making, not something to be superimposed as a surface effect. This development was a result of certain artists, notably the Impressionists, finding different ways of looking at the world. To them, it seemed that colors, and the effects of color in light, had a central role in methods of rendering immediate perceptions of form and space. The second factor was related to technical developments in color chemistry: the new synthetic pigments introduced at this time produced a far greater choice of colors for artists' use. This range has continued to increase, which is of great importance to the ways we use color in drawing and painting today.

Traditional color-drawing materials such as paints, pastels, and chalks have been joined by a vast array of colored pencils, crayons, markers, and pens which exist simply to be colorful. All these materials are convenient, direct sources of color, and artists in many fields are giving them increasingly serious attention.

Drawing has traditionally been seen as an activity secondary to "major" art forms such as painting and sculpture – a learning method or process of preparation that leads to a more polished visual statement. In this role, it is associated with economy of means and materials – dictionary definitions of drawing lay emphasis on picture-making with line and tone, sometimes identifying basic materials such as a pencil or pen. Some even include the words "without color," and if you look at any large collection of drawings in a book or exhibition, you will find that linear and monochrome techniques are dominant. Color was sometimes employed in drawing in the past, but mainly as a means of decorating or elaborating a monochrome image. The free expression of color values and the contribution of color to an image were considered the natural preserve of painting rather than drawing techniques, but color expression is no longer the preserve of painting. Artists often turn to drawing materials as an alternative – and sometimes preferable – way to tackling difficult color problems. And in the age of mixed media, many of the traditional distinctions no longer apply.

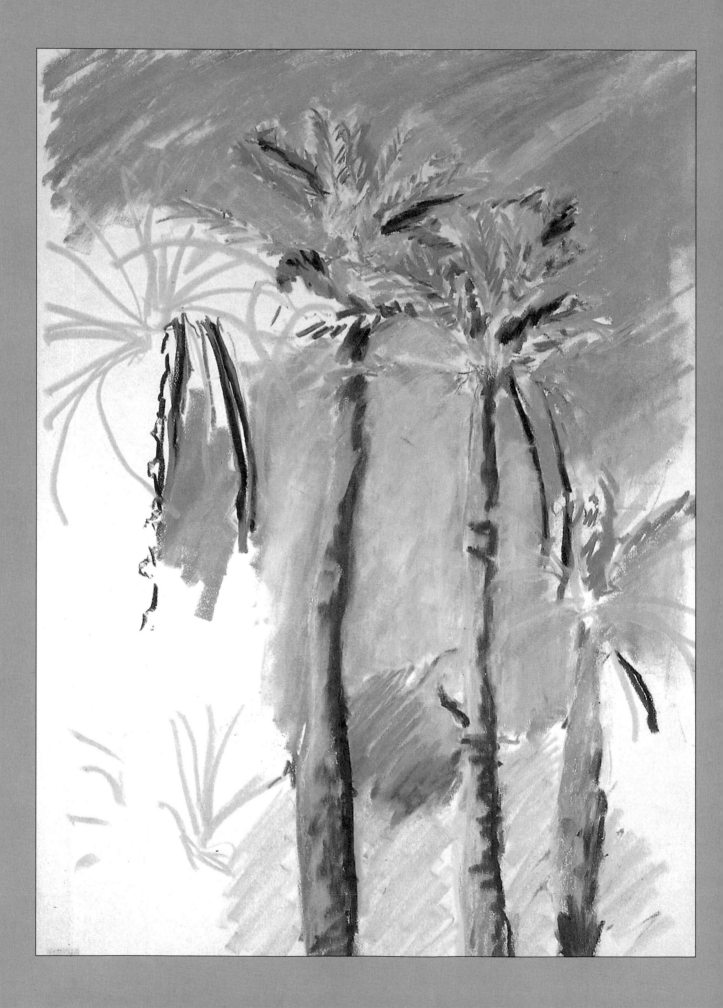

THE LANGUAGE OF COLOR

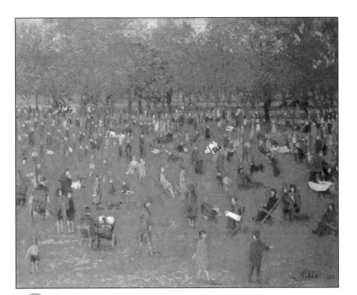

*C*olor is an effect of light. The range of colors that we see in a given context depends upon the quality of illumination created by the available light, but the color is a real phenomenon, not an illusory or transient effect. Each material or substance that we perceive as having a particular color is reflecting certain light wavelengths and absorbing others, and its ability to do this is inherent. A red object, for example, does not suddenly turn blue under the same light conditions, but it will not appear red if it is not receiving illumination that includes red light wavelengths. White light contains all colors, and it is under white light that you see what might be called the "true" color of an object – what artists term local color.

THE NATURE OF COLOR

*W*hen a beam of white light is passed through a glass prism, it separates into its component colors, and can be projected on a surface as clearly defined bands of color. This effect was first studied in the seventeenth century by Sir Isaac Newton, who identified the bands of the color spectrum as red, orange, yellow, green, blue, indigo, violet – a list that has become familiar to generations of children as the colors of the rainbow. The science of light and color has moved very far since Newton's time. The spectrum of colored light is estimated to include about 200 pure hues within the visible range, although not all are distinguishable by the human eye.

For the artist the practical points at issue are the visual sensations of light and color and the ways in which these are experienced. As this book is mainly concerned with the practicalities of color perception and how what is seen can be expressed through drawing, concentrating on complex ideas about the "behavior" of color in light is not a priority. However, there is one important principle that should be carried with you in your color work. Light is the source of color. It can thus be said that the artist working with color is always trying to capture effects of light, but is doing so using materials that contribute their own physical weight and density. Coloring materials that are solid and textured behave quite differently from colored light. Because white light is composed of colors, a certain combination of colored lights makes white but, with drawing or painting materials, the more colors that are applied, the more colorful or darkly veiled becomes the surface effect. The artist is dealing with substantial elements, and must learn how they can be used to create equivalents of the insubstantial effects of light.

The sheer wealth of color in natural and manufactured objects, together with the variations created by form, surface texture, and effects of light and shade, can make it very difficult to unravel the distinct and manageable aspects of color values when you start to make a drawing or painting. This chapter looks at the various elements involved in the phenomenon of color and our perceptions of it, and examines the ways in which these may influence our ability to make images. It is not concerned with actual techniques of color rendering, which are explored in the later chapters. The intention is simply to point to different aspects of our awareness of color, thus providing a brief grounding for a practical approach to color.

BELOW: *To capture the character of a landscape, it is often necessary to use the color cues of the natural model as a basic register that the artist can manipulate in terms of color interactions. Jane Strother picks out the contrast of yellows and warm browns against cold blues and purples in this open, windswept view.*

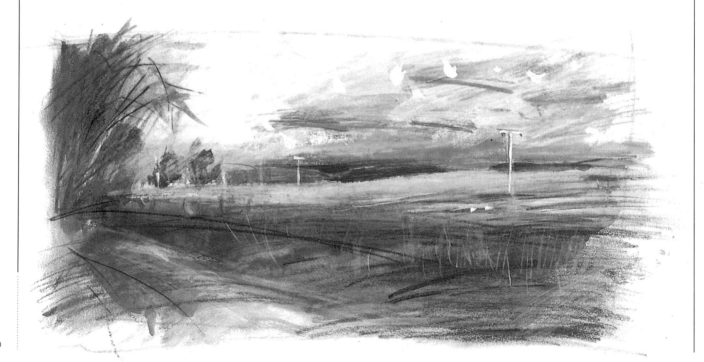

RESPONDING TO COLOR

Our responses to color are instinctive and wide-ranging. We use it as a means of recognition and analysis – it helps us to define space and form – we use color cues as invitations or warning signals; we appreciate its purely decorative functions and respond consciously or subconsciously to its emotional appeals. When we now watch re-runs of old television programs made in black and white we can appreciate how impoverished the world would seem without color. It takes considerable creativity to make a "colorful" statement in monochrome, though it can be done, and there is plenty of evidence in drawings, prints, film and photography to show this. On the whole, though, color is a more stimulating medium, and we have learned to use it with great variety and invention.

The colors of our surroundings are not what they seem, at any rate not to an artist. Think of a gray concrete wall. We look at it in bright sunshine, on a dull day, in the rosy light of sunset, and it's still gray. Under these three different types of illumination, the light reaching our eyes is of very different composition, and yet we still see the concrete as the same color. How can this be? The answer lies partly in the fact that we

ABOVE: *A large-scale drawing can be a good medium for releasing inhibitions about color work. This image is derived from a display of brilliantly colored flowers. Working with acrylics and pastels on a paper sheet 33 x 45 inches, Judy Martin allowed the drawing to develop freely and abstractly.*

BELOW: The Terrace, Richmond *by William Bowyer, oil, 40 x 40 inches.*

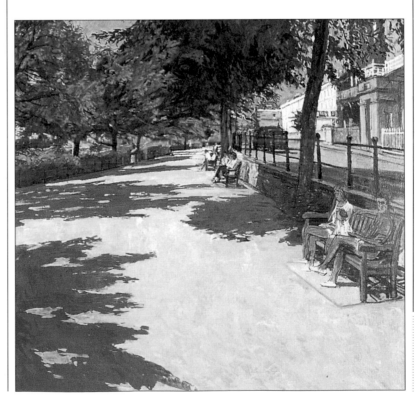

ABOVE: *This image is the result of color "doodling," an exercise begun by Judy Martin purely as an abstract investigation of color relationships. It was limited to the range of colors supplied in a box of soft pastels, which covered all the six main color "families." The image emerged simply from trying out all the colors and textures of the pastels and gradually organizing the different areas of the composition.*

expect concrete to be gray and we cannot believe it to be anything else, but this is not the whole story. Our eye and brain respond to color relationships rather than absolute color. Both the concrete and its surroundings are being lit by the same light source, and as this changes, the relationship of one color to another remains fairly constant.

Let's take another example, an orange. Hold it in your hand, and on close examination you can see that it is a uniform orange color all over. This is known as its local color. But now put it down in front of you and look again. You know that it really is still orange all over – but does it really look orange? To the artist, or anyone with good powers of observation, the orange in its particular setting will be an assortment of different colors, many of them being far from orange. It is the gradations of color and tone that appear around a solid object that give us the impression of three-dimensional solidity. Our orange is receiving light from

different parts of the room as well as from light reflected off other objects, so it cannot appear the same "orange" all over. It is the painter's job to observe the color relationships in front of him or her, to find their equivalents in paint and create an equivalent of the original subject on canvas.

We perceive color in physical terms by the action of light on the rods and cones in the retina of the eye. The cones distinguish hue while the rods register qualities of lightness or darkness. By some estimates, a person with normal color vision is capable of identifying up to ten million variations of color values. The conditions known as color blindness include several forms of incomplete color perception – an inability to distinguish red and orange hues from yellow and green is perhaps most common – and there are rare cases of people who see only in monochrome.

Whatever the scientific evaluation of our visual capacities, none of us can be sure that we see colors in exactly the same way as

anyone else. It may be possible to measure the color range of light entering the eye, and to check the efficiency of the physical receptors, but this says nothing of the sensation of color experienced by an individual. Our responses to visual stimuli are "processed" by the brain, which can add memories, associations and its own inventions to the purely physical information we receive.

It is accepted that color has an emotional impact, although it is not possible to qualify the precise effects of each color. Such implications are acknowledged in everyday speech by phrases such as "seeing red" or being "green with envy." The origins are not clear – why, for example, should blue be the color of a melancholy mood, as in "feeling blue"? However, even when there is a widely accepted color association of this kind, this does not make it a reliable factor in visual terms. Matisse's *Red Studio*, for example, is not an angry painting, even though it is flooded with red, and plants, real or depicted, are not associated with jealousy because their leaves are green. Color is a relative value in image-making, and its pictorial significance depends upon other aspects of the composition as well as on the context provided by the subject. Expressing mood and emotion through color is a relatively abstract exercise more dependent on color interactions than on external influences and associations.

The creative use of color can be affected by all sorts of personal preferences, with complex and often obscure origins. Attempts to use color as a personality indicator have uncovered widely varied influences. One person may dislike a color because it is associated with an unpleasant occurrence, while people with entirely different characters and tastes may all come to like a color because it is fashionable and widely promoted. Familiarity with the colors in a particular environment can make them seen independently attractive.

Most of us are fairly conservative about the colors we live with, and many people prefer to dress mainly in restrained or neutral colors accessorized with brighter accents. We usually look for harmonies, which leads us to choose restricted color combinations often containing more muted than pure hues. The same is true on a wider scale – many people might like the idea of putting a red sofa into a white room, but few would choose to paint their living room walls bright scarlet.

Some colors seem more difficult to deal with than others. Orange and purple can seem hard and artificial, oddly, since garden flowers present many rich and subtle shades of these hues. Blues and greens commonly seem more sympathetic, which might be to do with their predominance in nature. Yellow is a color that many people will not wear, as it is considered unflattering and sometimes brash; yet it is also associated with sunshine and a cheerful atmosphere and Van Gogh demonstrated very effectively how well it can work as the dominant color in painting.

BELOW: Sunflowers *(August 1888). In one of the world's now most famous paintings, Van Gogh exemplified the atmospheric and versatile qualities of the color yellow.*

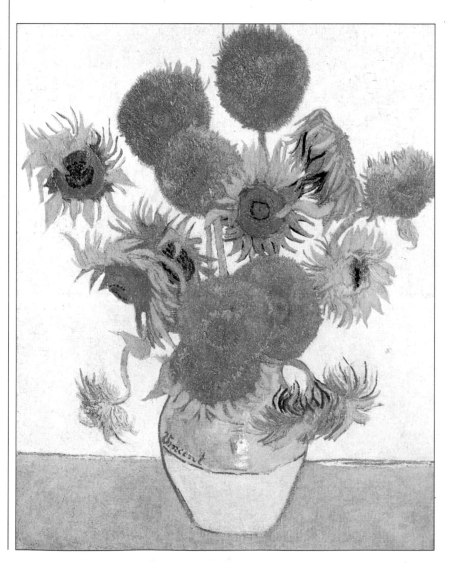

PRIMARY, SECONDARY AND TERTIARY COLORS

*B*efore going on to decide on a suitable palette to start with, it makes sense to examine the ways that paints mix, since what we want to do is to buy as few colors as possible and yet to obtain a wide variety of useful mixtures. When any two paints are mixed, one of three things can happen. The first is that the resulting color is an intermediate between the two original paints; the second is that the mixture is a dark muddy color bearing none of the character or brilliance of the originals; and the third is that the mixture is an entirely new color apparently unrelated in hue to the originals.

The mixtures of most colors with white come into the first category, although some colors do lose their character at the same time, an example being cadmium red which quickly reduces to a dull pink. Mixing yellows with greens, or any similar or analogous colors, also produces intermediates. This is often the best way to lighten or darken bright colors without destroying them; for instance, a touch of yellow will enhance the darker greens such as viridian or terre verte. Cadmium yellow can be darkened by adding yellow ocher; or cadmium red can be darkened by adding alizarin crimson. In contrast, if black is added to cadmium yellow, the result is not a darker yellow, but green.

In the second category come the mixtures of complementary colors (see page 20). Mix red with green and you get a muddy dark gray color – of course this may be exactly what you want! Yellow and violet give another gray; blue and orange yet another. Black, when mixed with reds or blues, usually creates a much muddier color than you might expect.

In the third category are certain pairs of colors which actually produce totally different hues. Red and yellow produce orange; yellow and blue produce green; blue and red produce purple. These three colors, red, yellow and blue, are called the primary colors, and are rather special in that when they are mixed in suitable combinations they can produce all the other colors, albeit in rather dubious hues and tones, but they cannot themselves be produced by mixing other colors.

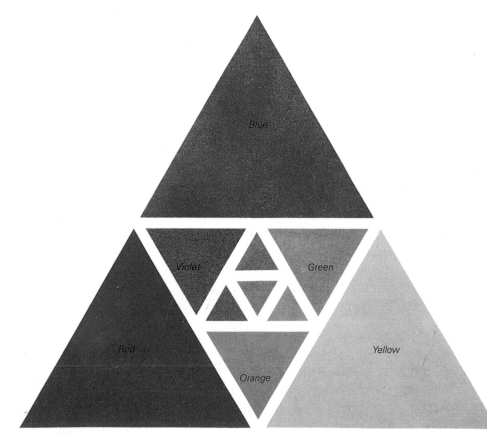

LEFT: *Painting color triangles like this one is a good way of learning the different mixtures that can be obtained from the three primary colors, red, blue and yellow. These, which cannot be mixed from any other colors, are placed one at each corner. The first inner triangle shows the secondary colors, mixed from any pair of primaries, while within this are the tertiaries, the neutral colors mixed from the secondaries. This triangle shows cobalt blue, cadmium yellow and alizarin crimson, but you can vary the primary hues by using, for instance, cerulean blue, lemon yellow and cadmium red, which will give a different set of mixtures.*

COLOR CHARACTER

*I*f we can see millions of pure hues and tonal variations of color, the range of color values that we can identify and use is more or less infinite – an alarming prospect. This huge number of colors, however, can be grouped into distinct "color families," and these are actually very few. We can categorize color sensations as belonging to one or another family, distinguishing colors that have a quality of redness from colors which tend toward greenness, for example, even though these are not always pure red or pure green hues.

In practical terms, artists' colors are grouped as six standard hues – red, orange, yellow, green, blue, purple. These represent the three primary colors, which cannot be created by color mixing – red, yellow and blue – and three secondary colors – orange, green, purple – which can be mixed from pairings of the three primaries. The broader variety of pure hues are theoretically capable of being mixed from different combinations of the six – degrees of red-orange, yellow-green, blue-green, blue-purple and so on. Also related to all pure colors are the different tonal values of lightness and darkness, increasing the total range of color values.

Theories that analyze and predict various aspects of color relationships assume fixed color values. But what is confusing is that there is no true standard for the fixed colors – no precise definition of, for example, primary red – and different theorists have come up with different ways of analyzing the relationships. To use color in drawing and painting, you must evaluate the actual color in your materials on the basis of your experience. This is not to say that theories have no place; they have produced some useful guidelines on organizing color relationships which can be put to practical use. These include ideas about the "presence" of each individual color and its interactions with others that are based on observation, but it is worth bearing in mind that they do not constitute set rules of color behavior. Part of the excitement of working with color lies in the feeling that it is still possible to make it do the unexpected. Painting widens the possibilities even further, but this freedom must be based on a clear understanding of how paints – and their corresponding colors – relate to each other.

ABOVE: *A landscape in watercolor and colored pencil by Jane Strother is described in subtly related colors. The deep blues are the pivot of the scheme; on one side they pass into warmer purples which in turn give way to hints of red-brown; at the other end of the range, the blues merge into the soft greens of the receding countryside, reverting to truer blues at the distant horizon line.*

THE COLOR WHEEL

The color wheel, linking the six color types in a circular formation, is simply a graphic device for explaining the basic relationships of primary and secondary hues. Placing the

arrangement in which each primary color faces, in the opposite segment, a secondary that is composed of the other two primaries. Thus by going around the wheel you can identify the relationships of adjacent or harmonious colors, and by working crosswise you can see the opposing pairs of primaries and secondaries known as opposite or complementary colors. Red is complementary to green (blue + yellow), yellow to purple (red + blue) and blue to orange (red + yellow). Between the segments occur more complex mixtures that create the range of subsidiary hues – such as red-orange, yellow-green, blue-purple and so on.

In addition to hue – a specific color value such as red or red-purple – the colors also have tone – a value of lightness or darkness. Color intensity refers to the strength of the hue, which may be "devalued" or "fully saturated." Hue, tone and intensity are coexistent within any given color value.

Various attempts have been made to produce three-dimensional diagrams and models describing the relationships of these different aspects of color, but these can be more confusing than instructive.

This is the color circle traditionally associated with artists' pigments. Color relationships in light, however, are quite different. The primary colors in light are not red, yellow and blue. There are other synthetic color primaries too, such as those used in printing inks, but contrasting such different systems is not useful here. However, when you use, for example, colored pencils or pastels to overlay red with blue to create purple, or yellow and blue to produce green, there is some degree of devaluation which varies with the quality of the materials. The influential factors are the apparent hue and tone of each color in the mixture, the purity and strength of the pigment content, and the presence of a substance used as a binding medium. For this reason, the color wheel should be viewed only as representing the basic principles of color interaction – actual effects of color relationships and mixtures must always be seen in the context of the specific drawing materials.

BELOW: The color wheel is a useful device for working out how different combinations of colors can be used together to advantage. Some color wheels show the pure colors based on those of the spectrum (the colors of light), but this one is a pigment wheel, which includes all the "basic palette" colors. Notice that the warm colors, the reds and yellows, are close together, with the cool blues and greens on the other side. The colors directly opposite one another (red and green, yellow and violet) are the complementary colors.

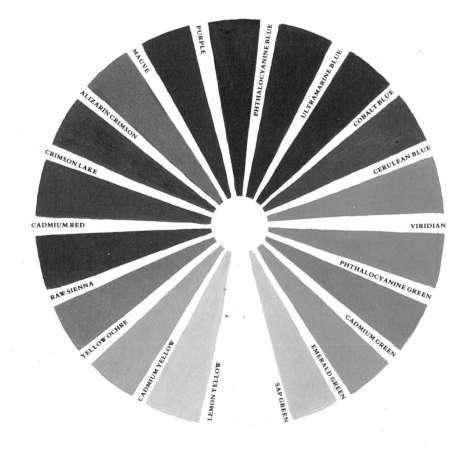

RIGHT: Colors do not have fixed, independent values in drawing. Any individual color is affected by another, whether this is complementary (see page 20), similar in value, or achromatic. These color exercises illustrate such different combinations.

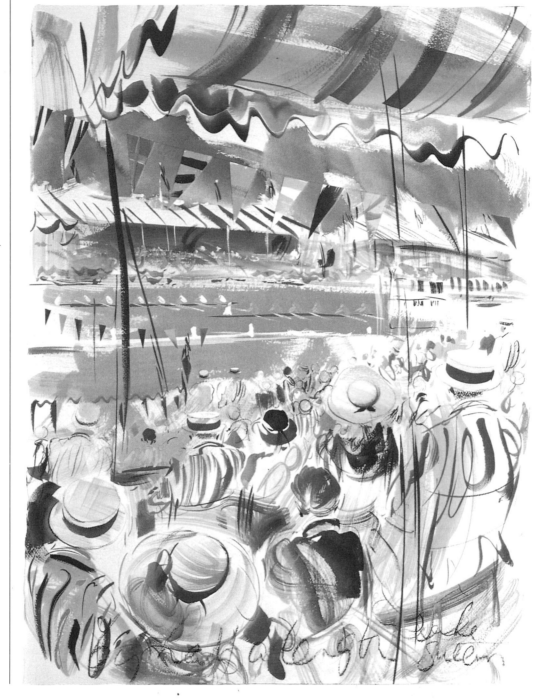

RIGHT: *Jake Sutton's colorful regatta actually contains relatively few colors. The effect comes from the strong values of primary and secondary hues – red, blue, yellow, orange, green – applied in translucent watercolor. There are no complex mixtures or muted tones, so the image has an unrestrained clarity well suited to the mood of the subject. The liveliness of the loose brushwork adds to the atmosphere, but the contrast made by the sudden sharp detail of the line of bright flags is a clever touch.*

COLOR PROFILES

Color interactions are all relative, but gaining a sense of color as an entity in its own right helps to focus your perception of color values in material objects. It is important not to take for granted your response to color or your ability to analyze it in real terms. To begin with, take a look at the intrinsic character of each color, its sources and associations. The color "profiles" below focus on the origins, range and family characteristics of colors, and are a preparation for considering the more abstract aspects of color relationships.

RED A powerful color – even in small quantities, it readily catches the eye, and the brightest and purest hues of red dominate most other colors. The extensive color range of reds passes from the dark-toned, earthy red-browns and rich red-purples to the lighter values of orange-reds and clean, vibrant pinks. Strong reds can have a violent presence, but also an inviting, enveloping density. Red occurs frequently in nature. Original sources of natural red pigments included insect dyes, making crimson and carmine, earth for red ocher, the mineral source of vermilion, cinnabar, and plant dyes providing a range of madders. Modern synthetic pigments create a richer variety.

ORANGE Standing between red and yellow in the color spectrum, orange is secondary to both these colors and shares some of their visual characteristics and emotional impact. Its values readily merge into yellow, red or shades of warm brown, leaving true orange as a color of relatively limited character. Yet natural orange hues seen in fruits, flowers and foliage, minerals, gemstones and warmly colored metals such as copper and bronze are rich and various. There have been few good natural sources of pigment or dye, and orange is usually a "manufactured" color, yet it is commonly associated with elemental resources such as energy, warmth and light.

YELLOW This color occupies a narrower band of the spectrum of colored light than the others. It is highly reflective and naturally light-toned, providing a sense of illumination. Whereas most colors will darken with increasing saturation, yellow tends to appear brighter as it gains intensity. The words used to describe different qualities of pure yellow are taken from natural contexts – sunshine yellow, lemon yellow, golden yellow. Earth colors such as yellow ocher and raw sienna represent the darker values, but the darker, heavier tones tend to "slip out" of the yellow family, to be categorized as light browns or muddy greens. When there is a strong bias toward another hue, yellow is quickly perceived instead as pale orange or citrus green.

GREEN It is impossible to disassociate green from the idea of life and growth in nature, but in fact there are few natural sources of green pigment, and the many values of green coloring agents, including those used in artists' materials, have been chemically developed. In physical terms, the eye focuses green easily and it is thought to be a restful color, a sensation underlined by its perceived naturalness. Green hues are extremely various, beginning with those close to yellow at one end of the range and ending with rich blue-greens at the other. Like the yellows, the true greens are given descriptive names from nature such as emerald green, grass green, sap green.

BLUE As a primary color and one with a strong presence and a wide range of hues and tones, blue tends to rival reds for dominance, showing little of the influence of other primary or secondary hues. Dark and light values of blue are often equal in intensity to its pure hues. An inevitably association with natural elements credits blue with qualities of airiness, coolness and peace, but it is also a vivid and decorative color in nature, seen in some of its richest tones in flower colors and flashing out from the otherwise dull plumage of some common birds, effects quite different from the pervasive clear blues of open sky. Lapis lazuli, the original source of ultramarine, was a rare and valued mineral pigment, and other blues came from plant dyes such as woad and indigo, but synthetic pigments have greatly increased the range.

PURPLE A secondary, or mixed color, purple combines properties of blue and red, the strongest primaries, so it can provide a powerfully rich color sensation. The color range includes hues which we describe as purple, violet, or mauve, each suggesting a slightly different quality. Violet is represented in the spectrum of colored light. Purples, of limited availability from natural sources, are typically manufactured colors which did not figure largely in the artist's palette until the late nineteenth century. Purple itself is a naturally dark-toned color, light purples usually being achieved by mixing with white. The word mauve suggests softer shades with a bias toward the gentler reds, such as carmine, madder and the paler pinks, while descriptions such as lilac or lavender, used as color names, are purely associative.

ACHROMATIC COLORS Chroma is the quality of "colorfulness" in colors. Black, white and pure grays are described as achromatic, having in theory no color bias. In terms of color science, black is the result of all colors in light being absorbed by a surface. White results from the total reflection of all colors, and a neutral gray is seen when all wavelengths of light are absorbed to an equal degree. In real terms, there is usually three to five percent inefficiency in the absorption or reflection of light, so we are often able to distinguish different qualities of whiteness, blackness or grayness that also include a hint of color value.

COMPLEMENTARY COLORS

*I*f you stare at a bright red area of color for a minute or two and then transfer your gaze to a white sheet of paper you will see a green after-image. The particular green that you see is referred to as the complementary of the particular red you looked at. If you reverse the process and start with an area of green, you will have a red after-image. Every color has its complementary, which can be found in the same way. These have nothing to do with the nature of light itself, but arise for physiological reasons related to the way our eyes perceive light. You will notice that on the color triangle each primary color has its complementary on the opposite side: blue is opposite orange, red opposite green and yellow opposite purple. When you mix two complementaries, you get a neutral tertiary color because you are in effect mixing the three primaries. In terms of painting, unmixed complementary colors are useful because they intensify one another. A small patch of red in a large area of green can make the green look that much brighter. Nearly all painters have used this kind of juxtaposition to some extent: seascape painters sometimes "invent" an orange sail to enhance a blue sea, and Van Gogh sometimes used complementaries to create a deliberately jarring effect. In one of his paintings, he said that he had "tried to describe the terrible passions of humanity by means of green and red."

BELOW: Beach at San Bartolomeo *by Andrew Macara, oil, 40 x 50 inches. Our eyes often perceive the shadows in a scene as being the complementary color to that of the illuminated part, and here the artist has played this up, giving a violet tinge to the shadowed area of the yellow beach. For the path on the right, he has used a purer violet which perfectly balances its complementary yellow at the left of the picture.*

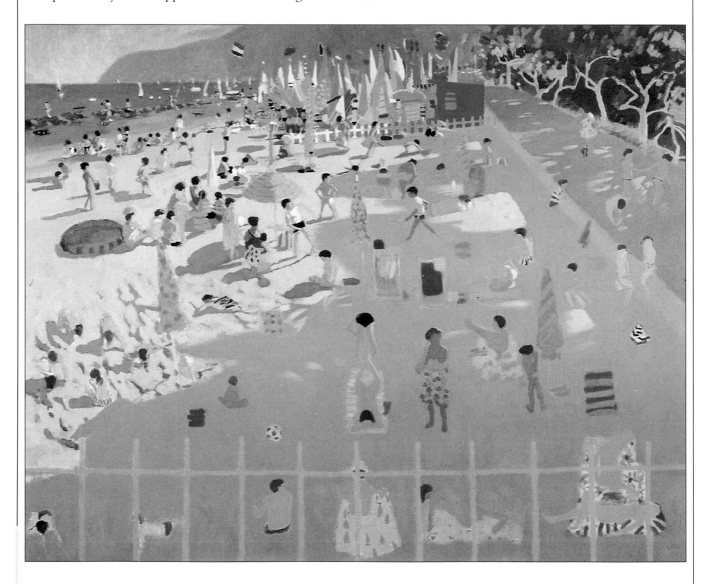

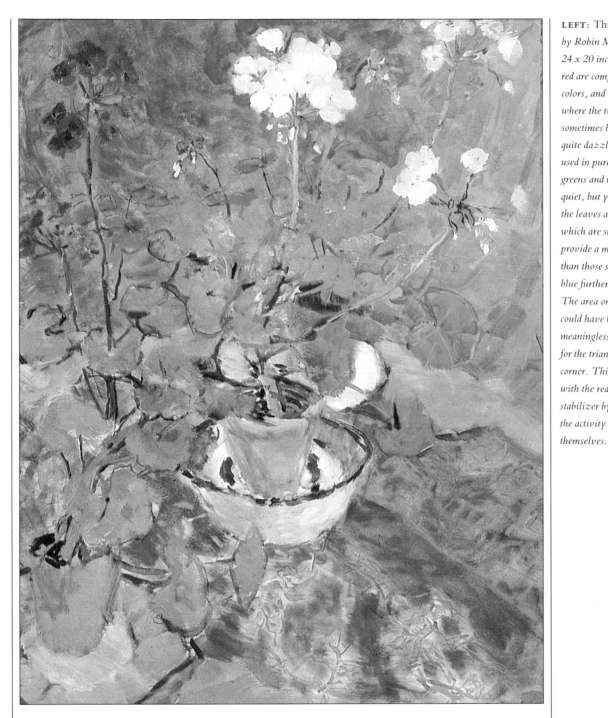

LEFT: Three Geraniums by Robin Mackertitch, oil, 24 x 20 inches. Green and red are complementary colors, and the boundaries where the two meet can sometimes be striking, even quite dazzling if they are used in pure form. Here the greens and reds are relatively quiet, but you can see how the leaves at the lower left which are surrounded by red provide a more forceful image than those surrounded by blue further up the picture. The area on the lower right could have been dead and meaningless had it not been for the triangle of green in the corner. This, contrasting with the red cloth, acts as a stabilizer by balancing all the activity in the plants themselves.

USING COMPLEMENTARY COLORS

Instead of using tone to describe form, modeling can be achieved by the use of complementary colors. The warmer members of each pair of complementaries are used to paint the highlights, while their cooler partners are used for the shadows; for example, an arm may be painted in yellow, with the shaded portion in violet.

Complementaries placed side by side form a particularly bright and eye-catching boundary which can be used to draw the viewer's attention to that part of the picture. This effect occurs even when the colors are quite muted; look, for instance, at the pale yellows and violets in Andrew Macara's painting of a beach (opposite). Robin Mackertitch has used reds and greens to enhance the colors of the flowers in her *Three Geraniums* (above). The cooler member of a pair of complementaries tends to recede while the warmer one advances.

THE COLOR KEY
OF A WORK

The "key" of a drawing is its overall impression of lightness or darkness, and its color emphasis, such as blues in a seascape, greens in a landscape, reds and yellows in a warm interior. A color scheme is said to be "high key" if it includes a high proportion of pale tones or brilliant colors, while a "low-key" scheme might consist of large masses of dark tone, relieved by highlight areas and color accents. However, an image basically composed of muted middle tones would also be described as low key, whereas mid-toned primary and secondary colors with colored shadows would create a higher key.

To assess the general impression of a subject's key, it helps to half close your eyes, cutting down on the details of light and color that you physically receive. You will then find that some colors and tones merge together and you can identify the most basic values of light, middle and dark tones and the tendency of the color values toward specific color families, such as red or blue, or general categories of color quality, such as warm or cool, vivid or neutral. This approach also helps you to decide on your

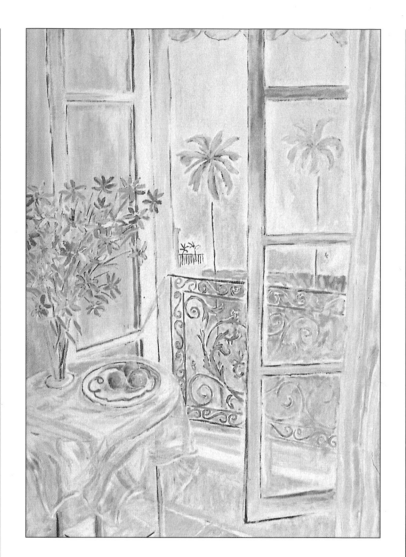

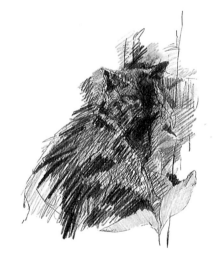

ABOVE: *The fur of a black cat seen under strong sunlight gives off many hints of color. In this graphite and colored pencil sketch, Judy Martin extends these color values to express form and texture.*

scale of colors and tonal values, which sometimes needs to be controlled and limited by comparison with the many incidental color effects in the real subject. Too many shifts of color and tone within a drawing can confuse rather than enhance the sense of form and space.

If a drawing or painting does not have a definite color key, it may well be unsuccessful. Imagine a piece of music written in a random motley of keys. The result would be a disaster unless in very skilled hands. Just one or two dominant colors give distinction to a painting. If there are too many they compete, drowning each other out instead of adding together. Likewise a key or theme is needed in other art forms including such everyday ones as cooking or choosing what to wear.

Certain subjects readily suggest their color key and its tonal values. A sunlit landscape of open fields, for example, is naturally

ABOVE: *Hugh Barnden's sunny window view maintains a high-key range of color – yellow, blue and mauve – and uses linear detail to define the structure of the composition. The geometric lines of the windows and the decorative balcony rail are traced in a warm mid-tone against the cool tints of the color blocks.*

highkeyed compared to a view into a densely wooded copse where there are strong shadows and natural darks in the trees and foliage. Similarly, a large-windowed interior seen on a summer's day with light flooding through the windows has a quite different color character from the same interior in artificial light or lit by low, wintry light from outdoors. In some circumstances, you will contrive a color key as the basis of a drawing subject – in setting up, for example, a still life of red, orange and purple fruits and vegetables rather than those that provide a range of greens and yellows.

Color accents can be used to help to emphasize a distinctive key. In a darkly shadowed interior or woodscape, tiny flashes of yellow, pink or acid green will emphasize the richness of the dark colors and tones without actually balancing them out. Where you have a naturally balanced subject, in which light, dark and mid-tones are relatively evenly distributed, you need to locate one particular color that will form the basis for developing the color relationships. This might be a background color giving overall color and tone – the tradition of pastel drawing on tinted paper serves exactly this purpose, using the paper color to set the middle tone. You might prefer, however, to first identify the well-defined areas of highlight and shadow that establish the lightest and darkest extents of the scale and then work within that range.

The quality of a dominant color is very important. You can ruin the general effect of a landscape, for example, by starting out with a broad area of green that is too blue or too yellow, too dark or too light, which then influences the color relationships.

On a practical note, when you make preliminary sketches to determine the color key of a composition, it is advisable to work with a medium that allows broad strokes and massed areas of color, such as pastels, markers or watercolor. With these you can quickly block the effect of an overall scheme, which gives you a basic construction for the drawn image. When you start to work on the final version of the drawing, you can feel confident about first establishing this general scheme based on the information in your sketches, and you can then develop the more complex aspects of surface quality and color accents.

ABOVE: *You can choose to interpret a subject in a high-key color, even though it may contain areas of deep shade. In this pastel sketch, Tom Robb converts the tonal balance to pure color values, using a dense bright blue for shadows that would normally have dark tone, to make a definite contrast with the warm reds, oranges and pinks corresponding to areas of the subject receiving more light. These two extremes are linked by the soft mauves standing for the middle tones.*

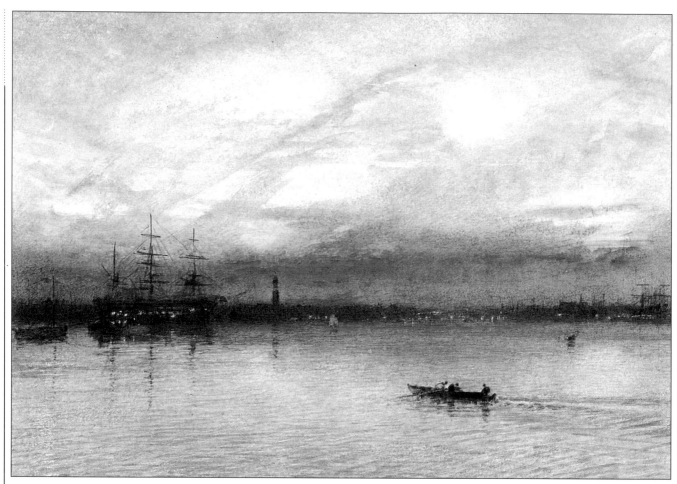

ABOVE: Portsmouth *by Albert Goodwin, oil and pastel, 8 x 12 inches. This picture is painted in a color key of pale blue, with all the blues, blue-grays and violets closely related to one another. Greens and reds have no place here, and the only other clearly defined color is orange which, being the complementary of blue, heightens the apparent intensity of sky and water.*

LEFT: *In this crayon and watercolor drawing the artist has adjusted the overall key of the image by giving the flat areas of grass a very intense, bright hue balanced by the vivid greens forming the middle range of tones. This increases the impression of brilliant sunlight.*

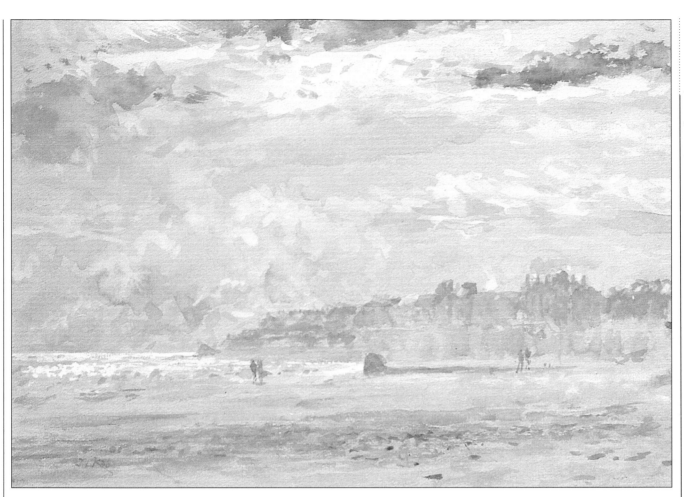

ABOVE: Whitley Bay Looking South *by Jacqueline Rizvi, watercolor and bodycolor, 8½ x 11¾ inches. This painting shows the use of high and low "keys." This is a very high-key picture, eloquently capturing the luminous light of sky and sea. Imagine a dark or bright color placed in the foreground – it would have completely destroyed the effect. The lightest touches are pure opaque white laid over the basic watercolor washes, and the darkest, the figures and other features on the beach, are nowhere near the darkest end of the tonal scale. The color range is also very subtle, with the muted blue at the top of the sky appearing quite brilliant in the context of the pale, warm grays with their hints of yellow and pink.*

LEFT: *The base of dark sepia-toned paper used for this pastel study of musicians sets the overall low-key impression, but Tom Coates has enlivened the surface with tiny dashes and streaks of high-key color.*

RIGHT: *Hugh Barnden's interior study creates space with a contrast of warm and cool color. The recession from rich reds into cold blue and mauve shadows is enlivened by the introduction of acid yellows and greens focused at the center of the composition.*

RIGHT: *A range of pure hues passing from warm to cool colors shows the variation of effects: yellow, for example, may appear warm and sunny or relatively cold and harsh.*

LEFT: *Grays and neutrals can show a considerable variation of color bias.*

TEMPERATURES OF COLORS

The idea that colors have a perceived effect of warmth or coolness is an often-quoted principle of color values that can be put to good use in color composition. Like all other individual and relative qualities in color interaction, however, it is not so simple as at first appears.

The "warm" colors are said to be those on the red, orange, and yellow side of the color wheel, and also mixed hues and values with a bias toward red, including red-purples, pinks and mauves. Blues, greens, violets and blue-purples are broadly categorized as "cool" colors. The form of "color behavior" attributed to these groups is that warm colors typically advance, while cool colors tend to recede, thereby providing spatial and structural characteristics which can be used to create a balance of color values in a composition.

The origin of these temperatures may be partly a matter of everyday associations – an over-heated person goes red in the face; the hot sun is orange-red; blocks of ice have hints of blue, as do the shadows in a snow-covered landscape. But whatever its origins, color temperature is a useful tool in painting, particularly to create a feeling of space and

BELOW: *Michael Upton's small oil painting shows a strong sense of draftsmanship in the basic structure of the image and the manipulation of the brushstrokes. The muted tertiary colors have an effective balance of tonal contrasts and color influence.*

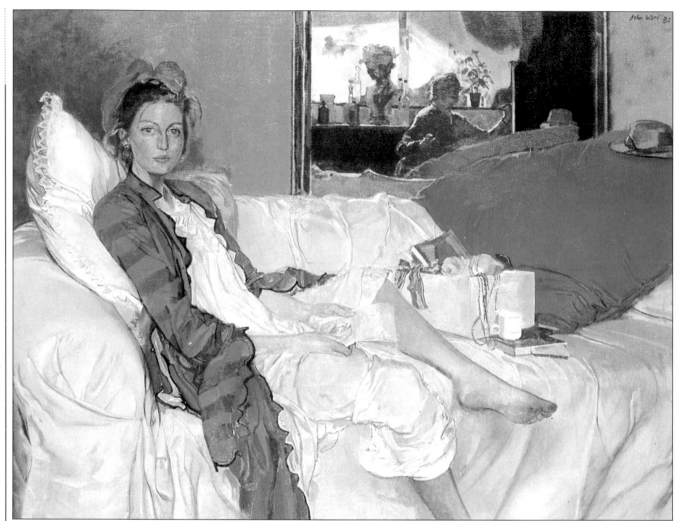

ABOVE: The Turkish Robe *by John Ward, oil, 36 x 40 inches. This picture, unlike Tia Lambert's, uses predominantly cool colors in a very carefully controlled range, and gives an impression of peace and relaxation. But even here some colors are relatively warm. For instance the striped gown is made up of alternating bands of cool blue and warm ocher, continued into the hair, while the pinks, yellows and oranges of the open gift box are considerably warmer than the blue of the cushion behind. The sheet and nightdress, as well as the face, hands and feet, are a mixture of cool and warm colors, reflecting the dominating blues.*

recession. Just as a line of distant hills appears as a cool blue-gray, the cool colors tend to recede, while the warm ones push themselves into the foreground. However, like everything to do with color, this is relative. Although the blues are theoretically all cool, some are warmer than others and some reds cooler. For instance, Prussian blue is cooler than ultramarine, which has a hint of red in it, while alizarin crimson is cooler than cadmium red.

There are properties of light and color that relate to this principle, to do with the speed and strength of the light wavelengths and the eye's receptivity to different colors. But it can be demonstrated in purely pictorial terms, and it is worthwhile studying paintings and drawings to see how artists have put these color qualities to use in enhancing compositional elements.

There can be a problem, though, if you depend on the apparent behavior of warm or

cool colors on the basis of a simple division of the color wheel, because the relative tonal values of colors and the influences within mixed hues also play a part. Some pale, cool colors will seem to advance quite strongly – such as an icy light blue or cold yellow-green – whereas some reds have a bluish tinge that makes them recede slightly from fiery orange-reds. Once again, this idea of color temperature has to be evaluated in practice within the context of your given range of color relationships.

A successful painting usually has contrasting or interlocking areas of either warm and cool colors or of dark and light tones, or often both. A painting which lacks these contrasts, for example, one that is all pale *and* painted entirely in cool blues and grays, besides failing to catch the eye, will be off balance and unpleasant to look at. It is a good idea to try to counteract warm areas with cool and vice versa even if it's just by using a warm ground showing through paint which is otherwise mainly cool.

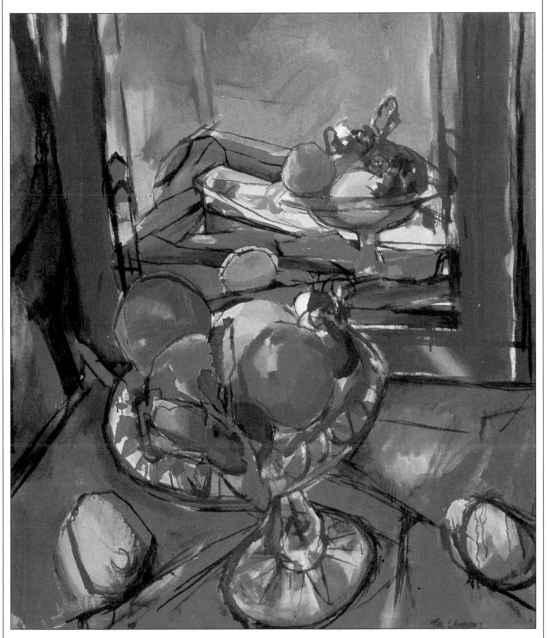

LEFT: Glass Comport *by Tia Lambert, acrylic, 40 x 34 inches. The interplay of bright, warm reds and yellows with equally bright but cooler blues and greens creates a lively and vigorous, but far from restful, image. It is interesting to see how the warm colors advance and the cooler ones recede, even though the position of the objects in space tells us something different. For example the red mirror frame jumps toward us although it is actually behind the blue cloth in the foreground, while the yellow patch in the reflection, the farthest away from us, is one of the most dominant features in the composition.*

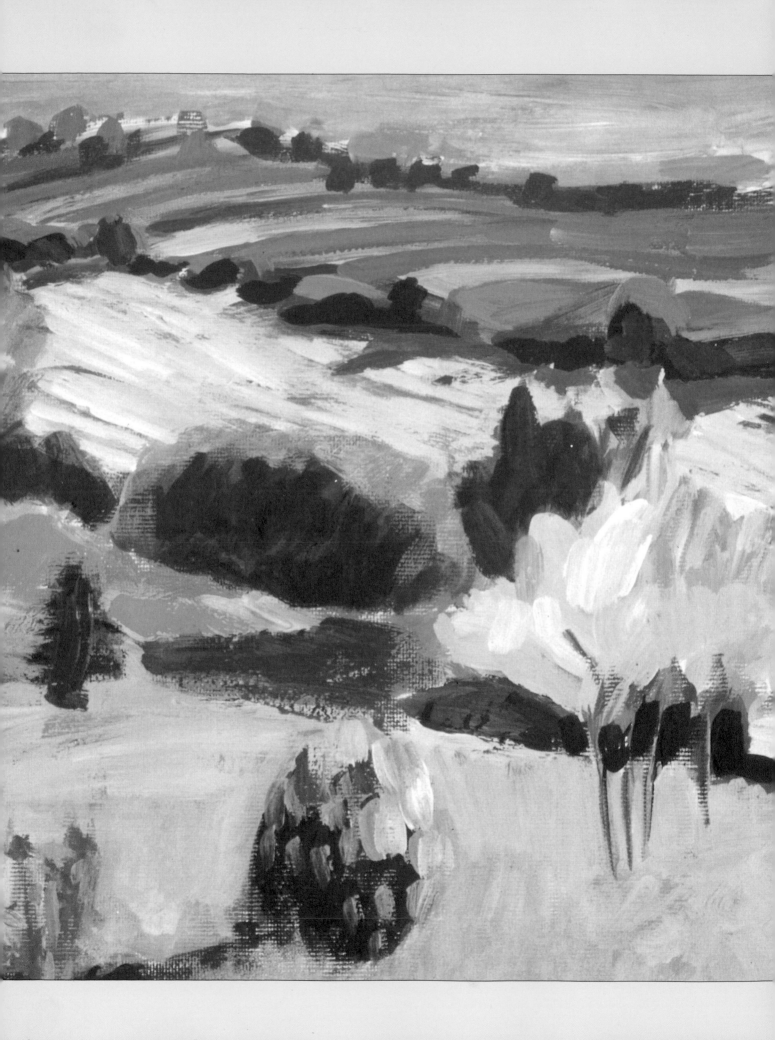

THE RIGHT
MEDIUM

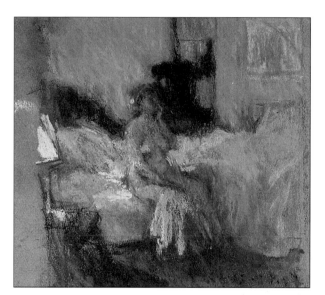

LEFT: *The crossover
between drawing and
painting techniques is
demonstrated in this acrylic
landscape by Jane Strother,
in which every brushmark
counts toward building the
impressions of space, form
and texture.*

*Some people are daunted by the array of
materials available for drawing and
painting in color. The choice of goods in
an artist's materials shop can seem
overwhelming, but in reality this variety
is meant to match individual preferences —
and limitations. There is no "right"
material — whether it is colored pencil, oil
paint or even paper collage. Instead, there
is a material or medium that is right for the
artist or right for a certain approach to a
work in color.*

Having decided to begin with a certain medium, an artist need not feel locked into it totally. Just think of successful mixed-media color works in ink and watercolor or using colored surfaces. Then think of the other combinations waiting to be tried, once you become familiar with them as individuals.

DRAWING

CRAYONS

The term is often applied to colored pencils, but should refer to solid sticks of color, similar in appearance to pastels but often supplied with one end fashioned to a rounded point. The binding medium is typically a waxy or oily substance. The inexpensive type used by children can be rather unsubtle, but there are also better-quality types suitable for artists' use. The slight translucency of the binding medium gives the colors a surface clarity. Crayons, like oil pastels, are particularly useful for resist drawing methods.

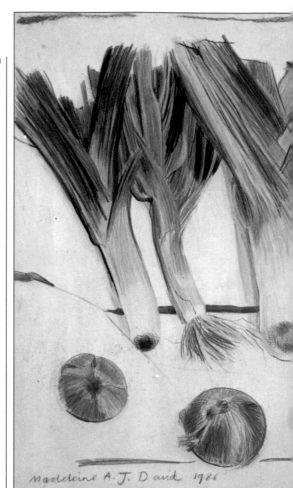

Madeleine A. J. Daud 1986

ABOVE: *The fineness of colored pencil provides considerably versatility in working up hatched and shaded textures. Despite the linearity of the medium, it can be used to achieve solid blocks of color or subtly graduated tones.*

COLORED PENCILS

The shape and texture of colored pencils – thin sticks of bound pigments encased in wood – provide a finer and more essentially linear drawing quality than pastels or crayons. Different types vary in the texture of the colored "lead." Some have hard, relatively brittle leads, that can be shaped into long, sharp points for very precise line work, while others are naturally soft and crumbly, more manageable than pastels but characteristically producing a broader, more grainy line than the hard pencils. The differences are caused by the binding agent used to hold the pigments. You can see and feel differences of texture if you look closely at the range of colored pencils in a display stand, but you will only know the precise drawing quality when you start to work with them.

Colored pencils characteristically produce a translucent effect that allows you to layer color marks to produce mixed hues and tones. Individual ranges may provide more than 60 colors. You can choose whether to maintain the same textural quality by using a single type in a drawing, or to take advantage of the range of textures by mixing different brands. You will probably need to use fixative to stabilize the drawing surface, either while the work is in progress or when the drawing is completed, especially if you use the softer types.

Some manufacturers produce water-soluble colored pencils that can be used either dry or wet. When you have laid the color on paper, it can be spread using a soft brush wetted with clean water. This enables you to produce effects of line and wash with the single medium. You can also dip the pencil point in water and twist and turn it on the paper to make vivid calligraphic marks.

LEFT: *Nicely regimented lines of vegetables have a vigorous character due to the freely worked texture of the colored pencil drawing in which Madeleine David has used an inventive approach to building the color mixtures. The yellows and browns in the onions are worked over soft purple shading, with strong white highlights overlaid to simulate the shiny skins. Dark-toned blues give extra brightness to the natural yellow-greens of the leeks.*

BELOW: *This detail of a landscape drawing by Moira Clinch shows how soft colored pencils have been used to create layered marks woven into mixed hues and tones. Working the pencil marks in one direction, in this case vertically, gives the overall image a cohesive surface.*

MARKERS AND FELT-TIP PENS

Markers have recently become an extremely important medium for certain types of color rendering, particularly in the areas of design and graphic presentation. They are quick, convenient, and available in a wide choice of coordinated colors, enabling artists to rapidly produce quite detailed and impressive color visuals that would take hours to do with paint. The drawback is the unpredictable lifespan of marker colors, as they change and fade on prolonged exposure to natural light. All artists' media are slightly variable from one pigment to another, but for practical purposes they are relatively stable, whereas some types of marker or felt-tip pen colors degrade quite quickly.

One solution is to use these media in combination with others, and to apply fixative, which slows the degradation of color values. They are certainly extremely useful tools for sketches and working drawings, being a source of varied and fluid color that is also easily portable and does not require use of a diluent or solvent. In these contexts permanence is not essential. Keeping examples of your sketches and color roughs over a period of time also

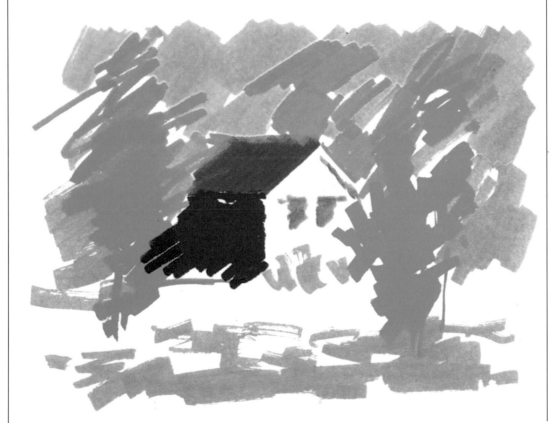

LEFT AND RIGHT: *Markers are excellent for quick sketches giving a vivid impression of form and color which can later be developed through more detailed drawings. Overlaying the transparent colors creates a sense of depth, and the movement of the pen tip contributes a vigorous quality to the subject even when, as here, it is rendered only as simple color blocks.*

RIGHT: *The transparency of felt-tip or marker ink provides a direct method of color mixing. It is useful to make a color chart of the various effects for future reference.*

provides a way of monitoring the relative stability of the colors.

Felt-tip pens and markers may have pointed or wedge-shaped nibs, either broad or fine, and may contain water-soluble or spirit-based ink. Spirit-based inks tend to spread, "bleeding" into the paper surface beyond the passage of the nib, so you need to make allowance for this if you want to work within fairly precise shapes. When working on a sketch pad, you may also find that the colors bleed through onto the next page, but you can obtain special marker pads in which the paper is formulated to resist color bleeding.

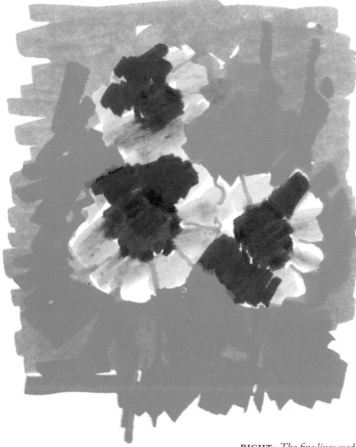

RIGHT: *The fine lines made by felt-tip pens give sketches a character distinctly different from that of marker work, though the colors have a similar boldness. Here hatching and shading have been used to develop an interesting "color notebook" of landscape impressions.*

PAINTING

OILS

*O*il paint consists of dry color pigment powder ground in a natural drying oil such as linseed or poppy oil to form a thick, buttery paste. When a layer of wet paint is applied to the canvas the oil slowly oxidizes on contact with the air and forms a solid skin. This oxidizing process occurs with each successive layer of paint applied, and gives a special richness and depth to the colors. Linseed and/or good quality turpentine can be added to the paint to make it flow more easily. More oil will give your painting a glossy look, more turpentine a flat look.

The color values of oil paints alter little during the drying process, though oil paintings do tend to yellow slightly over the years, the extent depending on which type of drying oil was used in the manufacture of the paints.

WORKING WITH OILS The appeal of oil paints undoubtedly has a lot to do with their tactile quality; their soft, viscous, buttery texture is irresistible to many painters. Oil paints also have a distinctive smell which, for many, is quite delicious. If you happen to detest the smell, you can use special low-odor thinners available from some manufacturers.

Oil paints have been widely used by artists for centuries. With the possible exception of acrylics, oil paint is the most versatile of the painting media because there are so many different ways in which it can be handled. The paint dries slowly on the canvas, enabling the artist to manipulate it freely and extensively, and to produce an infinite variety of textures and effects.

It can be argued that the personality of the painter is expressed more readily in oils than in any other medium. Broadly speaking, there are two contrasting types of oil painting; first there is the considered approach, in which thin layers of color are

BELOW: Bus Stop *by Walter Garver, oil, 32 x 44 inches. This artist works on a large scale, and uses oil paint in an unusual way. He paints on masonite primed with acrylic gesso, which gives an absolutely smooth, untextured surface, and he builds up areas of intense, flat color by using the paint very thin, in a succession of semi-transparent glazes.*

built up slowly over a prolonged period, often on top of a carefully planned underpainting. Then there is the direct *alla prima* approach, in which the painting is usually completed in a single session and without any underdrawing or underpainting. With this approach the paint is handled more freely and spontaneously, and various techniques may be employed within the same painting. For instance, you can apply thick paint with a brush or knife to build up a highly textured impasto; you can blend one color into another, or you can apply opaque dryish paint very thinly, with irregular, scrubby brushstrokes – a technique known as scumbling. If you want to alter or correct a passage, the paint can be easily scraped or rubbed off, or if it is completely dry, simply painted over again.

Once dry, an oil painting can withstand quite rough treatment (within reason!) because the paint hardens to such a tough,

flexible layer on the canvas. An old painting can also be cleaned without any damage to the paint itself.

Do oil paints have any disadvantages, then? Well, their slow drying times do present some problems, the most obvious one being that you are obliged to keep your still-wet canvas well clear of inquisitive children and hairy animals, and when painting outdoors, chances are that your painting will blow or fall over, inevitably landing "butter side down"!

Another point to bear in mind, and a most important one, is that if the paint is to be applied in layers, the first coat must be dry before the next is laid on; otherwise, the paint surface is liable to crack in due course. For the same reason, you should always adopt the principle of "fat over lean" when painting in oils. This means that oil paint diluted with a high proportion of oil ("fat") should always be applied over paint diluted

ABOVE: Red Tablecloth *by Robert Buhler, oil, 20 x 24 inches. Oil paint can be used in many different ways, but it invites itself to the kind of thick, rich application seen here, where each brushstroke of the barely thinned paint is discernible. Such brushmarks form an integral part of an oil painting, and give a characteristic texture to the picture surface, unique to this medium. The pale ground, showing through in places, enhances the impression of gentle intimacy.*

LEFT: Evening Shadows, Weymouth *by Arthur Maderson, oil, 25 x 38 inches. When oil paint is applied in rich impasto, as here, it never loses the glistening-wet look it had the day it was painted. Here, layer upon layer of thick paint has been applied loosely, with each small patch of color remaining* separate from its neighbor. *The artist has taken an obvious delight in the textural qualities of the paint, but has at the same time created a realistic impression of a particular scene. Making the paint play this kind of dual role is one of the secrets of a really good painting.*

with thinners ("lean"). If lean paint is applied over fat, the lean layer will dry first. The fat layer underneath dries more slowly, and as it does so it contracts, causing the dry paint on top to crack.

Beginners are often put off the idea of painting in oils because of all the equipment needed and the fact that they are so messy. These are disadvantages, especially if you want to paint outdoors. The minimum equipment you need is a box of oil paints (which come in tubes), bottles of linseed oil and turpentine to thin the paint, a palette on which to mix and thin the paints, some brushes and a primed surface to paint on. You will also need mineral spirits to clean your brushes, a rag to clean the palette, and an easel to hold your picture (or you can simply use your lap if painting a small picture out of doors.) Make sure you can take the wet painting home without smudging it! You should wear old clothes or an apron or smock because, however careful you are, the paint always seem to find its way everywhere it shouldn't. Paint-laden brushes can somehow flick out of the artist's hand and into his lap or onto the floor – so be prepared! Accidental spillages on clothing can be removed with a rag and mineral spirits. A universal solvent such as Swarfega, followed by a rinse in water, is best for cleaning the hands. Artist Jeremy Galton also offers this practical advice: "If I'm out painting a landscape for a whole day and

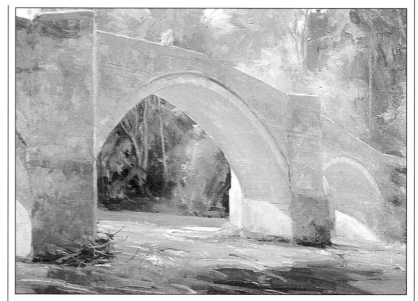

ABOVE: Bardes Bridge, Wasdale *by David Curtis, oil, 15 x 20 inches. Here the oil paint has been applied so thinly that it looks at first glance almost like* watercolor, the white ground *illuminating the paint from behind. On closer inspection, however, thicker, drier paint can be seen in places, notably in the areas of the left-hand* buttress and the water. The *individual brushstrokes have hardened in exactly the shape in which they were laid – the characteristics of oil paint.*

want to get the paint off my hands to eat a picnic lunch, I take along one of those tins of acetone-based cleansing pads which are designed for freshening up the face. I mention this because it is important not to let paint contaminate your food as many of the pigments are extremely poisonous (containing lead, cadmium, and mercury among others)."

WATERCOLORS

Watercolor paints consist of very finely ground pigment mixed with gum arabic until it is fully emulsified. This water-soluble gum acts as a light varnish, giving the colors their characteristic sheen. The paints are supplied either in tubes or in small blocks called pans or half pans. These have some glycerine added to keep them from hardening and are known as semi-moist. Watercolors can also be bought in dry cakes, which theoretically contain pigment in its most pure form, with no added glycerine, but they are not much used nowadays as it takes a long time to release the color from them.

Obviously, watercolor paintings are more fragile than oils and other opaque media, and must be mounted and framed under glass immediately or stored very carefully. The colors tend to fade slowly when exposed to bright sunlight so it is wise to keep them away from a sunlit window.

The equipment you need for watercolor is much simpler than for oil – the paints themselves which can be packed in very small boxes; a palette, which may simply be the lid of the box; a few brushes; a jar of water; and some paper. It is therefore much more portable and many painters prefer using watercolor when working away from home.

WORKING WITH WATERCOLOR

Watercolor has a unique delicacy and transparency that make it the perfect medium for capturing the subtle nuances of light and color in nature. When you paint in watercolor, you are in effect painting with pure water into which a small amount of color has been dissolved. The white, reflective surface of the paper shines up through these transparent skins of paint, and this is what gives the colors their inner light. A good watercolor painting has a freshness and poetry that are unmatched in any other medium. However, it is a popular misconception that bright or dark colors cannot be obtained in watercolor.

The disciplines of watercolor painting are quite distinct from those of oils. Because water dries relatively quickly, especially when working outdoors, you must work equally quickly; you can't manipulate the paint or push it around as freely as you can in oils. You must therefore have the courage of

ABOVE: *Watercolor washes are not only suited to broad expanses of atmospheric color. With strong hues and varied brushstrokes, watercolor can also convey a calligraphic energy.*

RIGHT: On the Bay of Sorrento *by Hercule Brabazon Brabazon, watercolor, 8¼ x 11¼ inches. Very loose handling of paint gives this picture the characteristic free, immediate effect unique to watercolor. Small touches of opaque white have been used in the foreground, but much of the picture has been painted wet-in-wet, a technique which produces unpredictable and not always entirely controllable results. The watercolorist is always on the lookout for ways of using semi-accidental effects to enhance the mood of a painting.*

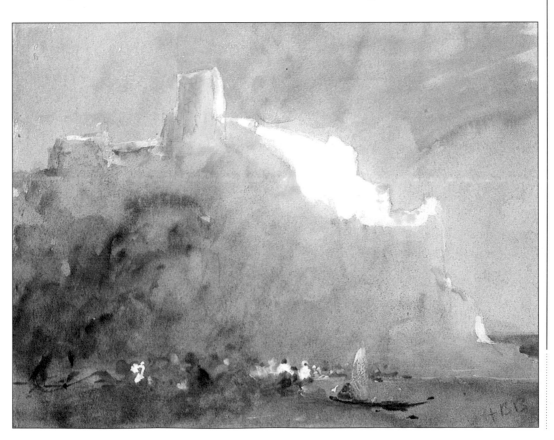

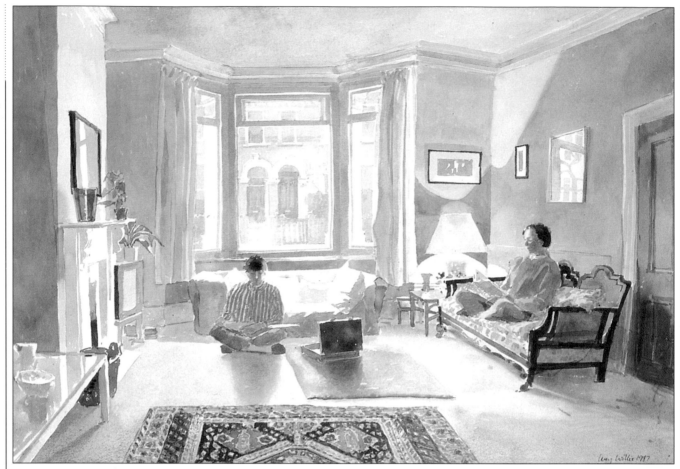

your convictions and be prepared to work boldly and confidently, with no hesitant pickings or proddings. In addition, a certain amount of planning and forethought are required because mistakes cannot easily be rectified.

Unlike opaque media, in which light colors can be applied over dark ones, transparent watercolor requires the artist to begin with the lightest tones and overlay with further washes.

The fluid nature of watercolor makes it less predictable than any other painting medium, but this is more than compensated for by the range of exciting and beautiful effects it can create – sometimes more by accident than design. Washes are the foundation of watercolor painting. When a brush fully charged with paint is swept across damp paper, the strokes dissolve together and the color shines out from the paper. Watercolor washes can either be precisely controlled, or allowed to flow together wet-in-wet so as to form exciting interactions.

ABOVE: The Yellow Room *by Lucy Willis, watercolor, 22 x 31 inches. The transparent feature of watercolor is apparent here, with the white paper glowing through all but the blackest areas. On both the figures and the right-hand wall, washes have been laid one over another, and in the extreme foreground some of the pigment has separated, giving a granulated effect, an example of the unpredictability of watercolor washes laid over earlier paint layers.*

GOUACHE

Gouache is essentially an opaque version of watercolor, made by mixing the same pigment with some zinc white. It is sold in tubes, pots or bottles, often labeled "designers' gouache colors." Some of the colors have the same names as their counterparts in watercolor and oil, but in addition there are a host of others with names like grenadine, Phoenician rose, ocean blue, onyx green and Parma violet. Each manufacturer seems to have its own range of colors.

Since the paints are opaque, they are usually handled more like oils or acrylics than like watercolors, although they can be thinned and used semi-transparent, just as oils can. In some ways, gouache is a tricky medium to use successfully. Although mistakes can be over-painted, and light colors laid over dark in a way that is not possible with watercolor, the paints remain water soluble even when dry, which means that putting a layer of wet paint over another layer below tends to stir up and muddy the paint already there. The other disadvantage is that the colors dry considerably lighter than they appear when wet, so it can be difficult to judge what the finished effect will be. Gouache paints are quite matt when dry, and have none of the luminosity of watercolors – because of their opacity, light cannot be reflected back from a light ground

below. However, they have many advantages for a beginner. They dry very quickly, which makes them useful for rapid landscape painting on the spot – the first landscapes I ever painted were in gouache, one of which is shown here. They are also excellent for laying solid areas of consistent color, which cannot be done with either oils or watercolor; for this reason they are used extensively in design and illustration work. Finally, they are less messy than oils, and the equipment needed is more compact.

LEFT: Evening Interior *by John Martin, gouache, 18 x 12 inches. Here gouache has been applied so dry that it almost gives the appearance of pastel. Gouache, unlike true watercolor, is totally opaque, each brushstroke obliterating the one below, but care must be taken to apply each subsequent layer lightly or the wet paint will disturb that beneath it, muddying the colors and losing their brilliance.*

LEFT: Olive Trees near Ronda *by Jeremy Galton, gouache, 7 x 10 inches. Most of the colors in this painting have been mixed with quite a lot of white, producing a high-key picture compatible with the dazzling light of southern Spain. The distant mountains have been lightly glazed over with white paint used thin enough for the colors beneath to show through, a technique more common in acrylic than in gouache.*

ACRYLICS

The development of acrylic paints went hand in hand with the development of plastics; indeed, the acrylic medium is a plastic, made from petroleum products. The paints were only introduced in the 1950s in America and the 1960s in Britain, so their full potential is still being explored by artists. Acrylics are the most permanent of all paints; because the medium is resistant to oxidation and chemical decomposition, they do not yellow with age as oils do, nor do they fade as do watercolors. They are also the fastest drying of all paints, and once the paint has set it cannot be redissolved.

Acrylics will adhere to almost any surface, so can be used on canvas, board or paper. Priming is not strictly necessary, but if it is used it must be an acrylic primer sold specially for the purpose, not an oil-based one (oil paint can be used over acrylic, but not vice versa). The equipment needed depends on the way the paint is to be used. If it is being laid on relatively thickly, like oils, then it is mixed on the same type of palette and applied with the same brushes, but it can also be used thinly for small-scale, detailed work, in which case watercolor brushes and palette are a better choice. Whatever brushes are used, they must be cleaned repeatedly through the course of a painting, as soon as the paint looks like drying, as otherwise it will be the end of that brush. The paints are sold in tubes or pots, and great care must be taken to replace lids and tube tops or the paint will dry out and be useless.

CHARACTERISTICS OF ACRYLICS Because acrylics are such a new medium, they are an invitation to experiment. They can be applied just like oils (although they do not look the same, being more matt in finish), and many artists use them to build up thick impastos, as they are so fast on drying, but they are equally well suited to the technique of glazing. The two techniques can also be combined, with thin glazes laid over thick impastos – indeed the possibilities are almost endless.

The paints can be thinned either with water or with a special acrylic medium specially formulated for the glazing technique. This can be bought in both a

glossy and a flat finish. For those interested in impasto work, a special impasto medium can be obtained to make the paint thicker and give it more body so that it can be applied with a palette knife.

Thin paint and glazes will dry within a matter of minutes, while rather thicker paint will be dry within half an hour. Thick impastos will stay workable for much longer periods, as will large blobs of paint on your palette. It is when mixing small quantities of paint that the fast drying time can really become a disadvantage. You can add a retarding medium to overcome this problem, but the best plan is to buy a "stay wet" palette, a special disposable tear-off palette in which water from a reservoir continually seeps up to moisten the paints.

ABOVE: Venetian Market by Nick Andrew, acrylic, 22½ x 30 inches. Here the paint has been used quite thin, with some layers allowed to overlap others. The white ground showing through these transparent washes, or glazes, produces color mixes quite different in appearance to those made by premixing the paint on the palette. Final touches have been added in pastel.

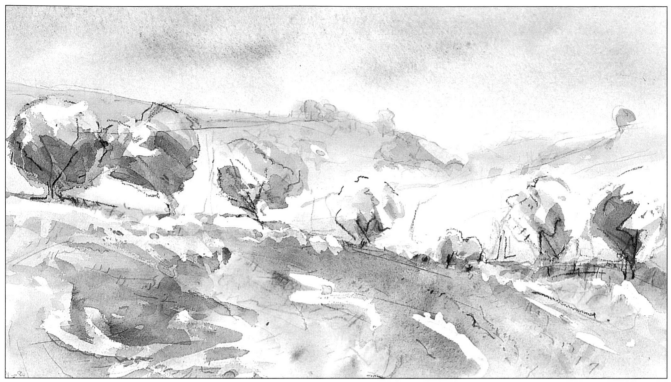

ABOVE: Black Hills *by Hugh Byrne, acrylic and watercolor, 26 x 14½ inches. The beauty of acrylic is that it can be used in so many different ways. This artist combines it with watercolor, thinning it with both water and acrylic retarder and laying a series of transparent washes on stretched watercolor paper. He finds that the acrylic, even thinned, provides extremely brilliant colors, which can then be modified as necessary by washes of pure color laid over them.*

ABOVE: Evening Watch *by Roger Medearis, acrylic, 16 x 24 inches. As a student, Medearis learned to paint with egg tempera, and he uses acrylic in a similar way, applying thin scumbles alternating with glazes, and building up coat after coat of paint. Of all the painting media, acrylic is the one best suited to this approach as the paint dries so rapidly. The same technique used in the slower-drying oil paint can not only take a very long time but also has a tendency to become overworked.*

Medearis works on either masonite or canvas primed with acrylic gesso, and because his emphasis is on tonal values he favors a very limited palette – for some years he used only the primaries, plus black and white.

MIXED APPROACHES

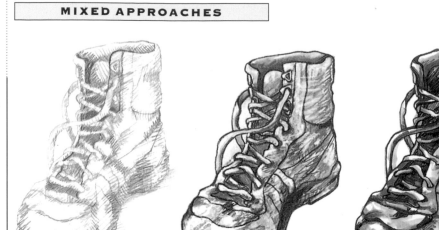

ABOVE: *This exercise explores the effects of different drawing media applied to the same subject. Colored pencil has a more lightweight, open effect than that of opaque, loose-textured pastel. Overlaid marker colors build a solid sense of form, while pen and ink drawing exploits calligraphic qualities.*

PASTELS

*P*astels have been in use since the 18th century, when they were particularly fashionable in France. They are made of pure pigment and varying amounts of whiting, depending on the lightness or darkness of the color, and bound with just enough gum to be pressed into stick form. As with watercolor, there is a prevalent belief that only pale and delicate shades can be obtained with pastels, but this is really not true; many modern pastelists produce wonderfully vivid work, and the greatest exponent of the medium, Edgar Degas, created some of the richest color harmonies ever seen.

As far as equipment is concerned, pastel is the simplest type of paint to use, since only paper, and the pastel sticks themselves, are needed. It is one of the most immediate of all the painting media – there are no delays while you mix colors or rinse brushes, and you don't have to wait for bits to dry before putting on the next color. No bottles, brushes or palettes are needed, and the pastels themselves are highly transportable – rather like drawing, but with color.

Pastels are made in three qualities, soft, medium and hard, with soft being the easiest to use and thus the most popular. Most manufacturers label the sticks with the name of the pigment, for instance "ultramarine" or "lemon yellow," and a number indicating the relative lightness or darkness. This is usually on a scale of 0 to 8, but manufacturers vary, and there is no standard system.

Soft pastels are a source of clear, brilliant color. The quality of the pigment is very little affected by the small amount of binding medium used to contain the powdery color

BELOW: *The clarity or density of soft pastel color depends on the closeness of the marks and the edge quality of the pastel stick, varying from sharp lines to solid, grainy color.*

ABOVE: *Pastel pencil is clean to use and gives a relatively even line quality as compared to thicker pastel sticks, although the linear texture can also be worked in hatched, stippled or scribbled marks to create densely knitted color effects.*

RIGHT: *Judith Rothchild's atmospheric drawing demonstrates the degree of detail that can be achieved with expert handling of pastels. The bright accents of* color in the red flowers and the dappled background light are effectively played against the dark tonal register of the shadowy trees.

in stick form. Though individual pastel strokes lay down clean, opaque color, the gradual build-up of powder on the drawing surface can create a muddy, veiled effect. This cannot be eliminated altogether, but experience in handling pastels teaches you how to maintain the color values or rework them to retrieve their clarity.

Medium and hard pastels contain more binding medium than soft ones, and are relatively more stable, but they do also develop a film of loose color and remain liable to smudging. When you work with pastel, your fingers quickly become coated with color, and for this reason some types of pastel are paper-cased, and others protected with a fine plasticized coating for easier handling. Pastel pencils, in which the thin sticks of color are encased in wood, are cleaner to handle, but less versatile. You cannot use them to lay in broad areas of color, as you can by using the side of the pastel stick, nor can you make the particular sharp line quality that the section edge of a round or square pastel stick creates.

High-quality artists' pastels are produced in tints (pale tones) and shades (dark tones) of a wide range of pure hues to facilitate tonal gradations and color blends. Boxed pastel sets offer selected colors, some representing a basic "palette" for color mixing and others representing color families – a range of reds or greens or a combination of colors such as greens, blues and browns for rendering landscape.

CHARACTERISTICS OF PASTELS

Unlike the "true" painting media, pastels cannot be premixed, although they can to some extent be mixed on the paper. Instead, the painter uses a range of sticks, each of a different tint, or shade, and the picture is made up of small strokes or marks of each stick. These can be laid one over another in a technique called hatching, or they can be softly blended together with the finger, a brush, a rag or a rolled stump of paper called a torchon. A great range of different pastel strokes can be made, from broad sweeps using the side of the stick to fine lines or tiny dots made with a sharpened end.

Most pastelists work on colored rather than white paper, leaving large or small areas to show through the pastel strokes, so that in effect an extra color has been added to the palette. The paper should have a little "tooth" to catch the pigment as the stick is rubbed over it. If the paper is very coarse grained, little specks show through where the pigment has not entered the "pits," giving a lovely sparkling effect.

A disadvantage of pastels is the fragility of the picture, both when finished and when working. The pigment is so easily rubbed off the paper that it must be handled with great care. Some pastelists spray their work with fixative at various stages while working, but this can deaden the colors a little and darken the tones. A completed pastel should be stored flat or framed as soon as possible.

OIL PASTELS These, although they look just like ordinary pastels, are more a painting medium than a drawing one. They can be mixed on the paper to a much greater extent than true pastels, as the color can be spread by dipping a rag or brush in turpentine (or mineral spirits). The pigment can be moved around on the paper in this way, and very subtle effects can be created by laying one color on top of another, mixing them with turpentine, and then laying dry pastel on top of this. There is more possibility for correcting mistakes than with true pastels, as whole areas can be lifted out – as long as the paper is tough enough to stand this kind of treatment. Oil pastels are excellent for rapid outdoor sketches and color notes, as areas of color can be built up very quickly, and they do not require fixing. They can be used on any paper, but those specially made for pastel work are the most satisfactory, particularly the toned papers.

BELOW: Oil pastel colors have a particular vibrancy because of the waxy medium used to bind the pigments. Like soft pastels they make characteristically grainy marks, but with overworking the colors readily fuse together.

BELOW: Wax crayons have a slightly more subtle effect than oil pastels. Although handled in similar ways, it may take longer to build the strength of the color values.

DRAWING INKS

These are a useful medium because you can use either pens or various types of brushes to make a variety of different marks. The color range is limited, incorporating, for example, two different values of red, yellow, blue and green with orange and purple, brown, sepia, black, white, and gold and silver inks for decorative effects. Some drawing inks dry to a waterproof finish allowing you to build a good depth of color density by overlaying linear marks or washes of color. Water-soluble inks, including products described as "liquid watercolors," offer a range of concentrated colors that can be diluted with water but are not fully waterproof when dry.

You can obtain dip pens with interchangeable nibs that provide you with a range of linear options, from very fine to very broad. But you can actually use any stick-like implement to draw with colored ink, so it is possible to experiment with loose and textured marks. Any of the paint brushes recommended for watercolor and

BELOW: A highly active black ink line is elaborated with watercolor washes in a drawing by Ian Ribbons of a biker in full leather regalia. Black is used not only to provide a structural framework, but also as a positive element of local color in the details of the bike and clothing.

RIGHT: A colorful image can be achieved using only line work and a limited color range, as in this pen and ink drawing of anemones.

acrylic work are suitable for ink drawing, but waterproof inks contain shellac or a similar drying medium that can clog brushes and pens; so be sure to clean your drawing tools thoroughly. And never use waterproof ink in a closed-reservoir pen such as a technical pen or fountain pen.

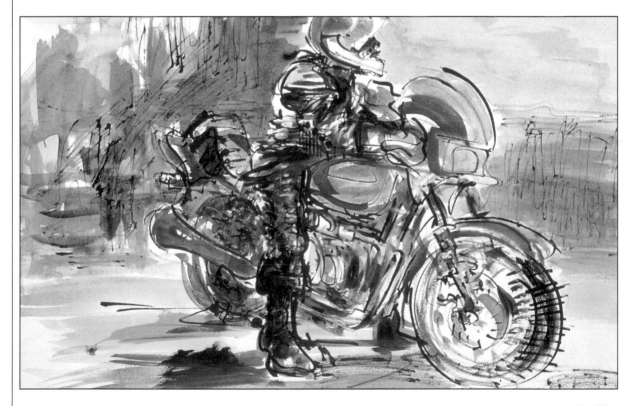

RIGHT: Pens and drawing inks are now rather neglected in favor of the convenience of markers, but metal pen nibs can be manipulated in ways that add rich textural detail to an ink drawing through variations of line and tone.

USING THE MEDIUM

DRAWING WITH PAINT

Any type of artists' paint can be used for drawing, and any technique of applying it. There is no particular advantage, however, in using oil paint: it is slow drying and requires special diluents and solvents. It is also necessary to prepare a ground of gesso or latex to work on, as oil mediums spread into untreated paper and eventually cause it to deteriorate.

Watercolor, gouache and acrylic paints are all quite suitable for use on paper. They are also convenient, as you only need water to dilute the paint and to clean your brushes. They can also be used in combination with the "dry" linear drawing media to create complex effects of color and texture. Acrylic and watercolor washes provide transparent color values that work well with colored pencil and crayon drawing, while opaque gouache dries with a surface quality similar to the density and color brilliance of pastel.

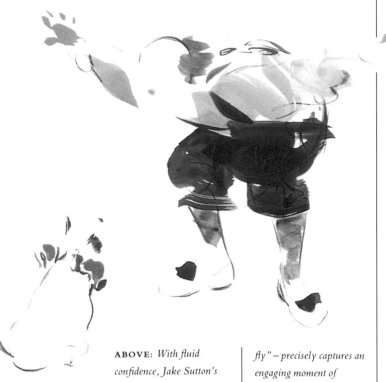

ABOVE: *With fluid confidence, Jake Sutton's bright watercolor sketch – captioned "Everyone can fly" – precisely captures an engaging moment of interaction between clown and dog.*

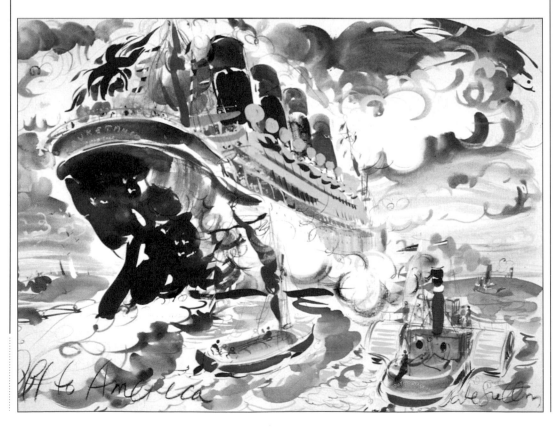

LEFT: *Jake Sutton's exuberant brushwork and clear primary colors create a vivid celebratory atmosphere, very far from the restrained character traditionally associated with the medium of watercolor.*

COLOR MIXING

Including mixed colors in a drawing tends to produce a greater depth and variety in the finished image than does simple reliance on the manufactured colors of individual materials. Mixed hues and tones are mainly created by layering or interweaving colored marks to build variations in the color values. The disadvantage of color drawing as compared to painting, where colors are mixed independently in a palette, is that it takes longer to discover whether the effects of the more complex color mixtures are the ones you expected or wanted.

An advantage is that colored drawing materials are relatively inexpensive, and as you increase your stock you have a great many colors to choose from. Also, because you will often be working gradually toward a finished image, you will have plenty of time to make adjustments to the colors you have already laid down by introducing new elements. As you develop the color qualities on the paper surface, you can make subtle and intricate combinations, either across the whole area of the drawing or in key passages that enhance the overall effect of existing color values.

There is no need to feel confined by working with basically linear media, as there are many ways to blend and layer the drawn marks to produce rich effects of color and texture. The variations in technique depend on four main factors: the texture of the material, the quality of the point or edge of the drawing tool, the angle at which it is held and the range of gestural movements you employ. The tone and texture of the paper are also important elements, affecting the surface qualities of the color work.

There are no fixed formulas for color mixing in drawing; it is a matter of trial and error, of becoming accustomed to each medium and understanding how its inherent color values can best be combined. You can experiment with the different values that can be obtained by working light colors over dark or vice versa, combining three or four colors to make a complex mixed hue or dark tone, varying the density and direction of the marks to alter the surface effects and so on. Investigate also how easy it is to overwork a correction successfully and how you can

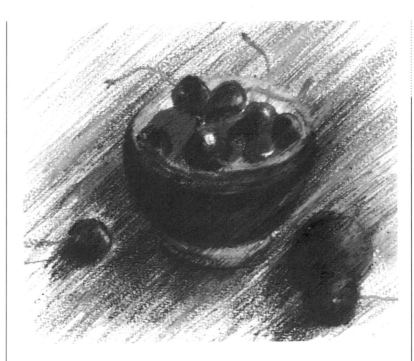

draw with the eraser to make "negative" effects, which further vary the color values and surface texture. Testing the purely physical qualities of color mixtures gives you a reservoir of knowledge which you can subsequently apply to specific goals in drawing. Technical practice also gives you more confidence in carrying out projects – it can take a while before the elements that you put into a drawing start to come together, and you need to keep a positive sense of what you are aiming for until the magic moment when the image really comes alive.

SHADING AND BLENDING

In this context, shading is taken to mean creating color values in terms of mass, the final result being a dense and relatively even color area. Subtle blends, mixed hues and graded tones are produced by overlaying shaded blocks of different colors. These can be made hard-edged to create abrupt transitions defining space and form, or softly integrated one into another to develop a more gentle description of volume or an atmospheric sense of space and distance. Blending blocks of shaded colors also offers the chance to use a subtle mixed-media approach.

Shading with a dry-textured and basically linear medium such as colored pencil, pastel or crayon tends to produce a grainy effect. The degree of graininess depends upon the

ABOVE: *Jan McKenzie builds the rich color effects of her drawings by mixing the media freely. The colors of the cherries were first established with a base of watercolor, over which oil pastels and colored pencils were worked together to develop the range of hues and tones. The technique of dense hatching creates the color mixtures. The direction of the pencil and pastel strokes is consistent throughout, although this is less apparent in the bowl and cherries where the colors have merged more solidly than in the open background texture. The lush effect of the fruits is enhanced by the opaque white highlights, a finishing touch which further enlivens the darker hues.*

quality of the medium itself, the texture of the paper and the amount of pressure you use to lay the color – heavy pressure forces color into the paper grain. If you start out by applying a densely compacted color layer, you will reduce the range of possibilities for developing mixtures. This is especially the case with wax crayon or oil pastel, when the fatty quality of the binder creates a resistant surface. Some colored pencils also leave a waxy finish.

The slightly broken effect of lightweight shading, which naturally occurs as the point or edge of the medium passes over the paper texture, allows successive color applications to build mixed hues and tones through integrated color layers. Different weights and emphases can also be created across a color area by varying the direction of the shading in separate color applications.

Colored pencil is characteristically a more transparent medium than pastel. Subtle and delicate effects are possible because movements of the pencil point can be finely controlled and colors maintain their clarity as the layers are overlaid. Opaque pastel is a bolder, looser medium. The texture can be exploited in blending the loose colors on the surface by rubbing with your fingers, a paper stump or a cotton swab. If you over-mix, you will devalue the color qualities so it may be necessary to use fixative frequently to seal each color layer before working over it. Alternatively, it might be more appropriate to use one of the open, linear techniques of color mixing described below, but the character of the drawing must be taken into account.

BLENDING MARKER COLORS

Felt-tip pens and markers naturally produce a different result because they lay wet ink that floods the surface, following the path of the felt tip. Mixtures occur because the ink is transparent, so each succeeding color layer modifies the hue or tone of the one before. Marker ink dries quickly, however, and you tend to get a streaky, lined effect in a block of color, the texture varying according to the width of the nib and whether it is pointed or wedge-shaped. The directional strokes given by markers are often exploited to emphasize form and contour, but you can obtain a

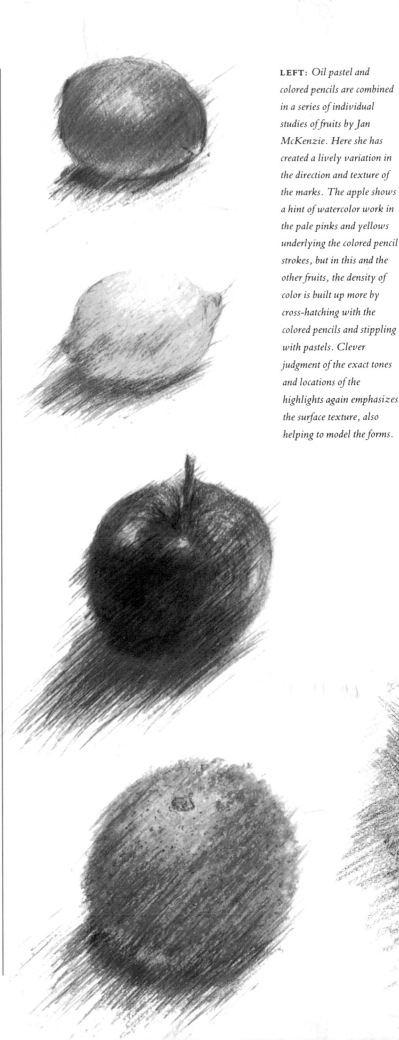

LEFT: *Oil pastel and colored pencils are combined in a series of individual studies of fruits by Jan McKenzie. Here she has created a lively variation in the direction and texture of the marks. The apple shows a hint of watercolor work in the pale pinks and yellows underlying the colored pencil strokes, but in this and the other fruits, the density of color is built up more by cross-hatching with the colored pencils and stippling with pastels. Clever judgment of the exact tones and locations of the highlights again emphasizes the surface texture, also helping to model the forms.*

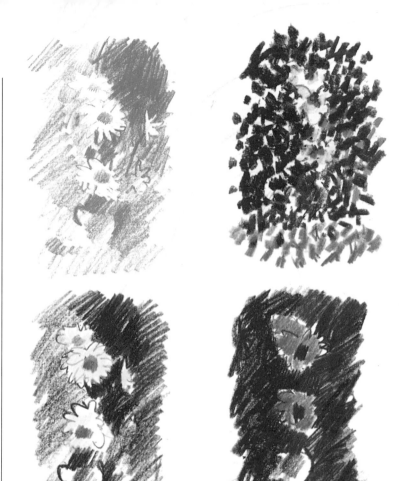

smoother effect if you wish, by working quickly and running each pass of the nib into a preceding wet edge of color. Color gradations are made either by overworking with the same hue to darken the tones where required or by introducing a different color – for example, running red-brown over a bright mid-toned red. Because the ink is transparent, pale colors make little impact on darker ones, so you need to plan the color sequence to obtain the right effect of light-dark gradations.

LEFT: *The only way to get to know both the textures and color qualities of your materials is to try them out, working in different ways to discover the typical marks and ways of mixing and blending the colors to create a range of effects. The purpose of this exercise is to become familiar with handling a particular medium, or combination of media, not to aim for a finished image, and it is useful to allow yourself a free approach. In these oil pastel sketches, the subject simply forms the basis for investigating surface effects and a changing balance of tone and color.*

LEFT: *In this convincingly detailed color rendering, the almost solid color areas in the background and the crab shell are mainly developed through hatching and cross-hatching. In some areas, oil pastel has been scratched through with the point of a light-colored pencil to lift the tonal values. Jan McKenzie combines not only two separate media, but also different types of colored pencils, with hard and soft leads, to achieve the required effects of color and texture.*

COLOR WASH

Transparent washes of diluted ink or watercolor are traditionally associated with drawing, for example, as a means of introducing color and tone to line work in pencil or pen and ink. In color drawing, washed areas laid layer upon layer with a soft brush can be used as a primary method of building form, but washes also combine well with the linear drawing methods of creating color mixtures. These could be colored-pencil hatching or stippling, or scribble-textured marker work, or intricate pen drawing using colored inks. The soft, fluid character of a color wash provides an effective background tone for a drawing or can be used to create soft veils of color over parts of a drawing to alter the focus and clarity in selected passages. If you intend to apply washes over previously drawn work, check first that none of the drawing media you have used is water-soluble; otherwise, you will lose the definition in the drawing.

LEFT: *In a painted study by Judy Martin, the brushwork is contrived to imitate a linear drawing technique. Opaque gouache allows light colors to be layered over dark, as where the light blue sky tones "showing through" the greens are actually the final layer scribbled in with the tip of the brush.*

RIGHT: *Tom Robb works with felt-tip pens to create a faceted landscape of hatched color blocks. The directional marks knit together the different elements of the image and the color gradation is closely integrated to make an easy transition through the space of the landscape. The strong touches of red provide a focal point in the middle ground.*

HATCHING

This is one of the most commonly used methods of creating blocks of color and tone in drawing, but the same technique can be used to dramatic effect in painting. Hatching consists simply of roughly parallel lines drawn with a pointed or edged tool. By varying the thickness of the lines and the spaces between them, you can make an optical effect of different degrees of tone. When two or more colors are hatched together, the hues and tones seem to merge into a complex mass of color values.

Hatching can be very neat and precise, or very loose and emphatic. It has a directional emphasis according to how you form the strokes, and this can be manipulated to create the effect of changing planes and curves in describing solid form. Cross-hatching is the process of overworking an area with lines angled across the previous direction of the hatching. This builds a more densely woven textural effect that can be varied by spacing the lines openly or close together and varying the angle of their crossing.

GLAZES AND WASHES

*M*ixing colors on the palette is not the only way to do it; they can also be laid over one another on the paint surface.

If a thin transparent wash is painted on a white ground, the color it takes on depends on two factors. One is the amount of light that is reflected at its surface; the other is the amount of white ground showing through. A very thick wash will cover the white ground almost completely, so it will be more of its own color. Glazing is a method of laying thin washes one over another so that each layer modifies the one below. Washes are most often associated with watercolor, but they can also be used in oil and acrylic painting as long as the paint is made transparent.

WATERCOLOR

Because watercolor is transparent, paintings are always built up from light to dark, beginning with white paper and laying successive skins of color, called washes, one over the other until the correct colors and tones have been established. Washes can be used to change or modify a color, or simply to darken it. For example, a sky which is too light can be given more strength by another wash of the same color, while a red area which looks over-bright in relation to the rest of the painting can be toned down in places with a pale wash of another color – perhaps blue or a darker red. Such washes must never be overdone – more than about three and the painting will begin to look tired and dead, as the white paper, which gives watercolor its luminosity, will no longer show through. Also, the wetness of each wash tends to dissolve the first color so that they mix rather than lying one on top of another. Each wash should be applied with a quick, broad brushstroke and not touched again. Normally, a wash must be darker than the layer it is covering, but an exception to this general rule is when a wash of a bright yellow (cadmium or lemon) is painted over any blue. The resulting green is actually greener and warmer than when a blue is placed over a yellow.

BELOW: *The granulation of the pigment that sometimes occurs when a wet wash is applied over a dry one can add extra interest to a painting. It is particularly useful in shadow areas, which can become flat and dull.*

ACRYLICS

Acrylics are particularly well-suited to the wash technique, called glazing in this case, because they dry so quickly. Thus each layer can dry before the application of the next, and the original layer does not dissolve, giving a clear, true glaze. If acrylic paint is diluted too much with water, the acrylic medium will not hold the pigment to the surface satisfactorily. Very thin glazes are best applied by mixing the paint with a special acrylic thinning medium, available in both gloss and flat finishes. As with watercolor, the same general rule of dark over light applies, but again, blue over yellow or yellow over blue make equally successful greens, and a thin layer of white gives a smoky appearance to a darker color.

OIL

Glazing in oil is carried out in the same way as in acrylics, but since oil paint takes longer to dry it is a much slower process – each layer must be fully dry before the next is applied. It is best to thin the paint with a glazing medium instead of an ordinary thinner like linseed oil, because oil does not hold the pigment in place so well. Nowadays, special glazing mediums can be bought which dry relatively quickly, and glazing is beginning to come back into fashion again. Formerly this technique was widespread: all the Renaissance painters made use of glazes, and Rembrandt created wonderful luminous effects by glazing over thick impastos.

THE ARTIST'S EYE
GLAZING

Ian Sidaway paints in several different media, but he finds acrylic, which he has used here, particularly sympathetic to his careful, deliberate way of working. For this portrait he has used the glazing technique, which allows him to build up layers of color without losing the luminosity of the child's skin. Very rich colors can be obtained in this way; the marvelous blues and reds seen in early Renaissance paintings owe their brilliance and depth to successive layers of very thin paint laid one over the other.

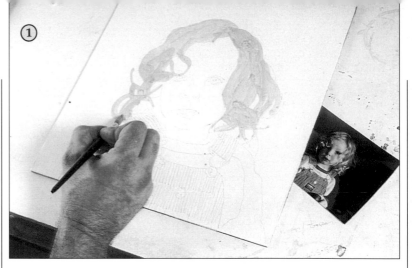

1: *First I make a careful drawing with a sharp H pencil, working on a white-primed ground as this provides the back-illumination essential to* successful glazing. Next I paint in the hair quite loosely with a thin mixture of cadmium yellow deep, yellow ocher, Payne's grey and white. Later on, the hair will be modified by glazes, but only when the entire picture surface has been covered.

3: *For the darker areas of the face, I have used the same basic mixture, but darkened it by adding some cobalt blue. Notice how the paint at this stage, heavily diluted with water, behaves in rather the same way as watercolor, with blotches of accumulated pigment, bubbles and other marks occurring quite unpredictably.*

2: *As I am painting with transparent color on a white ground, I find it helpful to mix on a white surface also, as otherwise I could not judge the color values correctly. To block in the face, I have made a thin mixture of cadmium yellow deep, cadmium red and white.*

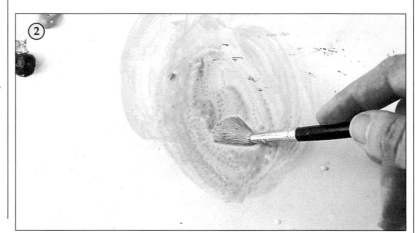

4: *Now I begin to give some depth to the picture by modeling the hair, painting the dark parts with a mixture of Payne's grey, burnt sienna and yellow ocher. I have already painted the eyes, with cobalt blue mixed with Payne's grey and white, and the lips, for which I used* burnt sienna and black laid over an earlier layer of cadmium red, naphthol crimson and cadmium yellow deep. Until this stage I had left the background white, which made all the other colors appear rather dark, so I quickly blocked in a mid-tone gray.

5: *Now I am ready to begin on the glazing of the shadowed side of the face. I prepare a mixture of cadmium red and cobalt blue and thin it with acrylic glazing medium (I sometimes use water, but prefer the medium when painting skin as it gives a richer look). Once the glaze is mixed, I apply it with single broad sweeps of the brush. Working into thinned paint too much can cause it to form bubbles and blotches.*

8: *My palette for this picture is simply a piece of plastic-coated blockboard of the kind sold for shelving. I lay the paint out from warm to cool, which I find a help when mixing, and I have used the following thirteen colors: cadmium red, naphthol crimson, deep brilliant red, burnt sienna, raw umber, yellow oxide, cadmium yellow deep, cadmium yellow medium, cadmium orange, cobalt blue, cerulean blue, Mars black and Payne's grey. Notice that I did not use any green at all*

6: *Most of the glazing is on the face and hair, but I want to keep the same kind of treatment in all parts of the painting, so I create the shadows on the sleeve in the same way, applying a glaze of cadmium yellow deep, cadmium orange and a touch of raw umber.*

7: *This close-up photograph shows the cumulative effect of the numerous glazes laid one over the other on the face and hair. The transparent nature of the paint enables you to see through several layers in places, showing how the colors are progressively modified with each layer.*

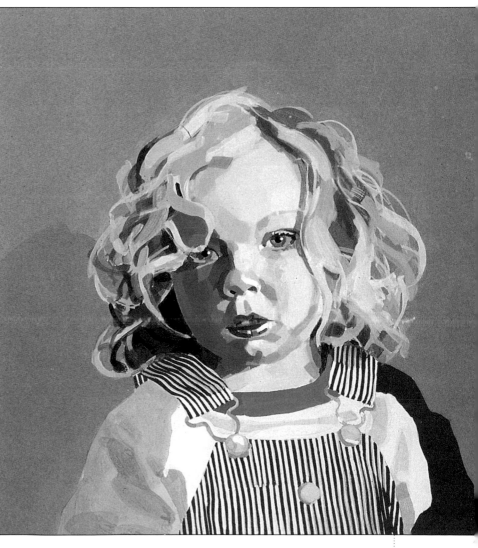

1

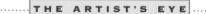

THE ARTIST'S EYE

John Martin nearly always paints on toned grounds, whether he is working in oil, as here, or in gouache. For pastel or gouache there is a wide selection of colored papers available, so it's just a matter of choosing one that relates to the painting, but for oils, the ground must be painted and allowed to dry before work can begin. Here the artist explains how he made his choice and how it has affected the finished picture.

1: *Some artists like to paint on a color that is the opposite of the "color key" of the painting. For instance they may paint a snow scene on a warm-colored ground so that the contrast makes the cool colors look even cooler. But I like to use a warm ground for a warm painting, and because I wanted this picture to give a real feeling of heat, I've kept all the colors warm, including the ground. I used a mixture of burnt umber and cadmium red, much thinned with mineral spirits and applied with a broad brush.*

2: *I begin by blocking in the big areas, using the approximate colors, which I will modify later on. The sky is a mixture of cobalt blue, white and a little alizarin crimson to give it extra warmth. Notice how the red-brown ground showing through already adds a sparkle, which is the effect I'm looking for. I have used red in all the color mixtures; cadmium red and yellow ocher for the headland; the same red with lemon yellow for the beach, and viridian and a little alizarin crimson for the trees. The shadows are cobalt violet, balancing the hot blue of the sky.*

2

3: *To break up the color of the sky, I add patches of pinkish colors (cadmium red and alizarin crimson mixed with white) and then lay a cooler blue (cobalt blue and white) on top. Using broken color instead of painting the sky as a flat area can often* *give a more realistic impression of light, but it is important to keep the tones very close to one another so that they blend together visually. Notice how the blue and pink patches are almost the same tone as the mauve-blue I started with.*

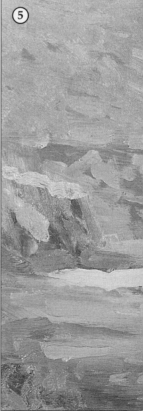

5

3

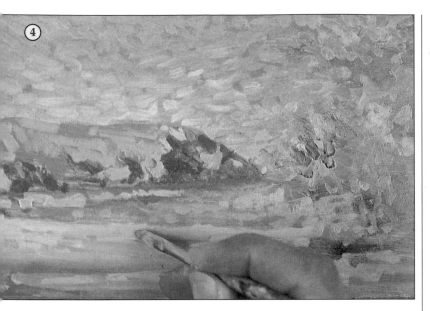

④

Working on tinted surfaces is another variation of the wash or glaze techniques, only here it is the color of the colored priming that shows through the paint layers. Once a canvas has been primed, it can be colored uniformly using thinned paint applied with a rag or a large brush. Any color can be used, but it must be chosen with the finished effect in mind. Artists often use a warm brown – raw sienna or a mixture of raw umber and yellow ocher – and sometimes they use a mixture of all or some of the colors left over on their palette after a day's work.

Painting can begin as soon as the ground is thoroughly dry to the touch. If you are using thin paint, the color of the ground shows through to some extent. A dark ground will lose the characteristic glow that occurs with a white one, which reflects back through the paint, but this is by no means a disadvantage unless the paint is very transparent, in which case it will not be very visible. According to Jeremy Galton: "When I'm out painting on location I always take with me a large selection of boards cut to different sizes and prepared in different colors. For warm

4 *Once I was satisfied with the sky (though I knew I might have to make more modifications later), I began to work all over the picture, making adjustments in color and tone. I added highlights of cadmium yellow and white to the trees and defined the* *headland more sharply with mixtures of yellow, red and cobalt violet. For the sea, I added an ultramarine and white mixture close to the cliffs, and lightened the inshore area with a greener blue made from cobalt blue and viridian mixed with* *white. I was careful to keep the tones very close to the original color – too much tonal contrast here and it would no longer have looked flat. Finally I worked on the beach, lightening parts of it with yellow ocher and white with a tiny touch of red.*

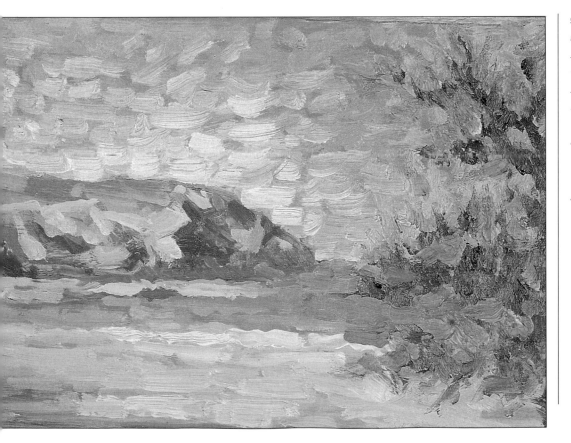

5 *Now the painting was nearly finished, but I could see that a few final touches were needed. These included some more shadows among the foliage, in pure cobalt violet and an ultramarine and white mixture, a lightening of the shadow on the left, and a few small patches of lemon yellow and white in the sky over the headland. Darkening the trees increased the tonal contrast between them and the sea, so I added a little viridian to the sea in that area.*

subjects such as sunsets I often use blue boards so that the oranges and yellows are heightened by the little patches of blue showing through. The overall blue appearance given by the ground also helps to hold the picture together by establishing a color key based on blue. It can be exciting also to paint over old pictures or on variegated grounds prepared specially for this purpose. The different colors peep through the final picture, apparently at random, giving an interesting finish to the picture."

Thicker, drier paint will, of course, cover the ground more thoroughly, but if the paint is applied patchily, the ground will show through in those places which have been left bare. A warm ground is particularly useful if the painting is to be mainly in cool colors.

In paintings where thick paint is to cover the entire picture surface, the color of the ground is irrelevant to the final picture, but it is a help to the painter during the painting process. A pure white ground can be very dazzling and makes it difficult to judge colors, as it makes your paint seem much darker than it really is. Once the picture is finished, you may be surprised to find your picture is pitched in a high tonal key, all your colors having been too light. A medium-toned ground prevents this from happening.

COLORED PAPERS

You can draw on or draw with colored paper – either way it is a positive factor in color drawing. Often you will find the brilliance

ABOVE: *The combination of dry drawing media with fluid color can be exploited to increase the range of texture within an image. This is a simple color exercise testing the effects of combining oil* *pastel with marker ink and watercolor. The greasy surface of the pastel repels the ink or paint, allowing the scribbled marks to show clearly through the overlaid color strokes.*

of white paper particularly useful in allowing your drawn marks to activate the surface most colorfully, but you might sometimes choose to work on a tinted or even quite strongly colored ground.

Colored papers are most commonly used for pastel drawing and painting. The neutral gray or buff tones are useful for setting a tonal key in the light to mid-toned range, while blues or browns can provide a basic "color temperature," cool or warm respectively. The range known as Ingres papers, much used for pastel work, includes various tones and colors, some very pale, others dark-toned, a few quite strong in color. Some high-quality watercolor papers are also available in color tints.

Because pastel colors are opaque, they can be used to cover up the paper surface completely, but if you use grainy shading or open calligraphic marks, the tint of the paper shows through and contributes to the color key. Brush drawing with an opaque paint such as gouache or acrylic works in a similar way. A more transparent medium such as ink or colored pencil is obviously more significantly affected by paper color, which modifies the overall effect of the applied colors.

Colored papers have a natural affinity with colored drawing media, and the positive color contribution they make gives a unifying effect that is not supplied by white paper. You can select the paper color according to whether you want it to stand as highlight or shadow, provide accents of color or act as a flat background tone.

As well as the neutral and subtly tinted pastel papers, there is a wide range of bright-colored cartridge and other relatively smooth-textured drawing papers. A strongly colored ground can be too harsh and dominating for certain types of drawing technique and some kinds of subject matter, but there is no reason why you should not experiment with vivid color in your drawing paper, especially if your medium has enough color strength and opacity to hold its own. A problem with all colored papers is that they vary in their permanence. Some will gradually fade on continuous exposure to light, and the effect of this color loss is not predictable.

RIGHT: *Jane Strother shows confident control of a mixed media approach, combining torn pieces of colored paper with pastel and watercolor to develop a vivid, freely described still life. The paper pieces dictate a strong color key, but are matched by a well-judged tonal balance in the drawn and painted elements. The translucent tissue paper provides soft-edged color blocks over which fluid brush lines and grainy pastel textures are used to draw in the still-life subjects. The white space surrounding the paper pieces has an important positive presence within the image.*

COLLAGE

The vigorous collages of Henri Matisse's later years are a wonderful advertisement for colored paper as a drawing medium. You can create fascinating images by arranging torn and cut paper pieces, exploiting the edge qualities and color values of different types of paper. Collage can also provide a good basis for single- or mixed-media work – pastel, ink, colored pencil. In the same way that a whole sheet of paper provides an appropriately colored ground for drawing, paper pieces can be stuck down to form the basic planes of an interior, a landscape or townscape view, for example, or the silhouette of a figure, and you can then start to develop the detail by drawing over the collage.

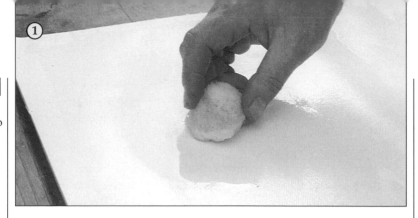

WET-IN-WET PAINTING

This technique is used in watercolor to obtain variegated washes where two or more colors "bleed" together. It is an exciting way of working because you never know quite what will happen. Watercolors used in this way are only partly controllable, but often the results suggest new ways of approaching a subject.

A wash is laid on the paper and while still wet another wash is laid in slightly thicker and darker paint. At the boundaries of the new wash the color spreads into the first wash as fan-like streaks, intricate lace-like patterns – or sometimes unsightly blotches! Little actual mixing takes place, and as long as it is not touched again, the paint will not muddy. To some extent you can steer the direction in which the "bleeding" takes place by tilting the paper in the appropriate direction. The technique is much used by watercolorists to describe the soft contours found in cloudy skies.

A similar, though less dramatic technique is used in oils, and was much favored by the Impressionists. They often scumbled or overlaid while the layer beneath was still wet, and sometimes deliberately tried to make colors run into one another. This can be particularly effective when creating soft effects in landscapes – skies, foliage or reflections in water. If touches of a lighter and brighter color are applied over a still-wet darker one, the two colors mix slightly, thus modifying one another. However, a light touch is needed, or a muddy mess may be the result.

1: *The first step is to wet the paper evenly all over so that the paint spreads in soft shapes. I use a sponge for* this, *making sure that there are no very wet pools left before I begin to put on the paint. You can also use a* large soft brush, but be careful to choose one that doesn't shed its hairs on the paper.

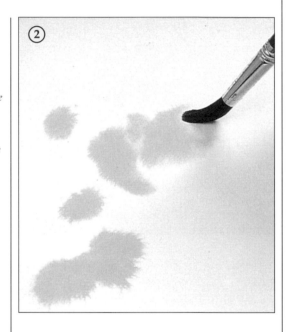

2: *I begin with the lightest colors, using unmixed cadmium yellow with very little water for the bright yellow of the flowers. Notice that in this case I have done no underdrawing, as I want the finished picture to have a free, sketch-like quality.*

3: *Now I am going to pick out the stems of the flowers in green, so I return to the yellow still remaining on my palette and mix viridian green into it. This gives me a color which is related to the original yellow, and very much the same tone. I like to keep all the colors close together at this stage, adding darker hues later for emphasis.*

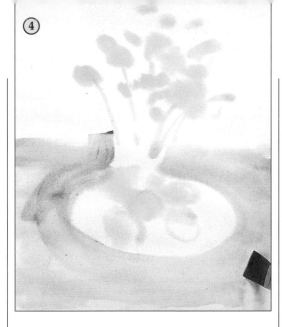

④

4: The paper is now beginning to dry slightly, so I can indicate the outside edge of the plate by laying in a broad, free wash of burnt umber in the foreground. If the paper had been too wet at this stage, the wash might have spread into the white area left for the plate – you never know quite what's going to happen with this technique.

⑤

5: The flowers now need more variety and depth of color, so I work into them with a strong wash made from yellow ocher and cadmium red to indicate the shapes, textures and shadows. At no stage do I attempt a precise description of the flowers, allowing the array of rich, softly blended color to stand as its own statement. At this stage I also add some loose brushstrokes of Payne's grey and raw umber to the background so that I am no longer relating the colors to a stark white.

6: The final stage is to indicate the deepest shadows and tones to give the picture more depth and solidity. I pick out the dark green leaves with almost undiluted viridian, and for the shadows under the lemons and beneath the rim of the plate I use ultramarine and burnt umber both separately and in mixtures.

7: Notice that when I work on the final details, I have the paper at quite a steep angle because by now most of the paint is dry enough not to run down the surface. When working wet-in-wet it is often necessary to change the angle, sometimes laying the board down flat and sometimes tilting it away from you to make the paint spread in a particular way. The important thing to bear in mind is that this kind of painting is basically about using the accidents of washes to your advantage.

⑥

THE ARTIST'S EYE

WET-IN-WET

Tom Robb likes to use the wet-in-wet technique for subjects like flowers and landscapes where he wants to create a soft, fluid effect, with no hard edges. Here he has used this same method all over the painting, but wet-in-wet can also be combined with wet-on-dry (washes laid over a previously dried layer) so that in some areas of a picture the colors mix together on the paper, while in others they are more precisely controlled.

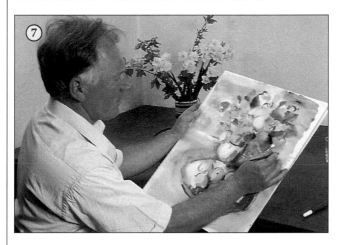

⑦

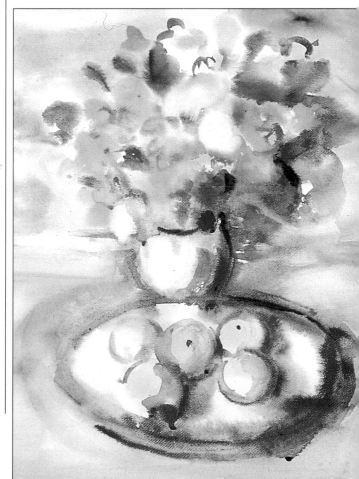

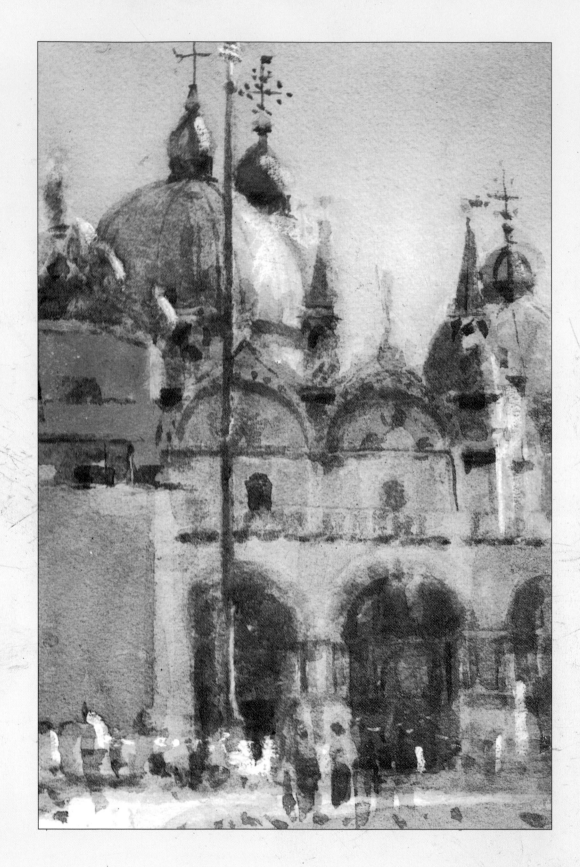

WORK IN PROGRESS

The previous chapters on color perception and the materials for dealing with color explain some of the reasons for the difficulties people find in working confidently with color. There is no set dogma about color which an artist can learn and use – color values are always relative: to each other, to their physical context, to expressive uses and to the range of possible responses. This makes it hard to "manage" color. But it is one of the most stimulating elements we have to work with, and it need not be overwhelming, although it sometimes seems so.

LEFT: St Mark's, Misty Morning, *Venice by Ken Howard, watercolor, 7 x 9 inches. This painting, although containing a wealth of architectural detail, is quite loose in handling, showing how watercolor can be used freely and accurately at the same time. Each layer of paint has been laid over previously dry washes so that there is very little mixing on the paper. Some highlights have been added in opaque white.*

ABOVE: *This drawing is a color exercise produced by picking up visual impressions from the changing pictures on a television screen. The changes are so rapid, there is no point in attempting a representational "copy." There is time only to note down abstract properties about shape and color.*

If a given view were to contain all the ten million color variations you have the potential for seeing, it would still not be either necessary or desirable to render them all accurately in a drawing or painting, even if it were possible. You need to find a way of sifting the essentials and explaining them visually in your own terms. You may have to work on sharpening your color perception and your ability to analyze various color effects – from the brilliance of broad expanses in landscape to the tiny shifts of color seen reflected from a white teacup. Thus you will collect a greater range of information from which to select the precise means of rendering your chosen effect. There is also a great wealth of experience provided by the work of other artists, both past and present. Their responses to color and the means they have found to represent them are legitimate sources of insight into perceptions that may parallel our own.

MAKING COLOR THE "SUBJECT"

Color is often the feature of a subject that makes us want to create a picture of what we see. The fresh greens of a summer landscape, the brilliant hues of autumn trees, the vivid artificial color in fabrics, ceramics and other manufactured objects, or the glowing natural coloration of fruits, vegetables and plants make a direct appeal to the eye. Just as enticing are the subtle shifts

RIGHT: *A composition which allows the visual elements to bleed out of the picture "frame" has the effect of drawing the viewer into the image. In Ian Simpson's colored pencil drawing of tomato plants, this creates an ambiguous sense of scale which, with the rich color, conveys a jungle-like atmosphere.*

BELOW: *A strong contrast of tonal values and the rough texture of wax resist re-create a powerfully descriptive view of a rocky outcrop overlooking an industrial town in this drawing by Julian Trevelyan. The smoky-toned watercolor washes are vigorously scrubbed across the wax drawing, producing a rugged image evocative of the landscape.*

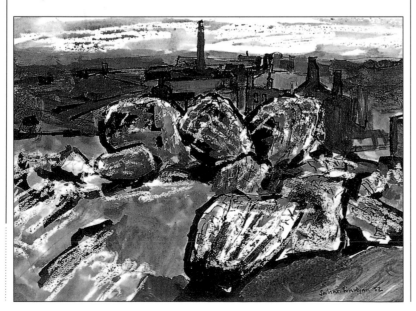

BELOW: *There is a delicate balance between line and mass in this still life by Jan McKenzie, and a good balance between the cold blue and warm orange hues. The symmetry of the central subject is offset by the arrangement of pattern detail in the background.*

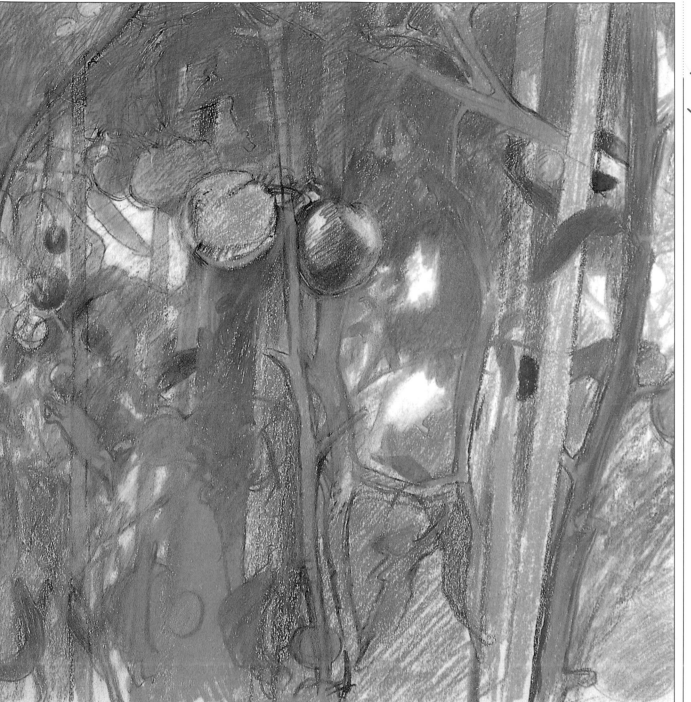

of color that can occur with equal delicacy in a seascape or in the flesh tints of the human body, and the bright accents in an interior or townscape view. Color drawings can, as much as paintings, capture the beauty and variety of these innumerable visual attractions around us.

This chapter investigates the concept of representational drawing with color and explains the processes which enable you to re-create your own impression of a selected subject. The key to descriptive color rendering lies less in drawing technique than in the visual skill of keen perception – in simple terms you need to look hard, and look again, before making any marks on your piece of paper. Once you can really see what it is you want to draw, you are better equipped to find the right technical means of doing so. Much of the information in this chapter relates to methods of visual analysis that can help you to organize your drawing.

BELOW: *In her pastel drawing of an olive tree set against the landscape of Malaga, Judith Rothchild places the tree at the center of the composition but, rather than appearing to divide the image, the curved trunk and branching crown form a sinuous link between landscape and sky. The colors and tones are carefully judged to capture the character of the landscape, the detail of natural and architectural forms, and the brilliant sunlight illuminating the view. This is achieved by the complete integration of patterns of light and shade across the local colors of the landscape.*

But technical skill is important too, especially as the different drawing media can contribute a wide range of color values and surface textures that leave their own impression on the final quality of the image. Improved perception and technique both develop naturally through the practice of drawing, "practice" meaning that you make drawing one of your regular activities and are prepared to work and re-work a particular problem until you achieve a satisfactory solution.

Any attempt to make a color rendering based on detailed and observant study does require discipline on the part of the artist. It should be viewed as serious work – but that doesn't mean you can't enjoy it. If you want to produce the kind of drawing that represents the subject reasonably accurately, you may find the challenge stimulating and absorbing. But if you find this close attention to the details of the real world more of a chore than a pleasure, this could mean that you will find other ways of interpreting a subject through drawing, as explored in later chapters, more rewarding.

THINKING IN COLOR

When you draw in monochrome, with graphite pencil or charcoal, the medium naturally prescribes which elements of the subject you can successfully convey. Because you are not using color, it is easier to focus on qualities of contour, mass and texture, qualities that can be described effectively with a medium of line and tone. The process of learning to view a subject selectively, to analyze and interpret its essential forms, is an important experience that can be gained through drawing, and is at least one of the reasons why drawing is often thought of as a preliminary to painting rather than as a self-contained method of developing finished images. The traditional relationship between drawing and painting encourages artists first to separate form and color, then to put them back together.

Drawing and painting directly with color require a different kind of approach, because you must regard color from the start as one of the major compositional elements, influencing both your choice of subject and your arrangement of it into a pictorial image. This does not mean you should ignore the other main ingredients of two-dimensional composition – outline and contour, mass and volume, light and shade, pattern and texture – but it is necessary to think in color from the beginning because the color relationships will significantly affect the character of the composition. The aim of the drawing exercises and finished examples on the following pages is to demonstrate the principle of "keeping color in the picture" throughout the process of planning and executing a drawing.

Whether your subject is a still-life grouping, a figure or a landscape, a singly focused or composite image, each real object or view that you are looking at presents a mass of visual information – basic forms, spatial relationships, color details, effects of light and shade. The fluid medium of paint allows you to manipulate these elements to some extent as you work, but with the slower processes of drawing, this is less easy: you need to develop a reasonably systematic approach that will provide the right foundations for the overall composition and enable you to build up gradually to the more

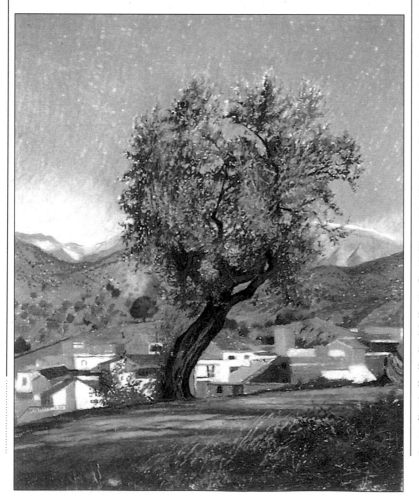

complex stages. The activity of drawing is a process of adding up the pictorial elements and technical effects to arrive at the finished values of the image.

What you need to do is to find a way of breaking down the different elements that you see in the subject, so that you can appreciate their separate contributions to the image. This must be done, however, by some means that maintains the essential color values in each area of the drawing and keeps in view the color relationships as a whole, since your materials can express these qualities directly. The exercises and projects that follow are designed to enable you to study the major elements of composition individually, but using methods that involve direct application of color. Always try to avoid thinking in terms of "coloring in" a drawing that might otherwise be monochrome – go for a clear vision of color values at every stage.

PLANNING THE COMPOSITION

*I*n drawing and painting you have two main factors under your control: the viewpoint you choose and the materials you decide to use. If, as we are assuming in this chapter, the main aim of your work is to record what you see, this places certain limits on the expressive or interpretive qualities of your drawing or painting. For example, if you are working on a still life of objects standing against a blue background, you would not suddenly decide to change the background color to red because you feel

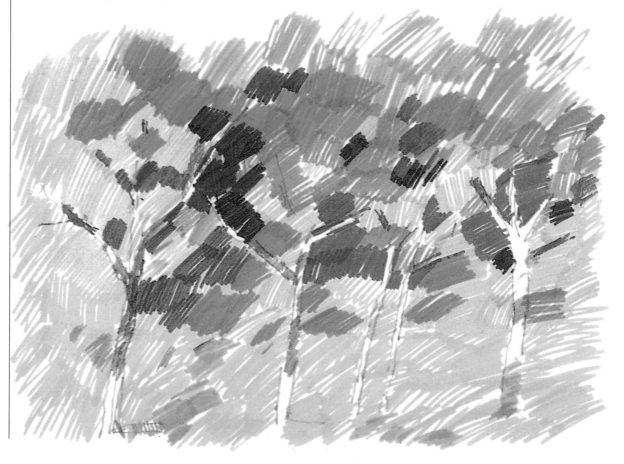

ABOVE: *The artist investigates an alternative way of rendering his impression. In this vigorously expressive sketch, the linear pattern of the composition is explored with paint squeezed directly from the tube.*

it might make a better picture. This would completely alter the relative color values and pictorial mood of the image which, although a valid approach to drawing, is inappropriate to a representational image. If you are using the subject as a direct model for a color drawing, it is up to you to decide beforehand whether a blue or red background will create the best effect.

A still life provides you with a wide range of choices which include the general forms and colors of the setting as well as those of the objects used to assemble the

arrangement. The same applies to a posed figure. The model can be positioned in a particular place to be framed by, say, a window, a mirror or a flatly colored wall; furniture, draperies and props such as plants or ornaments can be introduced to vary the shapes, colors and patterns within the overall design, and you can arrive at a pleasing composition before you start to draw.

In a landscape or townscape view, there are fewer ways of manipulating the combination of elements, and in any case, it is the actuality of what you see that attracts you to the subject in the first place. Here your methods of controlling the composition and "setting up the image" are limited to the scale of the drawing, the part of the view you select to depict, and the viewpoint from which you observe it. You have to find the particular viewpoint from which the subject is seen at its most descriptive, whereas with a smaller-scale subject you may be free to select and arrange the elements as you please.

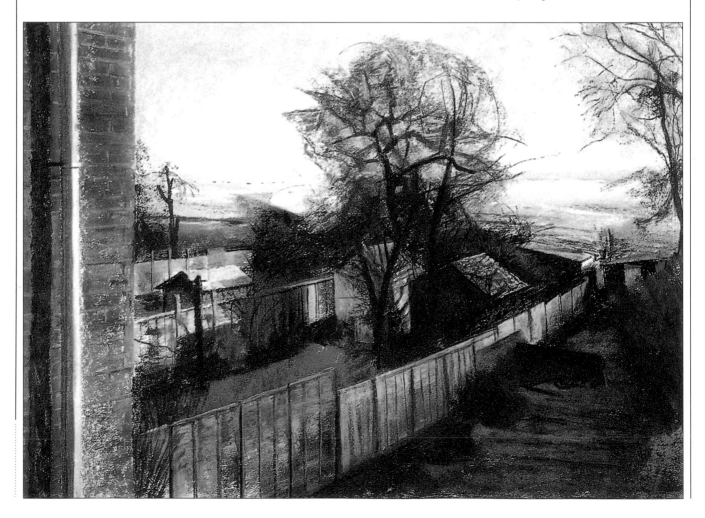

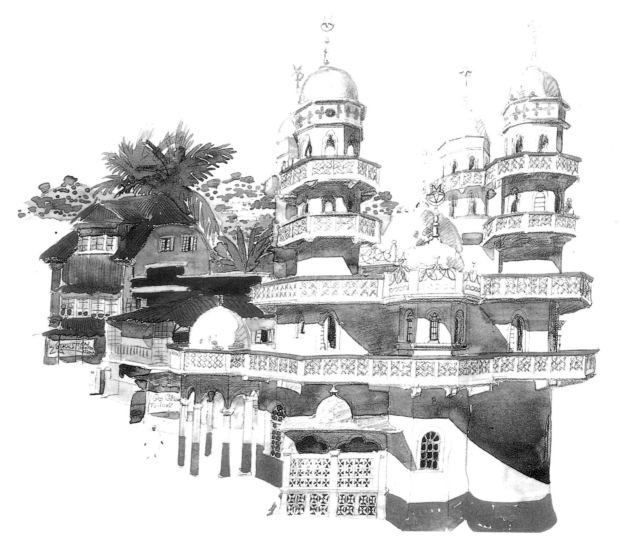

RIGHT: *A detailed architectural view displays an almost geometric pattern of hard-edged cast shadows. Paul Hogarth combines line drawing with watercolor washes to convey the clarity of form and color. The interesting shape of the composition derives directly from its subject. An irregular outline is traced by jutting balconies and minarets, then broken into the natural contours of the far landscape. The shadow pattern travels diagonally through the drawing from foreground to horizon.*

LEFT: *John Plumb's high-level view across back gardens to open countryside beyond incorporates a strong diagonal emphasis formed by the continuous line of fencing. The pastel color is heavily worked to create the contrasts of light and shade, with a golden quality of reflected light conveyed by the warm browns and yellows. The colors are dragged and blended on the surface to re-create the textures of brickwork, wooden fencing and tangled tree branches.*

Viewpoint is always a definitive factor in composition. Often the first impression of a view or an interesting object stimulates your mind's eye to form an idea of a drawn image. But this doesn't always mean that the exact position from which you first saw the subject is the ideal one. On closer examination you may see some aspect that is slightly disruptive – an ugly shape or a block of jarring color – which could be modified if you moved your position to left or right. A slight shift of position may provide a more balanced or a more complex image, or you might decide to take an angle of view that enhances a characteristic element of the subject. By moving closer to some tall buildings, for example, taking a viewpoint that forces you to look up a little, you will be emphasizing height in the perspective of the drawing.

COLOR IN COMPOSITION

The information that the subject of the drawing provides includes shape, contour, volume, light and shade, and color. But you must decide how to put these together to divide up the picture plane. It can be difficult to juggle them all at once and, often, a particular subject presents itself more dynamically in one respect than in another. The immediate impression might be of forms, or colors, or a wide range of details. Gradually, as you look further into the subject, and in the actual process of drawing, the different components of the image come together. To begin with, though, it is helpful to identify dominant elements and use these as a framework for developing the other pictorial values. You can do this by sketching the composition in various ways to assess the visual possibilities.

BELOW: *One of the purposes of color drawing may be to develop a composition for interpretation in another medium. Two working drawings by Elisabeth Harden (below and opposite top left), were preparation for a lithograph (opposite middle left). On the basis of a deliberately restricted color range, the artist used the* *drawings to work out the general form of the composition and the way in which the colors could be overprinted in the lithography. The printed color has a very different character from that of the gouache drawings, but each image displays a vigorously calligraphic sense of line and form, together with firm control of the color values.*

ESTABLISHING A COMPOSITION

The simplest way to map out a composition is to deal with each component as a characteristic outline or block shape. As explained earlier, it is important to think in terms of color from the earliest stages, and a good way to begin is to establish the viewpoint and general design of the image by drawing outlines or block shapes using only the local colors of each element of your chosen subject. For the time being, ignore the tonal contrasts of light and shade and the complexities of pattern or texture, and concentrate on individual shapes. Look at their relationships as flat elements on the picture plane, working in terms of their arrangement within the "frame" of the drawing paper.

ABOVE: *An image of strikingly effective simplicity is achieved by focusing on a single subject and handling the chosen medium with confidence. In this still life by Annabel Blowes, the fluidity of the watercolor washes overlays the sense of solid form. The colors are allowed to fuse while wet, creating delicately mixed tones. The atmospheric treatment is unusual for what could be described as a relatively mundane subject, but there is also a disconcerting touch of surrealism in the ghostly fish lying in the shadows of the bowl.*

RIGHT: *Rapid sketches in colored pencil give a good general impression of different compositional arrangements. The horizon level is kept constant: the horizontal stress of the landscape can be emphasized or opposed, with points of focus traveling along the horizon line or breaking through it.*

OUTLINE AND SILHOUETTE

The idea that things have outlines is more a convention of image-making than a reflection of reality. The outline or silhouette of an object is not usually a characteristic means of recognition, it is something you have to look for when drawing. If you start a drawing by mapping the outlines (which is not necessarily the best or only way to begin), you will find that as you work up details of form and texture, the original outlines become less and less important, and eventually obsolete. However, outlines have a useful function in planning a composition, helping you to chart the formal relationships of the various shapes within the image that will be used to build the overall design. They also help you to focus on edge qualities that contribute to the rhythms and tensions in the drawing.

It is important to notice the "negative" forms in the composition – the spaces between objects and the shapes and color values that they contribute to the image. When planning a composition, try to deal with these areas positively rather than allow them to happen by default as you concentrate on the more obvious forms.

Simplifying the color context at this stage to lines or blocks of local color, you can concentrate on the arrangement of the composition with attention to the following aspects of design in drawing.

BELOW: *A drawing which concentrates on line can still make a feature of the color values. A pen and ink drawing by Judy Martin picks up the cues of local color in green and red variegated plants. The drawing technique allows a clear expression of the naturally interesting composition of the plant group.*

BALANCE AND SYMMETRY

The balance of an image comes from the way you organize the distribution of weight and emphasis between basic shapes and color areas. A symmetrical composition provides balance because it implies a mirror-image effect arranged on a central axis. In general, it is good practice to avoid symmetry because equal divisions on the picture plane can create an even emphasis lacking visual stimulus. Sometimes it can be effective to use a central division that gives a strong axis to the image, but you need to consider carefully what happens on either side of this central focus. You can also create balance by giving unequal weighting to parts of the image, but in such a way that they offset each other effectively.

VIEWPOINT

Every slight movement of your head when you look at your drawing subject actually creates a slightly different viewpoint and subtly alters the composition. For practical purposes, the natural minor variations of eye-level and sight-line that result from making slight movements as you work can be ignored, but the general position from which you choose to work in relation to the subject dictates the sense of height and depth in the image. You can select a high, low or relatively level vantage point, a view that confronts the subject flatly or takes an angled view giving more depth. The viewpoint is described by the relationship of vertical, horizontal and angled planes within the drawing.

ABOVE: *A single color can be used to plan the main lines of the composition, the quality of the line and additional touches of hatching, scribbled brushmarks and tiny dabs of washed color build the basic picture. This is in effect parallel to the first stage of* *the drawing illustrated left. It could itself be elaborated in similar ways, or the artist might choose to create a whole series of such sketches, with minimal details, before deciding how to work up a selected composition more fully in color.*

FRAMING THE IMAGE

The dimensions and proportions are something you establish to suit the general shapes and patterns of the subject. Within this framework, you may wish to contain the focal points near to the center of the drawing, or allow shapes to be broken by the "picture frame" – the outer boundaries of the drawing area, which need not necessarily be the conventional rectangle. Such decisions relate to your chosen viewpoint and the impression of closeness or distance you want to create. Placing important compositional elements so that they "bleed" out of the frame suggests that the viewer is close to, or even within, the subject area; while greater distance is implied when it is only background elements that pass beyond the frame. Incomplete shapes can be used to create more complexity in the design, but are not always appropriate to the subject.

ABOVE: *The general arrangement of a still-life group is roughed out in a watercolor brush drawing by Tom Robb. Beginning with a thin layer of diluted violet,* *he establishes the main planes of the composition: the horizontal tabletop and vertical window behind are just loosely suggested in pale to mid-tones. Using a* *stronger purple, he draws up the flower vase and fruits, at the same time indicating cast shadow areas with heavier color. Gradually the process of overworking the* *brushmarks develops the tonal range and finally, small patches of local color are worked into the pictorial structure.*

ESTABLISHING A COLOR RELATIONSHIP

The way to do this is by clearing your mind of preconceptions, forgetting what you think is there and really looking hard and seeing. Look at the little oil study of textures called *Still Life with Daffodil*, which illustrates the type of variety of color and tone to look for when painting. First look at the orange to the right of the picture. How much of it is painted in orange paint? Only the top right-hand quarter, and even this is in three tints of orange. Below this area are shadowy browns, and behind the glass jam jar the orange is painted in an assortment of reddish shades, arising as reflections from the red plate on which it is standing. The red plate itself is painted in many different reds and mauves, their exact relationships giving the illusion of a flat shiny plate with a raised rim.

MIXING THE RIGHT COLOR

As already pointed out, there is no "right" color to paint, only right color relationships, so in a way it doesn't matter if you haven't mixed up the exact color of the bit you're painting so long as the surrounding areas relate correctly to it. But it may matter to you because the colors are what you find most interesting about a subject, and for the same reason many painters do strive to get as close as they can to the colors in front of them.

The act of mixing the color you want requires the same sort of mental process as trying to sing in unison with a musical note, or seasoning a soup until it tastes just right. Mixing paint until it's just right is much more difficult though, as both tone and color have to be adjusted, and there are far more wrong directions to take. It is a question of matching – adding a little bit more blue, now a little black and so on until you are satisfied you have the right color. Knowing when you have the right color can be tricky because while taking your eyes away from your subject and down to your palette you have to memorize the color for a moment. To complicate matters, the palette is likely to be under a different light than the subject, making exact color matching impossible.

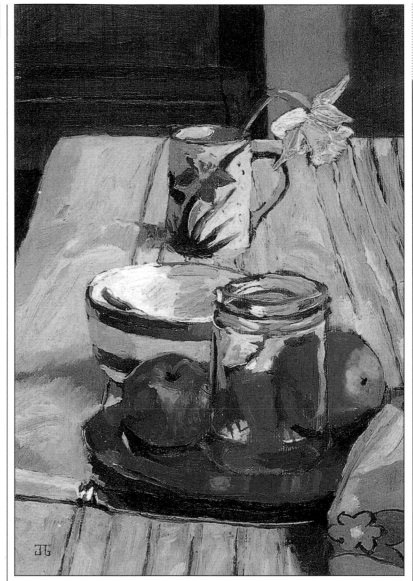

One way of doing it, however, is to simply hold the paint on your brush up to the subject so that the colors can be seen side by side. Suppose the paint is not quite yellow enough, mix in a little, bit by bit, until the colors coincide.

ABOVE AND LEFT: Still Life with Daffodil *by Jeremy Galton, oil, 9 x 6½ inches. Color isn't what it seems. Much of the "yellow" in this daffodil is painted in greenish paint, while the "white" of the sugar bowl actually appears as an assortment of blue-gray, green-gray and even a little pure orange. The off-white tablecloth is painted in a wide range of color mixtures.*

JUDGING COLOR RELATIONSHIPS

Color relationships can be established by continually comparing your picture to your subject, and marking alterations and modifications until you judge the relationships to be satisfactory. This does require very careful observation which develops with experience. Try to look at the world around you with a painter's eye all the time, thinking which colors you could mix for that yellow-edged cloud or those interesting greenish shadows on the unlit side of someone's face. You'll learn a lot, and you may find being stuck in a traffic jam less frustrating.

A good way of analyzing color changes is to use a piece of cardboard with a ¼-inch hole cut in it. Hold this up about a foot from you and look at an area of color which appears at first sight to be the same all over – an orange, for example, or the cover of a sketchbook. The little square of color you see, isolated from its neighbors, will look pretty meaningless, but now try moving the cardboard slightly, and you will begin to see variations in the color. You will notice darker shadow areas and slight changes in color intensity caused by reflected light or the proximity of a different-colored object. By taking one area of color out of context, you are able to see what is really happening in terms of color instead of simply what you expect. You don't have to use a piece of cardboard – your fist with a little hole between the fingers will do as well.

THE ARTIST'S EYE
NATURAL LIGHT

Jeremy Galton: "Unfortunately there was such a powerful wind blowing that I could hardly breathe, let alone paint a picture, but the colors of the sea and sky were so incredibly rich that I felt I had to record them, so for twenty minutes I mixed the colors which I judged to be the most important and painted them onto a small board [see detail]. After two months or so, when the paint was completely dry, I returned to these 'notes' and used them as a basis for a finished painting. I had also made a drawing on a separate occasion and, although the colors then were completely different, this did not matter as I had recorded the color in the sketch. When doing the finished painting, I matched the colors to the sketch by dabbing bits of mixed paint onto areas of the color notes."

BELOW: Fishing for Mackerel, Cley Beach, *by Jeremy Galton, oil, 12 x 18 inches. Shown here is a finished painting by the author, together with a rapid oil sketch done on the spot to record the colors.*

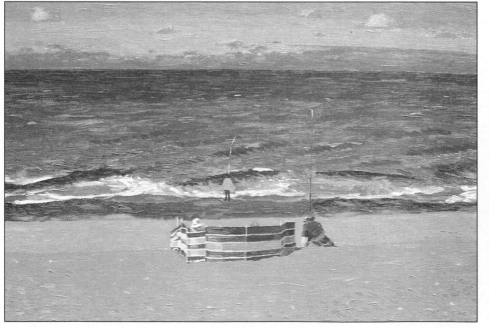

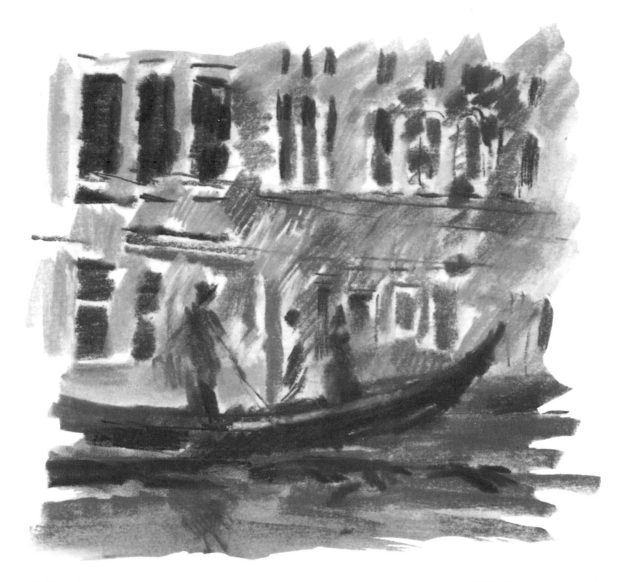

ABOVE: *Brief pastel sketches by Tom Robb use limited color ranges to study mood and tonal scale. A shadowy impression of a canal in Venice is unusually interpreted in close-toned hot pinks and reds (left).*

SKETCHES AND STUDIES

*I*t is not usual to make studies for a drawing – drawings are often regarded as studies leading to works in other media – but since a full-color drawing, particularly if it is an ambitious composition, takes at least as much time and effort as a painting, it makes sense to work out some of the problems beforehand. Sketches or studies based on the shapes, colors and tonal values of the image can be used for this purpose in the same way that you might use them to provide reference for a painting.

As well as planning the general shape of the composition and looking at the subject as basic blocks of color and tone, you might find you want to work on detail studies for particular aspects of the composition. For example, in figure work, many people find

hands more difficult to draw than faces; for a landscape view, individual studies of trees and smaller plants might prove valuable. If you have an idea of which parts of the subject could cause problems, preliminary studies will help to give you a sense of what you are aiming at.

This preparatory work reduces the risk of making a major error of judgment that could spoil a drawing when you have already put in a lot of time on the initial stages. It can range from little thumbnail sketches that give you a feeling of the subject to sequential studies providing a thorough examination of particular features. You can also use such studies to test the effects of different media to find out which materials give the most suitable color quality and surface texture.

To make these rapid studies, you can for the time being give secondary consideration to form, which will not change and can be studied at more leisure. You need only to

sketch out a view roughly to make a "map" on which the color values can be located. (See "Making color notes," page 80.) If you have a particular subject in mind that you can revisit over a period of time, it might be worthwhile making line sketches that you can photocopy, using the copy sketches as the basis for color notation to save time and allow you to immerse yourself in studying the transient color effects. However you

ABOVE: *In thumbnail sketches of a lighthouse against a flat horizon, he gradually distills the tonal scale, from a four-color range to a simple monochrome range.*

BELOW: *This watercolor by Ian Ribbons is highly descriptive of place and time, capturing the effect of late fall with the still-warm colors of turning leaves and trees already bare of foliage. The basic structure is sketched in with a brush in broken line, the color detail developed with lightly patched-in washes.*

RIGHT: *A page from a sketchbook kept by Andrew Bylo includes several engaging details which have caught the artist's eye, quickly noted down with brush and watercolor.*

arrange your opportunities to study the subject, there are particular elements to look out for that provide the necessary clues to the qualities you wish to capture.

When you are looking at a subject in which there are large blocks or areas of local color, try to identify the precise color values both in relation to each other and to the source of illumination. In a townscape, for example, a white wall may be washed with a yellow or pink tinge that seems very vivid against a clear blue sky. In landscape, look at the range of greens, their clarity and color bias toward blue or yellow. In the garden, think about the color changes between the solid materials of walls, paths or fences and the more complex color values of the plants and grass.

It is the tonal scale of a drawing that makes or breaks the sense of illumination, and this must be observed not only in terms of color intensity and light or dark values but also with close attention to edge qualities and gradations of light and shade. Do the shadows that model form show abrupt transitions between light and dark, or a wide range of middle tones? Does the light emphasize contours, creating hard-edged shapes, or soften and merge the forms? Does it etch the textures more strongly, or underplay surface differences? Cast shadows are crucial to a strong lighting effect – do these have heavy tonal density and solid outlines or a more fluid, amorphous presence? What is their direction and extent in relation to the light source?

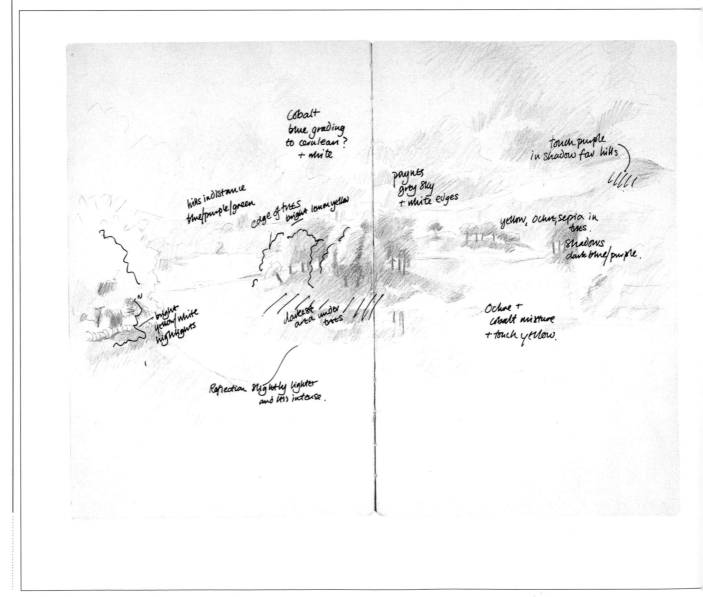

At the same time, be alert to the color qualities in the shadows as these will later help to give surface activity to the color rendering. Look for dark tints of blue, green, purple or red in shadows, as these provide color cues that can be played off against the lighter tones. Note also which shadows are in fact neutral in color value, but for this very reason have the effect of intensifying the pure hues and pale tones. Finally, look for the color accents – not of local color, but of reflected colors and highlights. Under certain lights, these may reflect an intense pink or gold, or perhaps cold bluish tones. Compare the depth of reflected color according to the surface quality – whether there are distinct patches of solid color or subtle passing tints.

MAKING COLOR NOTES

On these pages we show some artists' own systems for making color notes on location so that they can recreate a scene in the studio. You may remember the general impression of a color, but no one can recall the subtle variations, so if you're out looking for a likely landscape subject try to jot down some impressions in a rough pencil sketch. This can be done in words, for instance "sky very dark blue-gray, mixture of Payne's grey and ultramarine," or "green very blue, perhaps viridian and cobalt blue." If you have paints, pastels, or even crayons with you, make some quick visual notes there and then, trying out various combinations until you are satisfied. This is where a visual pocket guide to color mixes comes in handy.

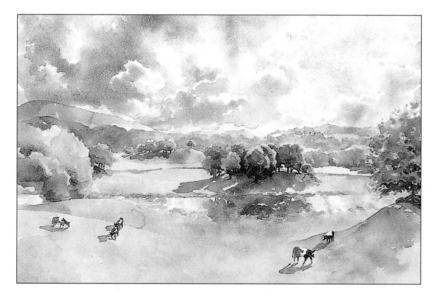

RIGHT: Rydal Water *by Moira Clinch, watercolor, 28 x 20 inches. This artist works in watercolor, but often uses crayons to record her on-the-spot impressions.*

THE ARTIST'S EYE
COLOR NOTES

Moira Clinch: "My watercolors are fairly large, and I'm a slow worker, so I usually do the actual painting in the studio, from sketches, notes and sometimes a photograph. Colored pencils are a handy sketching medium, and I tend to carry them around with me, sometimes making this kind of color notation in the car if the weather is cold. Here I've put down a general impression of the colors, but as pencils are a cruder medium than watercolor I like to make written notes as well. The most important things to note in this case were the direction and quality of the light, both of which radically affect the choice of colors for the finished painting."

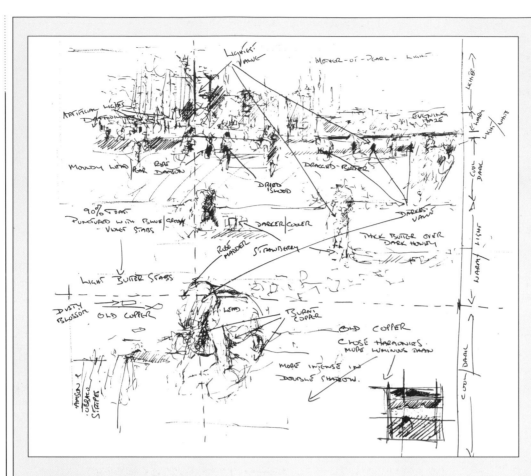

LEFT: The Sunshine Stakes, Weymouth *by Arthur Maderson, oil, 48 x 48 inches. Every artist develops his or her own method of recording the essentials of a scene which can be used as a trigger for a painting done later in the studio. Here Arthur Maderson uses nothing more sophisticated than a ball-point pen to jot down written color notes.*

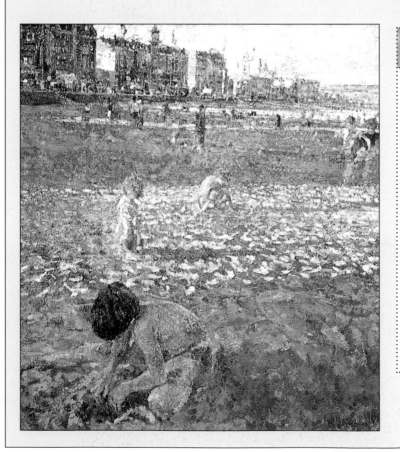

THE ARTIST'S EYE
COLOR NOTES

Arthur Maderson: "I am fascinated by the quality of the light at the end of the day – anywhere between late afternoon and dusk. Since the light changes so rapidly then, I rarely paint on the spot. Instead, I take photographs and make rapid sketches on which I scribble color notes in my own personal 'shorthand.' I tend to favor using associations of colors, which somehow trigger a quite specific value and textural quality. 'Ripe damson' tells me more than simply saying 'dark red,' for instance. 'Moldy lead' gives me variations on a luminous world of pale viridian and blue. I also try at this stage to establish a strong and simple pattern of light and dark values, which will hold the picture together."

COLOR MATCHING

*J*eremy Galton has evolved his own system for a direct matching of colors and tones, which may help a beginner to make accurate observations. It avoids the necessity of repeatedly looking up at the subject and down at the palette. "To explain what I mean I describe on the next page how I mixed some of the colors for a painting I did in southern France. I began with the sky, because once one area of a painting is correct in tone and color the others can be balanced against it. In this case the sky was the "key." I first took some white paint on my brush, then added a little cobalt blue to it. By holding the brush up to the area of sky in question, I could see by direct comparison that the paint was both far too blue and too light in tone. I continued to make adjustments, adding touches of raw umber and other colors until the color matched so perfectly that the paint was virtually indistinguishable from the relevant bit of sky.

The beauty of the method is that it establishes the correct tonal key. When I began on the buildings, I found that the paint needed here was close to pure white, but even the whitewash was not as white as titanium white straight out of the tube, and I had to add minute proportions of raw sienna and Payne's grey. Beginners are generally very frightened of using sharply contrasting tones, and I admit that I frequently have difficulty establishing a tonal key when conditions prevent me from using this method.

Shadows always present a problem. Their colors are elusive because they are often far removed from what we expect. The reason for this is that while the sun is shining on parts of a scene, the areas in shade are receiving only the blue light from the sky. Don't be afraid of the color you arrive at using the matching method – once all the surrounding colors have been painted in, they will work together and you'll see that the mixtures obtained in this way were right."

BELOW: Provençal Village, Lacoste *by Jeremy Galton, oil, 7 x 8 inches. This picture was done on the spot in two hours, using the artist's special method of direct color matching. In order to demonstrate the method, he has agreed to recreate part of the painting, using the same system – see next page for steps. When he painted the original, he was, of course, matching the colors on his brush to the actual landscape, while here he is matching them to the original painting. The process, however, is exactly the same.*

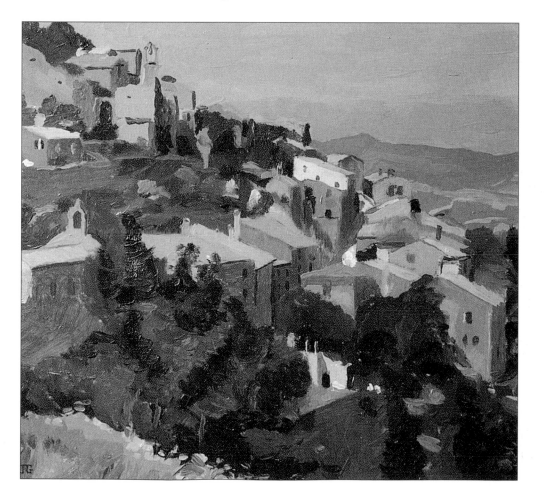

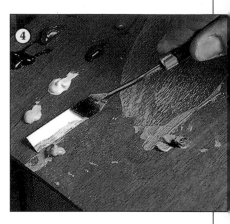

1: *I begin by mixing white with a little cobalt blue, on the assumption that the sky is quite pale. I hold the brush up to the color I am matching and find that it is much too light and blue. From experience I know that I can successfully modify it with Payne's grey and raw umber, so I mix in a little of both.*

4: *To make more space for mixing on my small traveling palette, I push aside the mixtures made for the sky and distant hills for possible use later on. I then block in large areas of foliage with green made from mixtures of ultramarine, Payne's grey and cadmium yellow, in places using terre verte straight from the tube.*

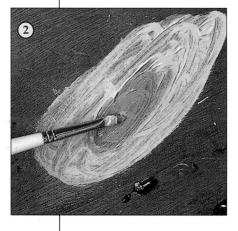

2: *Holding up the brush again, it is obvious that the sky is more violet than the paint. Something is needed to achieve the correct adjustment. The options include alizarin crimson, burnt sienna or Winsor violet. I choose the latter which, with adjustments, gives a color which perfectly matches the sky at the top of the picture.*

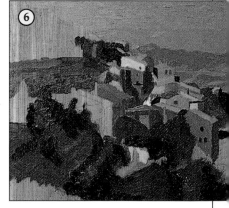

5: *Now the darkest areas have been established, I have a "key" for the colors and tones of the houses, and I find that the "whitest" house is surprisingly dark. The pinkish roofs are based on raw sienna and white modified with varying amounts of cobalt blue, raw umber and alizarin crimson.*

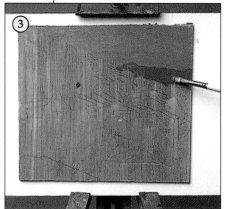

3: *Sky is often much darker than one thinks. Painting on a toned ground helps here – a white background would show up these sky colors as being unbelievably dark. Now I am painting in the distant hills with the same paint I used for the bank of clouds but with a small addition of Payne's grey, ultramarine and raw umber.*

6: *When using the direct matching method, it is important to have complete trust in it – never try to alter your colors because you don't believe that what you see is true. Once a number of adjacent colors have been painted, you will find that their inter-relationships are perfectly correct.*

OTHER COLOR-MATCHING METHODS

The main drawback with the direct method is that it can only work if the lighting conditions are just right. For example, if bright sunshine is lighting a landscape, then your brush must also be lit by the sun. If your paint-laden brush is in shade and held up to a sunlit landscape, the paint will look black against the landscape. There are also certain precautions to take. While holding the brush up in front of you, its angle of tilt is important. If it is varied, the apparent color of the paint on the brush changes, so this angle must be kept the same throughout.

Unfortunately the method only really works well for oil paints. Acrylics will tend to dry before you have mixed the color you want, especially if it's a difficult color and is taking a long time to match, and both gouache and watercolor are virtually invisible on a brown sable brush. However, a similar method can be used for the other media, which is that of mixing up a little paint on the edge of a small piece of paper and holding it up to the subject in the same way. This may not give you a perfect match, but it certainly helps you to judge tones, as you can see immediately if the color you have mixed is much too light or much too dark.

TONAL VALUES

*T*onal values simply mean the lightness or darkness of a color, and have nothing to do with the "blueness" or "redness" of the paint. Tone is just as important as color in a painting, and many painters, particularly in the past, have been more interested in tone than in color. Paintings were traditionally built up in monochrome, with the colors put in last on top of a detailed tonal underpainting. It is an interesting fact that a black and white photo of a painting in which the colors were painted quite differently from the colors of the subject, but the tones kept true to life would look entirely "normal."

The colors of the spectrum have varying tones because our eyes are more sensitive to some colors than others. Yellow is always light in tone because our eyes are most sensitive to it, while pure red and pure blue appear the darkest. Incidentally, in dim light our eyes are most sensitive to green and blue, the reds becoming very dark.

There are two distinct aspects of tonal values in color drawing and painting – the balance of inherent tonal values in the local colors, and the effects of light and shade that modify the color values.

It is easiest to think of tone in terms of a monochrome scale from white (lightest value) through a range of grays to black (darkest value). A three-dimensional object reflects degrees of light across its external form according to the strength and direction of the light source falling upon it. The tonal scale of reflected light is independent of the local color, but it can be difficult to perceive these tonal values accurately because of the relative values of different colors. Imagine a yellow cube standing next to a purple cube, both lit from above by the same light source. The upper plane of each cube has the lighest tonal value, because it receives direct light, but yellow is naturally seen as a lighter color than purple so, in a drawing of the cubes, two tonal factors would need to be combined to render the colors accurately.

Pencil

Oil

Watercolor

Gouache

LEFT: *Value scales, like these shown here, are useful in determining the tonal values of colored objects. Most painters tend to work with around nine to twelve values, but it is possible to create a perfectly good picture with only three to five.*

RIGHT: Self-portrait by Window *by Lucy Willis, oil, 15 x 12 inches. Large dark areas contrast strongly with equally large light ones in bold geometric shapes – the rectangles of the window, the triangle of the neck, the circle of the face and the crescent of the hair. The delicate, sinuous forms of the plant relieve the starkness of the picture, and also help to relate the pattern on the facial features to the window, and hence to the rest of the painting.*

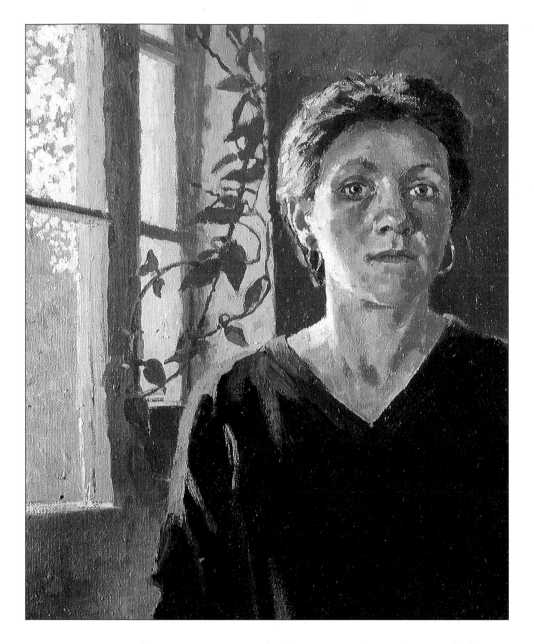

TONAL KEY

In addition to a color key, a painting has a tonal key, which can be described as high (light colors) or low (dark colors). It can also encompass a wide scale of tones from very dark to very light. The tonal key can be used to set the mood of a painting. A dark picture tends to be somber or serious, whereas a picture in a high key may be more light-hearted. This is by no means a hard and fast rule. One may expect a night-time painting to be dark, but this is not necessarily the case. Very often a successful painting depicting a night scene may be in a high key. Conversely a picture of a subject in broad daylight or even in bright sunlight may be painted in dark tones. As in the case with

color, too many tones in one painting may cause confusion to the viewer, possibly making the picture appear disjointed and destroying its overall harmony.

TONAL PATTERNS

To judge tonal values correctly, it helps to think of the effects of light and shade in terms of a monochrome scale, but this does not exactly explain how these can be translated in color drawing. If you depended on a system of adding white to lighten the tones and adding black to darken them, you would achieve a rather dead quality in the picture surface. Since we know that white light is composed of colors, we can assume that highlights and shadows have some

colorful qualities. You will also find that black pigments reduce the interaction of color values between pure hues, giving a corresponding reduction of subtlety in the surface effects.

If you look carefully you will probably notice that there are distinct color shifts in highlights and shadows, and you can use these to enliven the tonal values. A highlight area may have a slight yellow or pink tinge under warm light; shadows on a yellow object may have a green or red tinge, depending on the quality of light; a blue surface may shade into cold purplish tones where it falls into shadow. Some of these effects are innate properties of color values produced by a combination of local color and surface texture under a directed light. Others are more dependent on reflected color from surroundings or adjacent objects.

The tonal patterns of a subject can be broken down by using colors – perhaps gradations of a single color or a limited range corresponding to the darkest, lightest and one or two middle tones. When you have studied a subject in terms of tonal rather than color values, try putting together the tonal gradations with the blocks of local color as

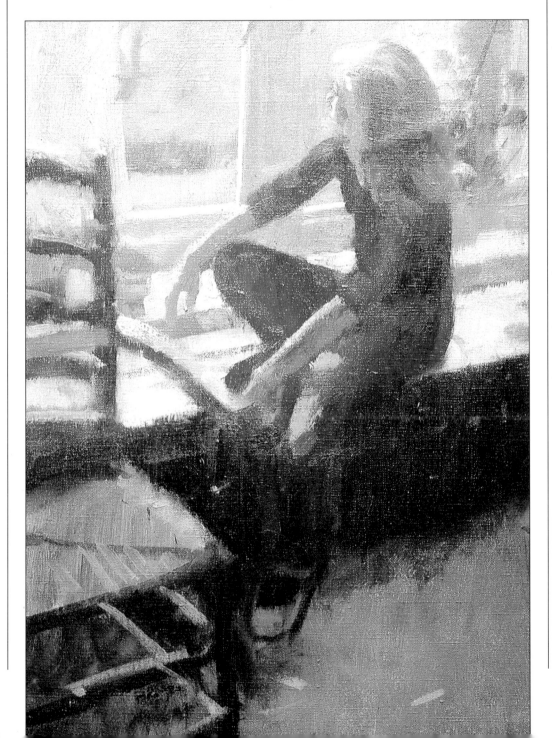

LEFT: Melanie Contre Jour *by Ken Howard, oil, 9 x 7 inches. This painting depends for its effect almost entirely on the pattern made by the distribution of lights and darks – color is minimal, verging on monochrome. Imagine how dull the picture would be if the chair were not there. Its pale seat contrasts with the shadow to the right, while the dark area beneath it is in counterpoint to the pale-colored floor. The bars of the chair connect the upper and lower halves of the picture, and are echoed by the horizontals and verticals of the window frame. Turn the picture upside down so that you see it as an abstract arrangement.*

ABOVE: *Very quick sketches can convey the atmosphere of a landscape view using minimal variations of tone and color.*

This pastel simply describes the vast space of an open landscape and cloud-studded sky.

ABOVE: *The textures in this color lithograph by Tom Robb show the techniques applied to preparing the printing plates – brush, pen and chalk drawing. The three-color interpretation is very effective, using the opposition of bright orange against deep blue and purple.*

previously described, and you will then begin to build a composite picture of the forms and colors.

A useful exercise in "thinking in color" in relation to tonal variations is to try creating "colored" blacks and grays by using combinations of various hues. Blue, purple and brown will mix to produce a rich dark tone that might stand for the darkest shadow areas in a drawing, eliminating the use of pure black. Experiment with combinations that vary the warm or cool qualities of the mixed darks, and the depth of dark tonal values according to the number of colors you have interwoven. In the same way, you can develop light tones using bright or pale hues: open techniques of hatching and stippling can give subtle color to an area that will still appear white in the drawing when it is set against the heavy, dark tones.

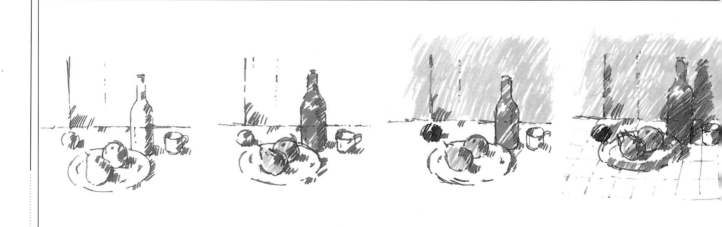

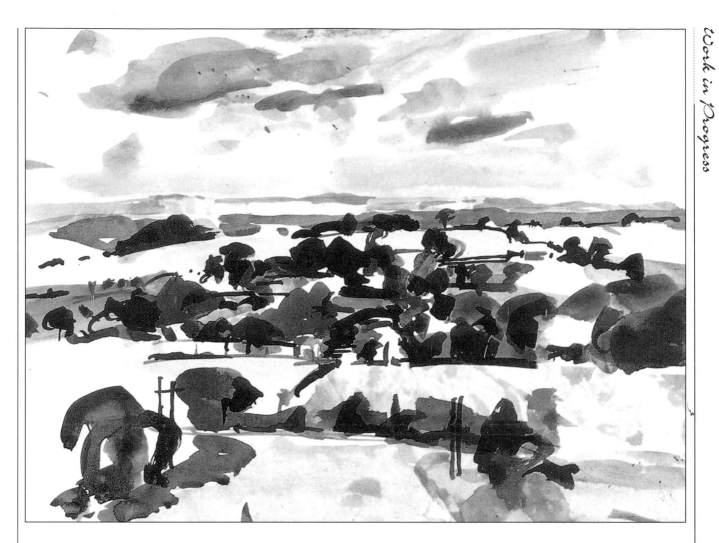

ABOVE: *Mike Hoare's watercolor landscape is described in restrained achromatic and neutral colors, with occasionally stronger touches of red-brown* *and green which emphasize the tonal range. This enhances the effect of distance and captures a subtle, even light spreading across the landscape.*

LEFT: *This sequence shows stages in an exercise in composition, first establishing line and tone, next introducing local color, then extending the color range and finally redeveloping the pattern of light and shade. This approach is simply demonstrated with felt-tip pens.*

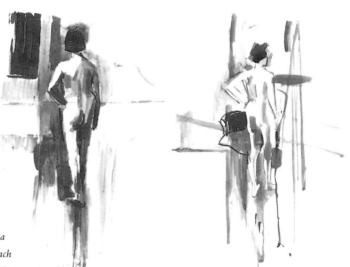

ABOVE: *Tom Robb uses a classic monochrome approach to a life study, modeling the form in terms of tonal values. The same exercise could be carried out with colored pencil or pastel using shading or hatching, the result being a similar image but a quite different surface quality.*

ABOVE: *This sketch is similar to the related study shown at left, but it has a much looser, more open treatment expressive of the figure but less concerned with* *a solid sense of the anatomy. Brush drawing is a very free technique which can help to lessen inhibitions about a "correct" approach to drawing.*

DECIDING ON THE FINAL COLORS

*T*raditionally, both in oil and watercolor, the artist would first establish the tonal relationships of a painting in broad areas of thin wash, or a pencil or charcoal drawing. In oils, an earth color such as terre verte, raw umber or sometimes ultramarine diluted with turpentine would be used to lay out the darker areas, thus producing a rough monochrome image. Bit by bit more color would be added, and the painter would gradually build up a network

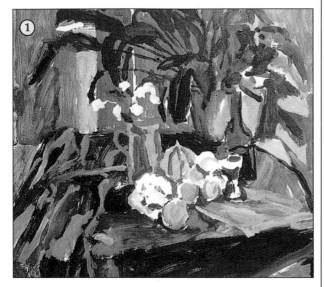

1: *This painting has been started in monochrome, a method which was standard up to the mid-19th century and which many artists still find the best way of working. The idea is to establish the broad areas of light and dark and all the basic forms before any color is put on, thus providing a complete "map" of the lightness and darkness of each color.*

2: *The next step is to paint the brilliant red and blue of background and foreground, because all the smaller areas of color, such as those of the fruit, bottle and jug, must relate to these. The big areas of vivid color can be modified later in relation to the rest of the painting.*

3: *Having painted the mid-green of the jug and the melon beside it, the darkest colors can now be painted in. Touches of white are added to the dark green bottle, to be toned down if they are found to be too bright.*

4: *The blue of the drapery needs to be given some modeling, and it seems too uniform in color, so some touches of lighter blue and violet are added. The artist has not had to waste time balancing dark, light and medium colors against one another because he was able to follow the guidelines he set himself in the first stage.*

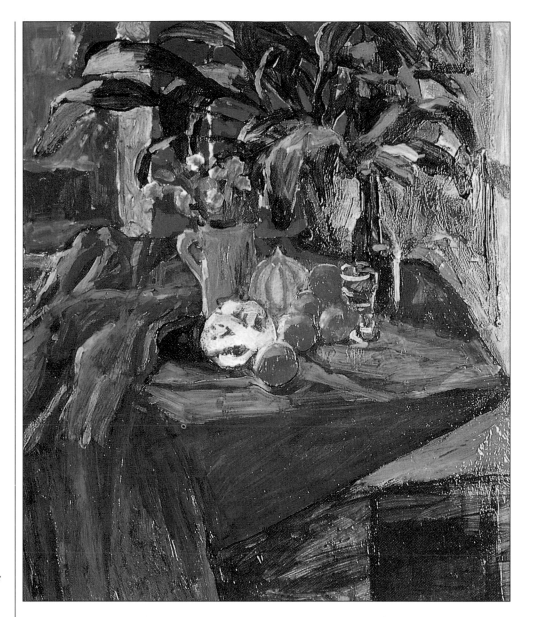

RIGHT: *The finished painting. The colors have been built up gradually, starting from a monochrome base.*

of tone and color gradations and contrasts, continually approaching closer to an equivalent of the subject in paint. Toward the end of this process the final adjustments would be made.

Some artists still work in this way, but it is by no means essential – you can aim for the final colors immediately. In pastel, every mark on the paper must be final because it cannot be erased satisfactorily or drawn over – a pastelist must plan the picture carefully in advance. Watercolor painters also now tend to start with the final colors, or paler versions of them, finding that this approach gives a fresher and more immediate look to a picture. This applies equally to oil; a free, spontaneous painting can be the result of treating every brushstroke as the final one, as

the Impressionists did. In many of my own paintings illustrated in this book, there has been little or no underpainting, the pitch of the painting being established from the start.

Watercolor differs from oil in that, although both bright and subtle colors can be achieved, accurate color equivalents are not always possible. Too much mixing destroys watercolor, as does a succession of too many washes laid on top of each other. Watercolor relies more on tonal relationships, which are gradually developed throughout the execution of the painting.

The advantage of acrylics, when used thin, is that layer upon layer can be added until the color you want is arrived at. Of course they can also be used opaque, and treated in much the same way as oils.

ATMOSPHERIC PERSPECTIVE AND COLOR ECHOES

Atmospheric perspective – also called aerial or color perspective – is a device that has been used for centuries by painters to enhance pictorial depth and the sense of distance in landscape compositions. Unlike linear perspective, which depends on scale and contour to develop spatial relationships, atmospheric perspective is an effect derived from particular perceptions of tonal and color values. In the foreground of a landscape, colors are at their brightest and most intense, the tonal contrasts are at their most emphatic. As the image recedes into the middle distance the definition becomes less pronounced and the range of color values diminishes, narrowing in the far distance to a scale consisting mainly of blues and grays. Details of form are also gradually eliminated so that background elements are presented in terms of broad masses lacking distinct and individual features.

You can see this occurring in an extensive landscape view. It is an optical effect caused by vapors and particles that hang in the air and, with increasing distance, create a "veil" that softens the edge qualities, surface textures and color and tonal contrasts. The convention has been used successfully in images ranging in style from meticulously realist to broadly impressionistic. It illustrates the general principle that color relationships contribute significantly to pictorial definition of space and form.

If we look at this idea in greater detail, we can see it in terms of a more abstract idea of color interactions. A flat area of a single color creates no particular spatial sense, but as soon as we add a second color or a different tone of the same color, there is an immediate tension, which begins to suggest a spatial relationship. This may be an effect of light and dark tonal values – the lighter color seeming to advance from the darker; or one of warm and cool contrast – a strong deep red, for example, forcing its way out from a cool mid-blue. It may be the way an intense color interacts with a somber one, as with a brilliant sunshine yellow flashing across a muddy ocher. In general, it can be said that contrasts create space, while evenly balanced hues and tones compete for space.

BELOW: *Natural features of the landscape often provide strong cues for the arrangement of a composition. In this view, Jane Strother makes use of the linear pattern of a planted grove of trees to lead the viewer from the foreground of the picture into the horizontal spread of the middle ground. There is an interesting perspective in the undulations of the land, and the artist has selected a relatively high viewpoint. The natural greens are shot through with yellow lights and dark blue shadows, the scheme of color fading gently towards the distant horizon.*

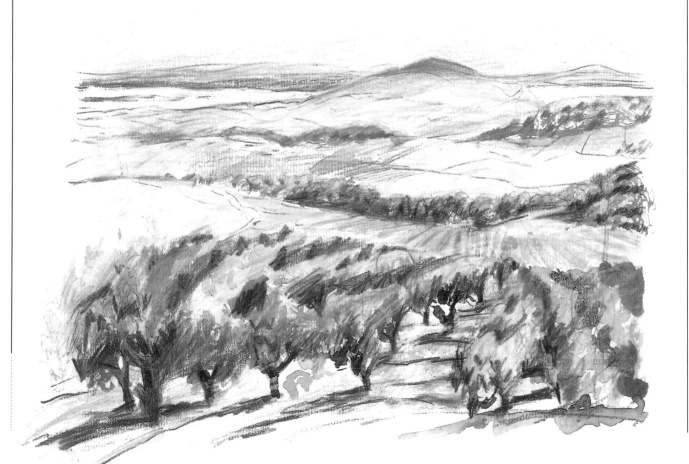

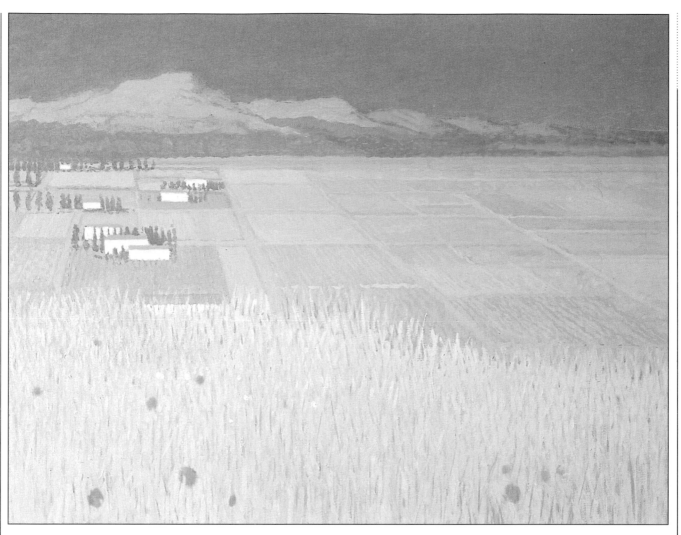

ABOVE: Mistral Plain *by Robert Buhler, oil, 40 x 30 inches. This painting has a very strong pattern element. The first thing we notice is the checkerboard effect of the regular, rectangular fields, which become increasingly linear toward the mountains, creating an obvious perspective. The shapes of the fields are echoed in the white buildings, while the trees that surround them have their echoes in the ears of wheat. Colors are repeated, too. Notice how the red of the poppies appears again in the roofs, in more muted form, keeping their place in the middle distance.*

ABOVE: *In a small pastel sketch, Tom Robb employs bright, distinct blocks of color to re-create the atmosphere of a park scene in brilliant sunshine. Strong patches of* yellow, orange, violet and pink are used to interpret the artist's impressions of form, light and shade.*

There is also, of course, a structure within a composition – created by contrasts between linear elements and mass, or the relative scale and interplay of shapes. To produce a naturalistic rendering, you need to make the color values work with the other formal elements of the composition. If you arrange colors and tones to act against the framework of the pictorial space, you are reinterpreting the image in a non-objective way that acts to flatten depth and form. These effects of color balance apply to any definition of the picture space whatever its extent and however it is organized – as important in the limited spatial context of a half-length portrait as in the much greater, more open space of a landscape or townscape.

The greater the actual distance you wish to convey, the more alert you have to be to the color cues that make the image work. In a broad landscape where there are dominant colors such as greens or earthy browns, you have to examine how these change with distance, and which precise values of tone and color will "pull forward" the foreground plane while "pushing" the distant areas away. Sometimes it is necessary to play up foreground colors, or the tonal emphasis, in

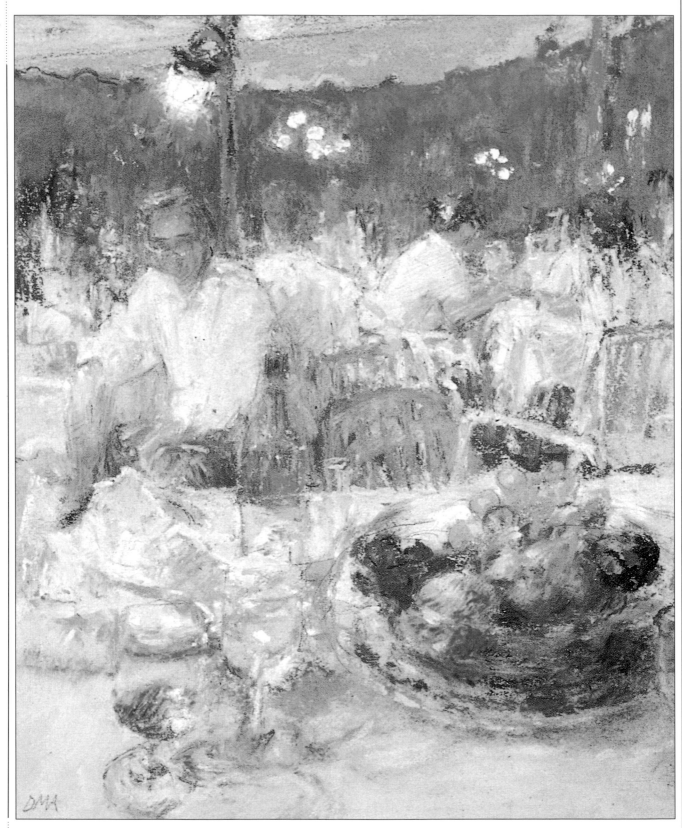

order not to lose the diminishing scale of values in the background.

The pictorial arrangement of color also depends upon where you want to place the point of focus in your drawing. If you have an interesting focal area in the middle ground, this has to be "played" in the right key against the foreground and background so that it does not become only an incidental part of the image. You may find that the darker tones defining this area are in the middle range of the tonal scale, and the values used to describe closer objects need to be carefully adapted in their apparent contrasts. The foreground must be treated in a way that establishes its closeness but leads the eye toward the focal point in the middle.

A drawing or painting needs to have a uniform pattern, whether simple or complex. The simplest type is the even distribution of forms over the entire picture surface. The danger here is that the picture can turn out dull and lacking life, but if the shapes direct your eye around the picture's surface this need not be so. A landscape consisting of a patchwork of fields gives a uniform scattering of shapes, as can be seen in *Mistral Plain* (page 93). What keeps the eye moving is that certain shapes and their colors are echoed through the picture, drawing the viewer's attention from the foreground to

the distance and back again.

Sometimes when you have nearly finished painting, you may find that a large area is bare and seems to have little relation to the rest of the picture. You can often save the picture at the last minute by echoing one or two features of the interesting part of the picture in the empty part. Imagine Diana Armield's pastel (opposite) with the table top totally bare in the lower half of the picture. It would be top-heavy and rather absurd. The man's face to the left is a striking, roughly circular patch of pinkish ocher. The peach in the fruit bowl echoes his face, since its shape and approximate color are similar. The tabletop now bears a relation to the top half of the picture. Not only this, the patches of dark blue of the bunches of grapes in the bowl echo the dark heads of two more people at the top of the picture. Continuing to explore the table top, we see that the red wine in the glass at the extreme bottom left again echoes both the peach and the man's face, thus linking the lower left quarter of the picture surface with the rest. The man's face, the peach and the wine glass are the corners of a triangle. The dark bunches of grapes and the two dark heads are corners of a rectangle. These interlocking shapes help to hold the picture together.

BROKEN COLOR

A fascinating way of mixing colors on the painting surface is to place unmixed colors in numerous small patches side by side on the canvas. This is sometimes called optical mixing. If the patches of color are small enough and at the same tone, they will appear to mix in the viewer's eye. Toward the end of the last century a number of painters, notably Georges Seurat and Paul Signac, carried this visual effect to an extreme, giving it the name of Pointillism, and creating pictures made up from an array of almost indistinguishable little dots of pure color. It was a very slow process, and has not been done in quite this way since, but somewhat similar effects can be produced by using a spray gun or even flicking flecks of wet paint onto the surface using a stiff brush

or toothbrush. This technique is called spatter and is most used by watercolorists, but it can also be done with oils or acrylics, using diluted paint.

Today, mixing colors by eye is quite commonplace. It is the way color printing works. Look at the pictures in this book through a magnifying glass and you will see the tiny dots of red, yellow, blue and black which make up all the colors. Color television uses the same system, but in red, green and blue only. In a painting, the patches of color do not have to be dot-sized to come under the general heading of broken color. Any patches of alternate colors that repeat themselves, however haphazardly, can be included. You can obtain soft, gradual transitions of hue throughout a picture surface by the use of overlapping marks of pure color.

SCUMBLING AND DRY BRUSH

Scumbling is another method of mixing paint on the paper or canvas. It involves applying relatively dry paint to a painted surface which has already dried. Scumbles are usually applied in a circular motion, using a stiff brush or rag, and the paint is loosely pushed around in all directions, leaving little specks and patches of the underpainting showing. Any color can be scumbled over any other color, and the technique can give a rich effect of color and texture. Very small amounts of scumbled color can be effective in subtly modifying an existing one. Scumbling can be done in all the media, including pastel, although it is seldom called by this name in this case.

Dry brush is really a variation on scumbling, and although it can be used in all the painting media, it is most often associated with watercolor. It is a method of dragging paint lightly over an earlier layer, and is done by splaying out the hairs of the brush so that the paint is applied in a series of tiny lines. The paint must be mixed with the minimum of water or it will simply be a wash – a good deal of practice is needed to get the mixture exactly right.

THE ARTIST'S EYE
BROKEN COLOR

Artist John Martin has made a lively and unusual still life from an arrangement of potted plants in front of a Victorian fireplace. The painting is in gouache, a medium he particularly likes, and he has chosen to work on a gray-toned paper, which gives the color "key" to the whole picture. He describes in his own words which colors he used and how he modified and adjusted them by using the scumbling technique.

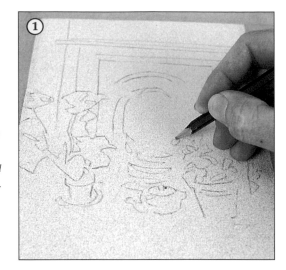

1: *Having worked out a roughly symmetrical arrangement, I map out the outlines of the main shapes carefully but briefly in pencil. Since this is a small picture, which I intend to finish at one sitting, I do not include too much detail at this stage or the picture could lose the spontaneous, sketch-like quality.*

4: *Having painted in most of the colors, I now begin to add more color to the fireplace and its surround by scumbling over the first layers of paint. The scumbled paint is used very dry so that it catches on only the highest ridges of the paper and leaves the underlying color showing through unevenly.*

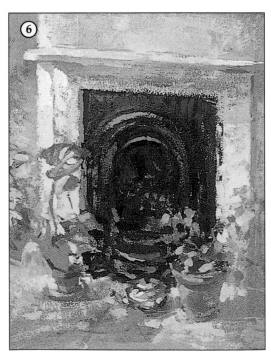

6: *Before leaving the fireplace and turning my attention to the foreground, I add some final accents and highlights. I have accentuated the curved relief shapes of the fireplace by adding streaks of cobalt blue mixed with white. At the same time I have given the teapot highlights of pure lemon yellow and blue-white mixtures. Notice how the curves of the teapot echo those of the fireplace, but in reverse, so that the middle area of the picture has a continuous flowing movement.*

2: *I then establish the tonal relationships, using well-thinned paint. The "blacks" of the fireplace are a mixture of ultramarine and burnt umber, with a little alizarin crimson added for the more reddish tones. The surrounding yellow is of yellow ocher and vermilion, and the blue strip is cobalt blue diluted with white. The mauve-gray wall is made of alizarin crimson, cobalt blue and white.*

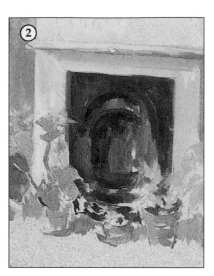

3: *The next step is the leaves, for which I use a mixture of lemon yellow and cobalt blue. I try to cover as much of the picture surface as possible early on, so that I can judge the relationship of one color to another before I begin the final adjustments.*

5: *For the scumbling method to work really well, the colors must be mixed carefully so that they are slightly different in both tone and color to the first layers of paint. If I had scumbled a very light color on the fireplace, it would not have kept to its proper place in the background. I arrive at the right color by trying it out on a scrap of paper and holding this up to the painting. For the fireplace surround, I use cadmium yellow instead of the original yellow ocher, mixed as before with vermilion and white.*

7: *I have left the foreground till last because I wanted to adjust this up the focal point of the fireplace. In order to give the picture unity of color and texture, I use the same scumbling technique here, applying a dry mixture of lemon yellow, alizarin crimson and white. The shadow of the pots is simply the blue-gray of the paper left bare. This is a technique often used in pastel painting, and the picture has a rather pastel-like look because I have used the paint dry and mixed the color with a lot of white.*

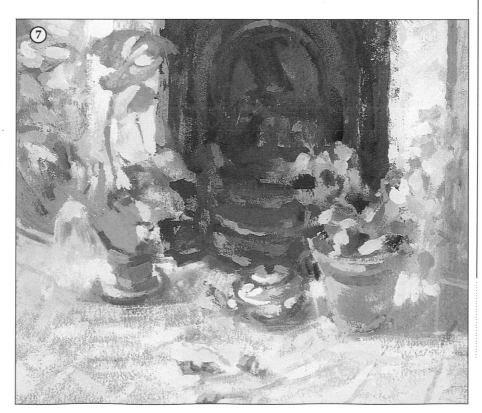

CHALLENGES

LEFT: The Indian Winter, Taj Mahal *by Albert Goodwin, oil, 10 x 14¾ inches. The richest and most varied colors occur at sunset, and artists have always been tempted by them. The artist has used a wide range of blues, from deep ultramarine at the top to cerulean at the bottom lightly scumbled over with pale yellows and pinks.*

You might think that, since all drawing and painting involves looking closely at a subject and recreating it on canvas or paper, the actual choice of subject matter should make little difference. But there is no doubt that some subjects are more difficult than others and place extra demands on the artist. There are several reasons for this, one being that people often just don't believe their eyes.

ABOVE: *Loose washes and scribbles of paint are overlaid with a powerful pastel line in Linda Kitson's portrait of a speedway biker. The way the line swings around the form, breaking open and then hardening into heavy slashes of color is appropriate to the tough character of the sporting subject and the unified movement of man and machine.*

The colors of foliage may be so far from what you expect them to be that you decide your eyes are wrong and your preconceived ideas right. Another problem is that some particularly bright colors, such as those seen in flowers, are unobtainable in artist's materials, so you have to resort to visual "tricks of the trade" to obtain the right effect. Some subjects, such as metal, with all its bewildering reflections, have so many colors that you have to make a selection of the most important ones, while flat surfaces, such as skies or water, can cause endless trouble if you don't know how to deal with them. In this chapter we look at a selection of these difficult subjects, and give some hints about how to overcome the problems. Watch how individual artists confront these challenges with their chosen medium – then imagine how you could use different materials to the same effect.

NATURAL LIGHT

Surface effects of color and tonal modeling are influenced by the direction, strength and color quality of the light falling on them. The quality of natural light changes according to the time of day and season, so if you can capture a particular quality in an outdoor subject, you will add an extra dimension to the sense of location. It is described by the overall color key, the relationships of the areas of light and shade and the individual notes of color provided by highlights and color accents.

THE ARTIST'S EYE
NATURAL LIGHT

When you seek to capture an effect of natural light, it is not usually possible to obtain all the information you need in a single period of concentrated drawing. Rather, you must train your eye to be alert to the cues of color, tonal contrast and patterns of light and shade which are typical of a particular time and place. If you make a number of rapid studies of a whole view or individual details, you build a body of reference work that subsequently can be used as the basis for constructing more complex and detailed drawings. At the same time, this process gives further opportunity to develop your visual and technical skills. The main color study in this sequence (far right) shows an outdoor view in afternoon light, with rich, strong colors under full sun and hard-edged dark shadows cast from the standing objects. In the two smaller drawings of the plant pots, the artist investigates the different qualities of cool morning light, with pale tints and cool shadows, and the more intense light of evening in which the colors are all tinged with red and gold.

The smaller studies go into further detail of shadow patterns and color values, trying out varied techniques of watercolor and colored pencil drawing. You should always bear in mind how the medium and technique that you select can most aptly convey the qualities of your subject.

Challenges

SKIES

Sky may occupy up to three-quarters of a landscape painting, so it naturally plays an important part in the composition as a whole. A painting, by its very nature, is a series of brush marks on a flat surface, but at the same time the paint also gives the illusion of the subject which the painter is intending to depict. The difficulty with skies is the successful creation of this "double identity" of the paint; so often it just looks like paint, failing miserably to appear like sky as well. Clouds are notoriously difficult. How can paint give a convincing impression of such distant, soft, amorphous forms?

FLAT AREAS OF UNIFORM SKY

In some respects the more variety there is in a sky, the easier it is to paint because your brushstrokes will have more obvious meanings. Sometimes the sky does appear totally uniform, particularly when hazy or completely overcast, but even if it has consistent color value throughout – usually close to white – if you paint it as you would a wall, the result will in most cases disappoint you. Paint will always look like paint, however smooth a surface you give it. To make it look like the sky as well, we can make use of various tricks of deception. The handling of the paint must be the same for the sky as it is for the rest of the picture so that the eye links the two areas as a whole. The brushstrokes should be compatible in size throughout the picture, with those of the sky echoing those of the land or sea. When painting with opaque paint on a dark-toned ground, it helps to allow this to show through in patches, easiest to achieve if the whole painting is begun in thin paint. With pastel, the ground usually sparkles through in any case. Breaking up the painted surface in this way rather surprisingly enhances the illusion of sky, even while emphasizing the fact that it is really paint.

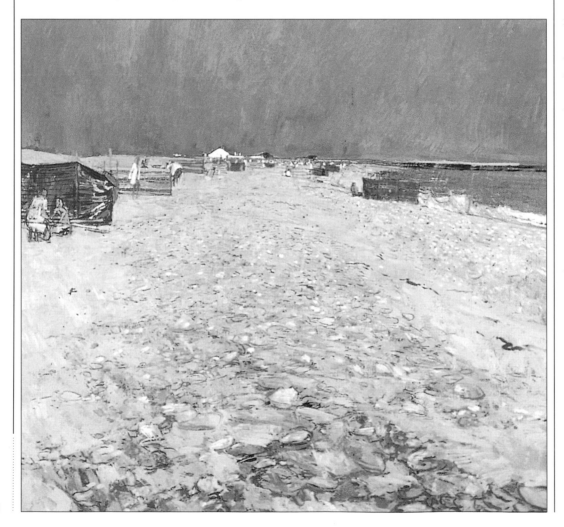

LEFT: Walberswick by Wiliam Bowyer, oil, 36 x 36 inches. The cloudless sky has been treated very freely, with each brushstroke discernible. The sky has been made to look much richer and more blue by adding touches of other colors, such as mauves and pinks, and it has been treated in the same way as the rest of the painting so that it forms an integral part of the composition. The picture is further unified by the way colors have been repeated. The blue of the sky is echoed in the windbreak, appearing again in more muted form in the shadowed sides of the foreground pebbles.

ABOVE: Cley Mill *by Jeremy Galton, oil, 12 x 18 inches. This part of the thinly overcast sky, away from the sun, is relatively dark, forming a natural backdrop for the white sails of the windmill. The sky was painted in just one color, a mixture made from white, a little Payne's grey, raw sienna and ultramarine, and the paint was applied thinned with turpentine to allow some of the warm ground color to show through. A very limited palette was used for the picture, and it was completed on the spot in one session.*

The other main task is somehow to make the paint appear as though it is far in the distance, just as real sky is. A good trick to make the sky recede is to break up the paint surface by adding small dabs of paint of identical tone but of different color. For instance the artist may have painted a sky in a thin creamy white color. By adding small patches of a bluish paint of the same tone, the sky will now take on a glow, which may be difficult to focus on, and thus appear to the viewer as sky. The use of patches of complementary colors stippled throughout the sky can sometimes have the same effect. Our eyes cannot focus perfectly on more than one color of light at once so that, coupled with the dazzling properties of complementaries placed side by side, the sky becomes intangible and recedes into the distance. In watercolor, skies are usually painted in thin washes of dilute color, and accidental effects that occur can often be used to advantage.

CLOUDLESS SKIES

You may be deceived into thinking that a perfectly blue sky is also uniform, but there is usually a marked gradation of color and tone downward to the horizon. Again our expectation is more powerful than our observation, but next time you are in front of a large expanse of sky, try turning your head so as to view the scene upside down. At once you will notice colors you never expected to be there, and you will be surprised at the difference between the horizon and the higher elevations. A clear, dark blue sky pales toward the horizon, sometimes becoming yellowish or pinkish, the exact color depending on the amount of water vapor and haze in the air.

In a simple oil painting I usually find it sufficient to mix up the colors of three areas of sky – toward the top of the picture, half-way down, and close to the horizon. The junctions between these areas must be handled carefully. Obviously a boundary

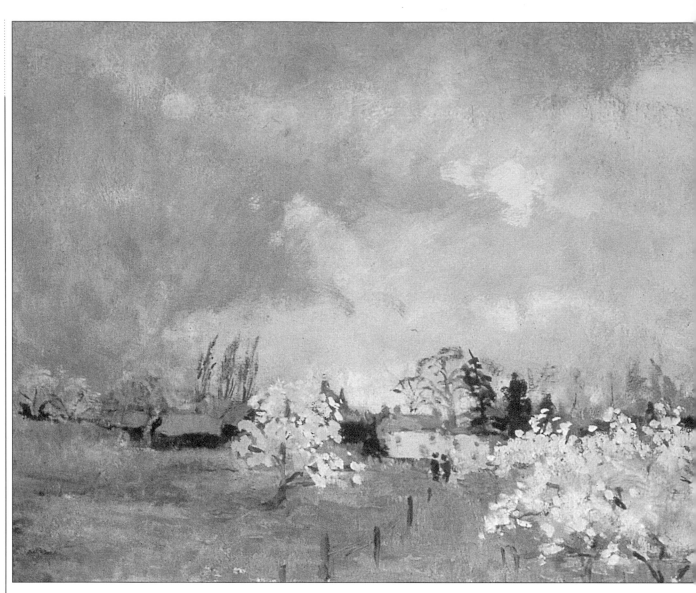

must not be sharp, but if the colors are mixed on the canvas, the paint begins to look like paint rather than sky. Try to allow horizontal brush strokes of one color to encroach into the adjoining area, and vice versa. This makes the boundary difficult to see, but keeps a suitably broken paint surface.

A blue sky is often less blue than we think, necessitating considerable dulling of blue paint from the tube. In oil, cerulean is often a useful paint here, as only tiny amounts of other colors are sufficient to dull it to the required color and tone. It is less useful in watercolor, and can really only be used pure, as it does not mix well. Close to the horizon, the amount of blue paint required is often minimal, whites, ochers and crimsons sometimes being all that are necessary.

HOW LIGHT IS THE SKY?

When compared with the lighter features in a landscape including buildings, a blue sky can be seen to be very dark. The more haze there is, the lighter it becomes. An overcast sky is usually of a fairly uniform brightness, owing to scattering of light by cloud, and sometimes it is so bright that it is impossible to paint the true tonal contrast between the sky and the land. On these occasions remember that, above all, you are painting a picture rather than simply copying your subject, and a darkening of the sky can be quite permissible. Sometimes a cloudy sky is very dark in one area, but the landscape below it is still being lit by the sun and is consequently very pale. In such a case, if we turn around, we will see a bright sky and sunshine, with the landscape below it darker than the sky.

LEFT: Orchards at Haddenham *by Robin Mackertitch, oil, 24 x 12 inches. The colorful sky perfectly complements and echoes the blossom below. The pinks, blues, greens and browns of the clouds are all taken from the same palette as the rest of the painting, so that the picture hangs together as a whole. Although the sky is "inspiration" rather than being an exact description, and it is not possible to make out the structures of the clouds, it gives a powerful impression of a typical early spring day.*

PAINTING CLOUDS

Look carefully at the colors of clouds. They are often totally unexpected both in color and in tonal range. The color of a cloud depends firstly on its illumination by the sun. When the sun is low as at the end of a day or in winter, its light is yellowish, and the side of a cloud lit by it will be a light yellow. The other side of the cloud, in shadow, may be reflecting blue sky, so will appear a dark blue-gray, but sometimes it may be brownish, particularly when overhead. If there are a lot of bright yellowish clouds in the sky, you may find that the shaded sides of the clouds appear violet – the complementary of yellow. The higher the sun in the sky, the less varied are the colors of the clouds, the lightest parts appearing very white indeed. Second, the color of a cloud can be modified by its distance – the more atmosphere (containing even the thinnest haze) there is between the cloud and yourself, the more it tends to yellow, pink or violet. Chaotic cloudy sky has the greatest variation in color. It is an exercise in mixing grays – brownish grays, bluish grays, pinkish grays, yellow grays and so on. At sunset all the colors of the spectrum appear, giving you the chance of painting with brilliant reds and yellows close to the sun, and blues and greens away from it. You'll have to be quick though when painting or drawing clouds – the sky changes by the minute.

Remember that the shapes of clouds are important. They are not merely amorphous random masses, but have a definite structure, albeit a constantly changing one. On any one day they will form at a particular level (sometimes two or three levels simultaneously under certain conditions), and they thus form a kind of ceiling which follows the normal rules of perspective as it vanishes into the distance. They appear to be far more bunched together toward the horizon, and their apparent size increases to a maximum overhead. The blue sky between scattered clouds will appear more extensive overhead than in the distance, simply because we cannot see through these spaces at too much of an angle.

Possible color mixtures for skies

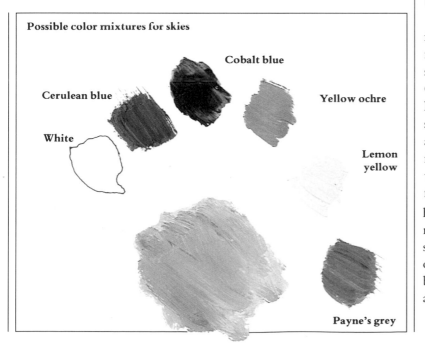

Cobalt blue

Cerulean blue

Yellow ochre

White

Lemon yellow

Payne's grey

ABOVE: *William Tillyer works with watercolor on a large scale to produce atmospheric landscape effects. The calligraphic image shows the fluid passage of the brush, laying in soft washes and hard lines of color.*

RAIN AND SNOW

The colorful effects of different kinds of natural illumination are combined with and modified by the atmospheric qualities of varying weather conditions. This is another area in which you are reliant on your perceptual skills and visual memory in devising a method of mark-making that can represent, for example, falling rain or snow, a dense mist or the shimmer of seaspray hanging in the air. There is continual change and motion, and with this, an apparent lack of substantial visual cues.

These are ambitious subjects to tackle in drawing. The vaporous and liquid qualities of such phenomena are perhaps more readily described with a fluid paint medium which allows a rapid technique.

RAIN

To bring the problem into more familiar territory, consider that rain, mist and spray are, like light, all elements that are acting upon tangible forms and surfaces, things you can identify and convey. The problem is thus not so much how to "draw rain" as how to represent its effect on the colors and forms of a landscape or townscape.

Concentrate your analysis first on the kind of rain. Are you seeing heavy rain that seems to pass directionally across the fixed elements of the view or a fine drizzle or mist, which masks the definition of forms and "grays" the colors? Now think about drawn marks that might correspond to that visual sensation. Stippling, layered washes or finely drawn colored scribbles might create the diffused, amorphous quality of form seen through mist or spray, whereas a more definitive, calligraphic style might capture the slanting fall of a heavy downpour. It could be effective to work in terms of an overall texture on the drawing surface, with a veil of active marks and no clear areas of flat color.

It has to be said that this area of image-making is not easy, and many artists "solve"

the problems by avoiding them altogether. But if you are interested in the challenge of atmospherics, do not be put off by the difficulties. Give yourself time to study the effects in relation to a familiar subject – such as the view from a window in your home – and try out different ways of transmitting what you see through a variety of drawing media and techniques. In this way you have a good chance of arriving, either by accident or design, at a technical solution that corresponds to your perception.

SNOW

Fresh snow, the tops of cumulus clouds lit by the sun and breakers at the seaside are among the whitest features to be found in nature. But even though their local color is pure or almost pure white, the colors we perceive stray dramatically from this, depending on the lighting conditions, reflections from adjacent objects and our own viewpoint.

In winter the sun is low, and if the sun is shining from a clear blue sky, the areas of the snow being illuminated directly will appear dazzling white. If the snow is lying on undulating ground, it will vary in color and tone depending on the exact angle in relation to both the viewer and the sun. Areas largely turned away from the sun will be mainly reflecting light from the blue parts of the sky, so will appear bluish, and there may be shadows (long because the sun is low) which for the same reason will also be blue or blue-gray.

On a cloudy day the color of the snow will depend on the thickness of the cloud cover. When the winter sun filters through thick cloud, it is often quite yellow, and the snow often will reflect this color. There will, of course, be no clear-cut shadows, but shaded areas, hidden from the yellowish light, will take on something of the complementary hue of violet, together with various cool grays and purples.

In oil paint all these variations of "white" can be mixed by starting with pure white from the tube and adding bit by bit the blues, violets, reds and ochers and so on until you have the desired color. As snow is cold and the shadows are cool blues and grays, it is often helpful to emphasize the coolness by painting on top of a warm ground of ocher, raw sienna or even a red. The ground will show through the thinner patches of cool paint, also helping to break up monotonous white areas into a more exciting pattern and aiding the illusion of snow by baffling the eye. A little confusion helps us to forget that we are merely looking at paint on a flat surface – our eye is compelled to sort out what the artist intended.

In watercolor, bare white paper is the equivalent of white oil paint straight from the tube. Thin pale washes can be used to break up parts of this surface, and progressively darker colors can be added, ending with the darkest shadows. As always, nothing can beat looking, seeing and experimenting.

ABOVE: Winter's Light by Cathy Johnson, watercolor, 15 x 22 inches. A large area of the white paper has been left exposed in the foreground, with the blue shadows laid in lightly and softly with no hard edges so that they suggest the gentle undulations of the snow-covered ground. The artist has used the red-gold of the central tree as a foil to the blue and mauves in the background, and the wintry effect is heightened by the delicate, rather calligraphic drawing of the tree-trunks and branches. The shining white snow is thrown into relief by the small areas of near-black at the base of the trees and on the wall of the pavilion.

WATER

Clear, clean water, like glass, allows us to see through it to whatever is at the other side, usually the mud, sand or rock below it. If the water contains suspended mud or vegetation, then the water takes on its own color – for instance, mountain streams are often brownish because the water is colored by peat, while the sea in some places is greenish-brown from the algae in it. Water also reflects light at its surface, and thus acts as a mirror. For painting purposes these are the three important points to remember. It is the reflections that usually play the most important part in contributing to the appearance of water in a landscape or seascape. Unlike a mirror the strength of reflection increases in proportion to the degree of slant with which you view the water. A calm lake in the distance reflects almost a hundred percent of the sky; if the sky is blue, the lake is blue; if the sky is gray, the lake is gray. In contrast, if you look down from a bridge into a slow-flowing river, most of what you see is the river bottom or mud suspended in the water, with possibly a weak reflection of yourself and the sky above. Thus any stretch of smooth water becomes lighter with distance as it reflects more sky. Nearby areas of water may be reflecting buildings or trees, but the same principle applies.

The reasons why choppy water is so difficult to observe, and therefore to paint, are threefold. The first thing you have to take into account is the shapes of the waves or ripples; the second is their color; and the third is the fact that the water simply will not keep still. Look carefully to see what is being reflected – this is always vertically above the reflection. The color of the reflection is always a little duller than the original, so add a little raw umber or Payne's grey. Each wave or ripple will be reflecting more than one color, but don't try to be too precise; these are usually adequately represented by interspersing horizontal patches of color.

BELOW: San Giorgio and the Dogana by Albert Goodwin, oil, 23 x 35 inches. Calm water is a particularly tricky subject. Paint it too flat and it looks solid and static, but too much variation in tone and color will ruin the impression of a horizontal, liquid surface. The artist has made the water much darker in the foreground (as it always is), while the farthest stretch is a bright blue reflected from the sky. But he has kept the transition from dark to light very gradual, and each area of color is composed of several different hues of the same tone so that one has an impression of the movement and transparency of the water.

ABOVE: San Giorgio Maggiore, Morning Light *by Ken Howard, watercolour, 7 x 9 inches. The elegant Venetian skyline also features in this treatment, but that seems to be where the similiarities end. This picture gives a wonderful impression of the wind-whipped waves in the pinkish gray morning light. The artist has used a special method – of laying down touches of opaque paint (Chinese white and Naples yellow) and then laying thin washes over the top. He finds this method more satisfactory than using opaque paint on top of washes, as it gives a more subtle effect.*

METAL AND GLASS

These are best treated together because in a sense they are opposites, but with similarities. Metal reflects all the light falling on it whereas glass lets most of it through. The appearance of a metal object depends almost entirely on its surroundings, which it will reflect in a multitude of distorted shapes. These shapes are dictated by that of the metal object itself, which calls for very careful observation when setting out to paint. The paint mixtures to use for the reflections will be very similar to those used for the surroundings, but bear in mind that the reflections are often a little less brilliant in color than the originals. This is not always the case, though. Convex metal surfaces concentrate reflections into small areas, giving high-intensity patches of color we call highlights, and if these happen to be reflections of the sky or a strong light source, they are particularly bright. The inclusion of these in a painting will increase the illusion of shininess.

Similarly the darker areas of the surroundings will be concentrated by convex metallic surfaces so that the general appearance of a shiny metallic object is that of extreme light tones side by side with extreme dark ones. Often these reflections form such intricate patterns that they cannot all be painted. Instead try to simplify the shapes. If you have difficulty doing this, try half closing your eyes so that you see only the most important ones.

Apart from the shiniest metallic objects, many metals appear predominantly of different shades of gray. This is because their surfaces are often covered with myriads of tiny scratches through wear which, together with tarnish, scatter light to some extent, giving less true reflections. Brilliant colors will be reflected more dimly, so that you will have to dilute the paint more for the reflections than for the original sources of them. Aluminum always has a thin coating of oxide on its surface which scatters the light so that the highlights are muted and the darker areas lightened a little. A quick way

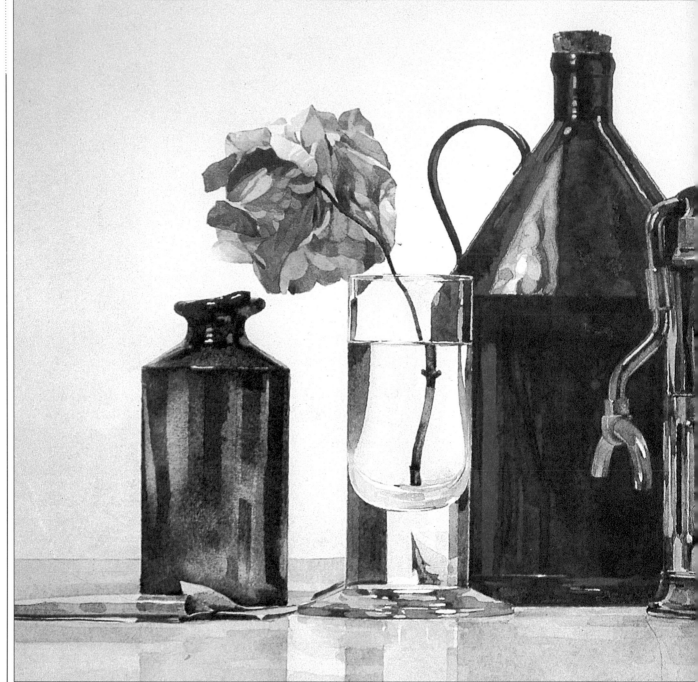

to mix these colors is to start with lemon yellow (or Naples yellow if you have it) and a little ultramarine (to give a greenish-gray) followed by a little red (to counteract the greenness). Different reds in different amounts will give a range of grays, many of which may suit your requirements. Metals (apart from copper and gold) tend to look cold. This is partly because we know them to feel cold to the touch, but partly because the tarnish or scratches do actually reflect the cooler colors (the blue end of the spectrum)

more efficiently than the warmer ones (the red end of the spectrum). To mix the colors of copper and gold and their alloys, which are pink and yellow respectively, it might be a good idea to start with an alizarin crimson and white mixture for copper, and ocher for gold. Modify these colors according to the reflections. Copper and gold look warm because these metals are best at reflecting the warmer end of the spectrum.

As light travels through curved glass, it bends, giving rise to the characteristic

*M*aterials that are highly reflective do have their own colors – think of the warm red tones of burnished copper, for example – but the visual impression they give is to some extent a composite of colors. Where they receive direct light, you will see dazzling highlights, sometimes strongly contrasted with dark tones on curves and angles, and there will be a range of reflected colors picked up from those of neighbouring surfaces and objects. You may also see some unexpected influences from quite a distance, especially if there is a strong lighting effect farther away. An object standing in light from a window might reflect faint sky tones and sunlit yellows, while interior light sources such as a coal fire or candles throw warm, flickering tints that can strike quite vividly on a reflective surface across the room.

The more reflective a surface is, the more pronounced the contrasts of tone and color. Although the initial effect is confusing, materials such as chrome, silver and glass offer distinctive shapes and patterns in the reflections that are relatively easily identified once you start to study the subject closely. In strong light, tinted glass can be as completely reflective as an opaque, shiny metal, as seen in the glass-clad façades of modern buildings, which mirror their surroundings in astonishing detail.

In a solid or hollow glass object, the color effects derive both from the reflected colors and those seen through the transparent material. It is the combination of these elements that visually defines the quality of "glassiness": color treatment in the drawing must explain the relationship of surface effects and transmitted colors in a way that represents the whole object coherently.

A material with surface sheen can be a more difficult problem in color rendering than one that is polished and shiny, because the tonal keys are less dramatic and the color shifts more subtle. Whereas with high-contrast reflection you see hard edges and clear contrasts of color values, the lower tonal register of, say, aluminum or varnished wood will include softer gradations and muted, mixed hues that can

LEFT: Still Life with Hydrangea *by Ronald Jesty, watercolor, 13 x 18 inches. The shiny glaze of the dark blue container reflects its surroundings, but it is only the very brightest area of reflected light that hides the blue. Glass, unlike metal, transmits most of the light striking it. Light is bent as it travels through curved glass, and the images of objects seen through it are always distorted. Here the stalk of the flower is magnified and shifted in position, and because of the curve of the glass, none of the blue container can be seen through it.*

distortions of the objects seen through it. Glass also reflects light, particularly when it is viewed at a low slanting angle to its surface. Thus a jar will reflect light at its edges, where distortion is at its greatest. Tonal contrasts can be quite large at the edges, the highlights sometimes approaching pure white, and the dark areas being as dark as other dark tones in the surroundings. The least distortion and reflection occur at the center – what we see is not so much the jar as its absence.

be hard to distinguish. They are related to the surfaces they are reflecting from, which provides the color cues, but the reflected colors are seldom if ever as pure as the originals, so you must look carefully at both the original source and the reflected values.

Reflected colors in landscapes provide additional depth and detail. In a snowy landscape, for instance, there are different qualities of whiteness, and there are washes of color in the lights and shadows that relieve the starkness of form masked by snow. A pool of water can provide an impressionistic reflection of general shapes and colors or, like a mirror image, show the clearly delineated forms of surrounding trees and the clear colors of the sky.

BELOW: *A lithograph by Ellen Gilbert re-creates the gentle textures of ink wash, brush and chalk drawing. The subtle transition from the yellow-green cacti in the foreground through clear yellow to blue is enlivened by accents of red traveling around the central curve of the composition, across the plant tips and along the jetty to the flat top of the moored boat.*

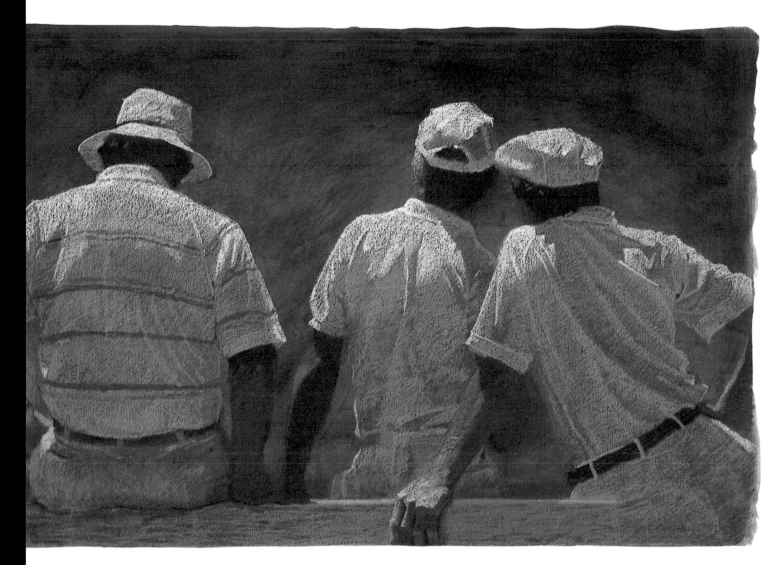

COLOR ACCENTS

*I*t is possible to create an effective description of objects and their location by using only local colors and tonal values (see page 85). But although the task of simplifying what you see helps you to recognize how to organize a composition, you cannot help noticing the variety and subtlety of color values in even the most basic subjects.

All surfaces, even those that are not highly reflective, will pick up some color influences from the prevailing light and the surrounding colors. Sometimes these are mere hints of color, but all such accents serve to modify the appearance of local colors and create the more complex network of color values in a given context. If you look closely at the petals of a white flower, you may identify traces of yellows and greens in the white, blue or purple tinges in the shadows, a hint of warmth where the outer edges of

the petals catch the sunlight. Some of these color emphases belong to the texture and color of the flower itself, and others to the influence of its surroundings. To catch the small accents of color in a composition, you will need to pay close attention to detail. This is true for all subjects, and is not always just a question of delicate surface changes, such as those described in the flower. In a broad area of landscape, for example, you might see a blue shadow among the greens, or a yellow patch of sunlight, or a scattering of vivid red flowers. If you were designing a room, you would be conscious of deliberately contriving color accents by adding bright cushions or ornaments to a coordinated room scheme, and the same principle applies to drawing and painting – you incorporate touches of color that bring the image alive. All such elements create points of focus and contrast that make a color rendering more interesting and, usually, more real.

ABOVE: *Tom Coates selects a subdued range of browns on buff paper to establish the structure of this pastel drawing, developing a strong tonal scale by the intensity of* *white highlighting in the window area. Into this tonal scheme, he introduces vivid color accents of deep pink and clear blue-gray.*

SURFACE QUALITIES

One of the most difficult problems in color rendering is to find technical equivalents for the surface textures seen in the subject. Some surfaces produce complex and confusing color combinations while others are blandly smooth, giving few clues as to the precise characteristics that explain their physical quality.

A plain-colored flat surface contains little color variation. Gradations of reflected light or color are minimal, and tonal shading corresponds to the way light models the form. A patterned surface – such as wallpaper or printed fabric – is obviously far more various in terms of local color, and this can disguise the effects of tonal modeling that would be more easily distinguishable in an expanse of single color. One way of dealing with this is to treat the subtle shifts of coloration in shadow areas in the same way for each color within the pattern. This, although producing a complex surface in terms of drawn marks and their relative color values, does create a coherent sense of overall form.

Pronounced textures, such as those of brickwork or tree bark, will usually form an irregular pattern of color and tone. This, once identified, can be simulated by equivalent marks and blocks of color in the drawing. Sometimes it is useful to exaggerate a textural effect to give emphasis to different surface qualities in different objects. Your viewpoint also affects the influence of actual texture in the general impression of the subject. If you see things from quite a distance, emphasizing surface effects may break up the balance of the composition by drawing attention to one area more than another. In closer studies, though, texture has a more important role by way of identifying objects, and the technical ways in which you render such characteristics can give liveliness and force to the finished image.

RIGHT: *The subdued gray-blue tones of the harbor wall lined with ships are loosely touched in with ink and watercolor, but Ian Ribbons makes full use of the focal point of brightly colored flags in the foreground. This not only provides an interesting color balance, but emphasizes the deep perspective of the view.*

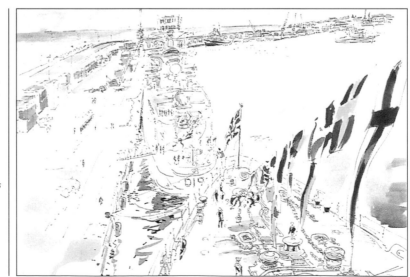

RIGHT: *Autumn at Roche Abbey by David Curtis, oil, 18 x 22 inches. Pale yellowish greens give a fresh, spring-like atmosphere to this picture. The pinkish and bluish grays of the distant, still wintry, trees to the right contrast with the dark ones in the foreground, presumably evergreens, and a wide range of colors is used for the "greens" of trees and grass. This gives a harmonious composition with a pleasing balance of warm and cool colors and light and dark tones, while the angular shapes of the house, treated in the same way as the foliage, help to unify the picture.*

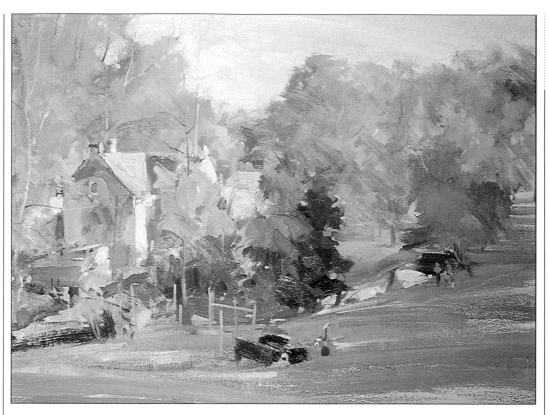

TREES AND FOLIAGE

The questions that an artist may ask himself when confronted by foliage are: "How much detail is needed? Is it necessary to paint individual leaves?" "What is the minimum I can put on canvas and yet give the best impression of the foliage before me?"

In some respects our eyes are too good. They see to much detail, and often trick us into concentrating on the minutiae at the expense of larger shapes and patterns. This is fine for everyday life, and often an asset, but for the painter it is a potential handicap. Anyone intending to portray flowers or foliage has somehow to convert that mass of detail in front of him into a few marks of paint in such a way that the viewer of his picture can re-interpret them as the original trees, grass, flowers or whatever.

But how can you decide which features of the subject are the important ones? One way to do this is to blur your vision increasingly until the last moment that your subject is still recognizable. This can be done by almost shutting your eyes, by removing glasses if you wear them, or by viewing the subject through frosted glass. In this way the subject will be reduced to the simplest of shapes, and these are the ones that should be painted in first. Individual leaves or twigs can be added later if you think it is necessary to describe the type of tree or plant, or if the painting still looks ambiguous and unfinished. Perhaps surprisingly, if you include too much detail, a painting will tend to become less true to life. Of course to a large extent, it depends on how close you are to the subject. The leaves on a distant tree cannot be seen clearly, while a potted plant right in front of you may well have leaves which you will want to paint individually, showing their shapes accurately as well. It is up to the painter to strike a suitable balance.

The color of the paint marks must now be considered. There are difficulties here as well, because foliage is all green. Or is it? It is true that if we were to pick a selection of leaves from one tree and examine their color, we would find they would all be identical or at least pretty similar. It is when they are on the tree, presented to us in every conceivable angle and position, that the variety of colors and tones is apparent, because the light strikes each one differently. The colors of individual species vary widely, too, and if we consider all the other types of vegetation,

the variety is extended further, even into the blues, yellows and reds. The painter must see these colors and learn how to mix their equivalents in paint. Certain greens can be obtained by mixing from a limited palette, and also some brighter ones can be obtained directly from tubes. Of the mixed greens, the warmer ones arise when you mix cadmium yellow with any of the blues, the richest and "greenest" being made from Prussian blue. Cerulean gives a clean, pale green, still warm, although with a hint of blue. Lamp black and Payne's grey also give warm greens; they are slightly brownish without being muddy. The greens obtained from a combination of lemon yellow with blue, black or gray are all much cooler and bluer than a cadmium yellow mixture. Yellow governs the warmth or coolness of green.

BELOW: The Hawthorn Tree by Jo Skinner, pastel, 24 x 15 inches. Very rapid drawing, almost scribbling with the pastel sticks, helps to create the impression of the leaves and grasses flickering in the breeze. Notice the colors in the tree: the artist has used a foundation of dark green (perhaps a dark tint of Hooker's green), followed by ultramarine to emphasize the shadows, and lemon yellow running down the left-hand side. Patches of deep red give warmth and depth to the densest parts of the foliage.

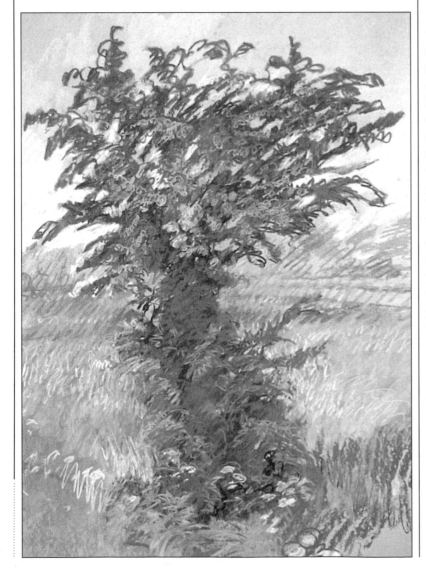

ABOVE AND RIGHT: Shadow patterns are described in different ways in these drawings, in one by distinct color changes, in the other by a tonal scale.

Foliage directly illuminated by the sun will probably need a warm green, whereas a shadow area will call for a cooler one. For a really bright, warm green I recommend cadmium green straight from the tube, but keep the areas small by adding tiny flecks or dabs to give an impression of sparkling, among darker greens. Emerald green is too synthetic for foliage. Chrome green is a warm green similar to that obtained by mixing cadmium yellow and Prussian blue. Viridian and opaque oxide of chromium are both cool bluish greens. I use the former only occasionally, for the very bluest foliage, such as a field of cabbages, or for cool patches of shadow. Do be careful with these two greens as they can easily pervade a picture if over-used. Viridian with cadmium yellow, on the other hand, mixes to a middle-temperature green rather similar to cerulean plus cadmium yellow, but mixed with lemon yellow it gives a strident color similar to emerald green.

SHADOW PATTERNS

Cast shadows are especially illustrative of the way light spreads at different times of day. The strong overhead light of noon creates contained patches of dark shadow closely linked to the subject. Morning light is angled but naturally weaker in intensity, making less emphatic cast shadows, but these are

particularly pronounced in late afternoon, when the angle of the sun is low and dark shadows extend from the objects that create them in strange, distorted shapes.

An atmospheric effect of cast shadows is the dappled light that falls through tree branches and plant growth. This makes a softer, more spreading pattern than the hard–edged shadow silhouettes thrown from individual, solid objects, but it is extremely descriptive, and gives an opportunity to weave rich color effects passing from light tones to dark.

Heavy cast shadows and the substantial modeling of form created by strong, angled light provide a sense of drama. In pictorial terms, the light source may lead in from one side of the picture plane, giving slanted emphases, or it may seem to fall from a high point directly behind the viewer, flattening form and texture in the frontal surface effects but creating pools and receding streams of shadow on the ground plane. The light source may be located behind the central objects of focus, creating a dramatic backlit effect in which outlines are "haloed," and surface details thrown into deep shade.

ABOVE AND RIGHT:
Cast shadows on the ground form linear patterns in these two tree studies, both treated with a tonal range of emphatic contrast.

BELOW: *A sunlit orchard of apple trees in blossom provided attractive inspiration for a pastel and gouache painting by Judy Martin. The lines of the slanted trunks and cast shadows form a pattern of* dark stresses through the high-key colors. The pastel strokes are slashed and scribbled across the watercolor base to suggest the impression of flickering light through the foliage and blossom.

FLOWERS

The pigments that flowers produce are among the most brilliant colors found in nature, and some of these cannot be matched even by synthetic paints. Once you have started to paint flowers, you will soon find that our starter palette is too limited and you will want to try some of the other colors available. Since the manufacturers' names for their paints vary somewhat (see pages 156–7) it is best to ask in your art supply store for the types of color you want.

Sometimes you will be caught unprepared during the course of a painting and will be forced to use the colors you already have. Fortunately there are various illusory devices available to the artist to make colors stand out and sometimes appear brighter than they really are. We saw in the previous chapter how the eye responds to color relationships rather than absolute color, so that it is quite possible to heighten the effect of a painted flower by contrasting it with its immediate surroundings. A neutral gray background will draw the viewer's attention to the colors

RIGHT: *Chrysanthemums by Jo Skinner, pastel, 24 x 33 inches. Here the real flowers are integrated into the pattern of the background, unifying the picture as a colorful whole. The yellow flowers stand out, because they are contrasted with cool blues and violets, the latter being the complementary color to yellow. All the colors look deceptively simple, but a close scrutiny reveals all kinds of unexpected tints and hues.*

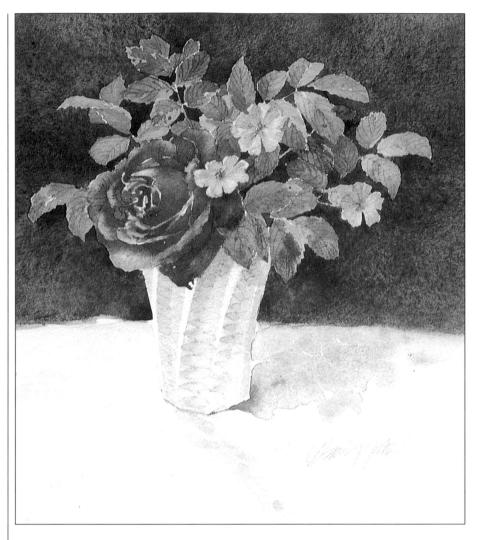

RIGHT: Winter Rose in a Lalique Vase *by David Hutter, watercolor, 12 x 10 inches. The vibrant pinks and yellow-greens in this lovely, delicate painting owe much of their richness to the color of the background, which has been chosen with great care. A neutral but far from characterless gray-brown, it is dark enough to make the flowers and leaves stand out, but not so dark they look like paper cut-outs. The flowers themselves are carefully modeled, and the rose shows a considerable range of both tones and colors, from the pale pink highlights at the edges of the petals to the dark blue-red of the shadows.*

of the flowers, and if the background is dark, the apparent tone of the flowers will be raised, the contrast making them seem brighter than if the background were light. The cooler colors – the blues, grays and blue-greens – tend to recede when contrasted with warmer ones, like red, orange and yellow, so if a red flower is placed in surroundings of a cool color, the flower will make its presence felt by dominating that area of the picture. When complementary colors are placed side by side, they set up a dazzling effect where they meet, and the warmer or paler one of the pair will appear much more brilliant.

Try to keep the colors fresh by not over-mixing, particularly in watercolor. To achieve greater luminosity for painting delicate petals in watercolor, the more transparent the paint the better, as the white paper can reflect through it. Instead of using the more opaque cadmium colors, those

such as permanent yellow, permanent red or vermilion may be a better choice (though vermilion is very expensive). In watercolor, ultramarine and cerulean are less transparent than cobalt or phthalo blue. Cerulean is quite surprisingly opaque, and needs to be handled with some caution. Some of these effects can be found in the accompanying illustrations.

This discussion has centered so far on making paint appear brighter than it really is, but sometimes flowers are actually less colorful than they seem – it is more a case of what we expect than what we really see. Take daffodils, for example. We all know that daffodils are yellow, but when we set about painting them, it comes as a surprise to find that very little yellow paint is needed. A major proportion of the petals turns out to be shades of green and ocher, but a casual glance at the picture still shows us the daffodils as yellow.

ABOVE: *Ian Simpson's watercolor study of a festively decorated interior has a subtle mood of wintry light. The color key is restrained, keeping even the stronger accents of color within a quietly atmospheric range.*

INTERIORS

*I*n any outdoor scene, even in dull weather, there is a relatively strong level of light, whereas interiors have naturally lower light levels. We do not always perceive the dramatic change between indoor and outdoor illumination, as our eyes function perfectly well in the weaker light and we adapt quickly to the relative intensities.

Interiors provide, however, more variety of light and of visual mood, because of the varying qualities of the sources and the ways they occupy the space. On a bright summer's day in the morning, a room with large windows seems flooded with light, but by early evening, it is easy to see the contrast between the direct light from a window area and the much lower light level within the room. By night, the same space will be lit differently, creating pools of light, making the colors, tonal values and modeling of space and form very different.

STRUCTURING

The framework of interior architecture provides a well-defined compositional structure for a drawing. The flat planes and angled junctions of ceiling, walls and floor, together with solid furniture, shelving and other fundamentally geometric forms, create the basic "building blocks" of local color that underpin the more complex effects of color and light. Within these blocks there are additional color details in fabrics, pictures, books, plants, ornaments and so on, and all of these elements may provide a setting for a figure or figures.

Color values contribute their own spatial emphasis to a controlled framework. As we have seen, cool or neutral values have an effect of greater distance than warm or brilliant hues, while high tonal contrasts are more structurally dynamic than close tonal relationships. These are aspects of color interactions that you need to consider both in analyzing your subject and in organizing the relationships within the drawing.

LEFT: *In her print of tulips, Ellen Gilbert mixes hatched lines with washed and textured color. Careful evaluation of reflected colors in the tabletop provides an effect both decorative and highly descriptive.*

In an enclosed space the true distances are small, and you may have the impression of seeing each part of the space with equal clarity, especially as you focus on particular features as you draw them. But this is an area where you must be selective, because if you treat each section of a drawing with the same sharp definition, intensity of color and contrasts of tone, you may find that your drawing gives a confused sense of spatial relationships – the eye has no obvious clues about how to move around or into the image. You need to create a scale of relative values – in color, tone and treatment of form – that indicates points of focus and the links between them, providing the emphases that explain the centers of interest you have found in the subject.

The position, direction and strength of the light source are important cues in creating these focal areas, and can form the basis of visual interest and complexity in the drawn image. You may be particularly attracted by the simple arrangement of shapes and colors in an interior, but you must also consider the

ABOVE: *Daphne Casdagli uses heavy strokes of oil pastel to describe the cast shadow of a window frame forming a checkered pattern of light on the floor. Against the dark brown and purple shadows, she uses delicate streaks of yellow to enhance the highlights. The color range is extended by the little dogs playing in the light on the floor, with contrasts of blue-gray where the light falls on their backs against the warm browns and yellows of the fur on their faces and undersides. The study makes an interesting semi-abstract composition from which the details gradually emerge.*

RIGHT: *In a second study of the same subject, the artist uses watercolor and colored pencil to enhance the color values of the lights and darks. Clear blues and purples offset the yellow patches of light, with the dogs strongly highlighted by splashes of opaque white laid over the drawn color.*

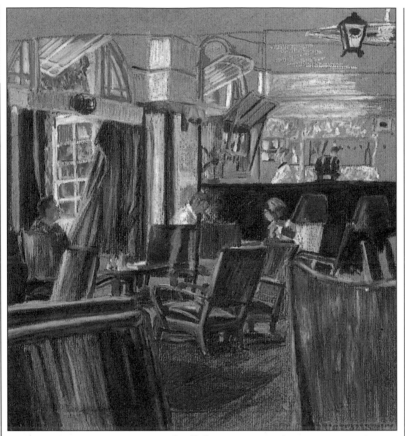

ABOVE: *Ashley Potter's colorful interior, in crayon on buff paper, gives an impression of strong light diffused through the room. Every color accent is played up, creating a sense of space and atmosphere. The light from the windows is emphasized by, for example, the deep blue-purple shadow on the face of the figure at the left and also by the strong yellow and orange highlights on the chairs. The vivid color in the foreground at right suggests a second light source, or possibly reflected light thrown back onto objects within the room from a direction near to the artist's viewpoint.*

way the light acts upon these to create the atmosphere of the scene.

If the illumination is relatively bright and evenly spread, there will be fewer "depth cues," less abrupt variation across the range of color and tonal values. For this reason, artists often choose lighting that provides a more obviously descriptive mood or contrive such an effect by adjusting the normal light levels. Another important factor is that sources of light – windows, a fireplace – naturally form the focal points of an interior and you relate your impression of the whole space to such reference points.

CONCENTRATION OF LIGHT
The most atmospheric effects in interiors are created by having a single concentrated source of light – daylight entering through a window or door or a single lamp giving a more or less focused spread of illumination. Firelight or candlelight, although more difficult to represent effectively, contribute a distinct mood and color-cast to the image. In purely practical terms, remember that if the main source of light is distanced from you, you will also need light to draw by, so you will need to consider how this may affect the

mood of the subject.

Daylight is usually of a cooler kind of illumination than artificial lighting. The clear, brilliant yellows seen in shafts of sunlight are contrasted with blue, gray and sepia tones in shadows. The intensity of the highlights formed by reflection of strong natural light makes it difficult to assess color, but where you see hints of color, the amount of emphasis you give to them should be related to the color values – or neutrality – of the shadow areas. The degree of contrast in light and shade depends on the concentration of light: wintry daylight filtering into a room has a generally lower key and more even tonal balance than strong summer sunshine.

Lamplight and firelight have a warmer character, sometimes even quite strong red and orange tints. Often the spread of concentrated light from such sources is quite limited, but there may be flickering hints of color or soft, warm tones giving depth to the shadow areas. Variations of color in light alter your perception of local colors, so you must carefully analyze the overall color key of the subject.

The direction of a concentrated light source may act to emphasize or even radically change the modeling of form and volume. Sidelighting tends to give angularity to solid forms and intensifies the tonal contrasts that create an effect of volume. Light from overhead reduces the recessional depth of the pictorial space but may emphasize lateral space. A contained pool of lamplight can be used to "pull in" the spatial structure or to offset an impression of vast shadowy spaces surrounding the focal area. The lit shape of a door or window creates a layered framework, indicating the spaces beyond.

Such atmospherical detail works in conjunction with your angle of view into or through an interior. If a frontal view of one wall dominates the compositional frame, the spatial sense is directly related to its apparent distance from you as observer. Angled views that take you into corners or alcoves give a more pronounced feeling of enclosure. A view through, showing a room beyond, a corridor or a door to the outside, progressively opens out the space.

Backlighting objects or figures within the interior by placing them in front of a window or lamps always creates a dramatic mood. You may lose interior detail, other than soft haloing and contouring of the objects, but reducing the amount of visual detail can suggest a more intimate feeling, as it leaves more to the viewer's imagination.

SHADOW PLAY

In interiors, as in landscape, cast shadows can provide particular interest. They can divide up the picture space between light and dark tones, create an alternative rhythm of new shapes or throw a more complex variety into the modeling of solid forms. Shadows may contribute counterbalances of weight and direction in the color relationships or simply create a decorative effect of patterning.

A very basic but surprisingly effective form of shadow is the grid-like pattern of a window frame running at a distorted angle on the floor where the shadow is cast by natural light from outside the window. This idea of using shadow to set up alternative movement and direction within the framework of the composition can be elaborated if there are such elements as trailing houseplants at the window, a slatted blind or boldly figured lace curtain. These things create linear pattern elements and also an interesting tonal counterpoint of rapid changes between light and dark areas.

Concentrated sources of artificial light throw shadows onto walls and floor, echoing the shapes of solid objects within the room. A similar and more complex effect comes from cast shadows falling from one object onto another. This complicates the interactions of shapes and color values, sometimes giving more emphasis to repeated shapes and sometimes disguising the reality of the subject by the almost arbitrary relationships between cast shadows and the tonal gradations that model form.

It is natural to think of such effects of light and shade broadly in terms of tonal rather than color values, and you must remember to look for the color accents and influences and relate your drawing techniques and choice of materials to the development of these elements.

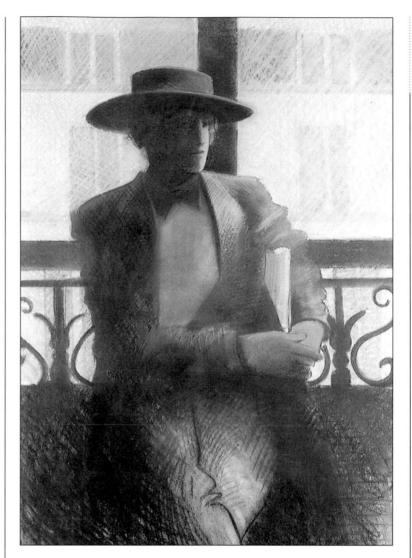

ABOVE: *Adrian George makes an effective tonal study in pastel which is alive with subtle color accents. The solid darks are laid in with blended or slightly* broken color, then overlaid with vigorous hatching. The light tones are worked in the same way on the figure, but to define the plane of the window behind, the artist has built a complex network of crisscrossed marks which throw the dark figure into relief.

WINDOWS

When you look at a view through a window, are you conscious of the window glass? Do you notice it as a material plane, or do you ignore its substance, as if it were simply a hole through the wall that enables you to see the outside world? It is most likely that you only take account of the window pane as a thing in itself when it reacts with some other element – raindrops on the glass or reflections thrown back into the room at night. More prosaically, you notice the glass if it needs cleaning because it interferes with the view.

THE ARTIST'S EYE
INTERIOR LIGHT

Compared to outdoor light, the light sources within an interior are more readily controlled by the artist, although it is often a chance effect of daylight entering a room that provides the idea for an effective composition. However, there can be great variety in the color quality and intensity of the light depending on whether it comes from a natural or artificial source.

Whereas you may have strong natural light at a window, the level falls quickly further into the room. In two studies here (far right), the artist describes the brilliant light from a large window complemented by a smaller pool of lamplight focused on the shadowed work area. These provide interesting patterns of light and shade enhanced in one case by the central force of the window frame, in the other by the slatted blind drawn down over the window.

Smaller studies (top right) deal with the enclosing effect of concentrated lamplight, which draws in the space of the room and creates a warm glow. This effect has been interpreted in loose watercolor washes overlaid with crayon and pencil work, and in a colored pencil rendering with an atmospheric grainy texture.

The linear pattern of the louvered blind is exploited in the third small study (bottom right) and its effect in highlighting the objects standing in front of the window.

THE HUMAN FORM

What color is skin? The answer is that no two skins are alike, even within the same ethnic group. A "white" person can be ruddy complexioned or sallow; a "black" person can be pale golden, rich brown or almost blue-black. As skin folds or stretches or goes around corners, its color changes also. Look at your own hand and see this for yourself. From a variegated pattern of warm and cool pinks on the palm, the colors change to a completely different set on the back, from the loose, folded skin of the knuckles to the tighter skin of the fingertips.

There are various paints on the market called flesh tints, pinkish colors which are supposed to resemble the color of white (caucasian) skin. These are best avoided, since they seldom coincide with the colors of real skin, and an additional danger is that all the colors in one painting will tend to be too similar and hence lifeless. With suitable mixing you can quickly match many of the colors of white skin. Addition of a little ultramarine or violet makes cool colors. Additions of reds, ocher, burnt umber or burnt sienna make warmer colors. Instead of starting with, and diverging from, one color, it is always better to try to converge on a range of skin tones by mixing a few widely different paints. There is one version of a commercial "flesh tint" which can be matched exactly in oils by mixing roughly equal quantities of white, alizarin crimson and yellow ocher with a tiny bit of cadmium red. By starting with these colors and mixing them in different proportions, a far more interesting range of skin tones can be created. There could be a mixture of white, Naples yellow (a very useful color here) or ocher, burnt sienna and raw sienna, adding touches of cobalt blue, crimson or violet to obtain the exact color required.

The colors of each individual's skin depend on many different factors, but degree of pigmentation is the cause of its overall appearance. This depends both on race and on the amount of exposure to the sun. The painter must observe not only the color relationships between the different areas of one body, but also the relationship of these colors to the surroundings. A lightly sun-tanned skin will appear a warmer overall color in relation to the surroundings than will a pale, cooler skin. This will affect the proportions of the warm and cool paints used to mix the colors: cadmium red and yellow ocher are warm colors; cobalt blue, Payne's grey and viridian are cool. A black skin may at first glance appear to be variations on raw umber; indeed, it is possible to mix most of the colors you need by adding to this either warm ochers or reds or cool blues and greens. Again it is preferable to obtain the various – and far more interesting – browns by mixing reds, blues and greens (cadmium red, ultramarine and viridian) with yellow ocher.

Stretched skin, such as that on the forehead, tends to be pale and cool, while loose or wrinkled skin is usually darker but warmer. Skin is sometimes shiny, particularly on the forehead and nose, where

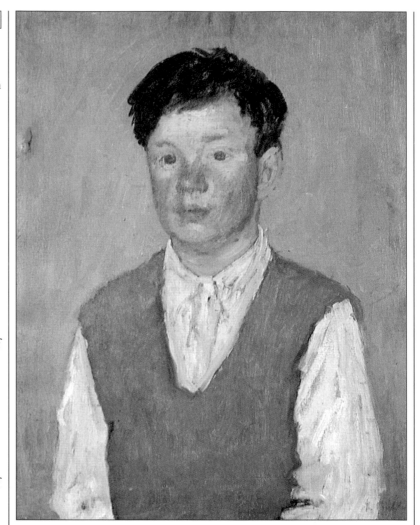

ABOVE: Portrait of Patrick Gould *by Robert Buhler, oil, 20 x 24 inches. Underpainting in thin ochers and umbers can still be seen in the finished painting. The artist has chosen this warm, golden color for the underpainting because it echoes the colors in the face, and the small patches which have been allowed to show through the greenish-gray of the background create a harmonious whole. The skin itself is given color with thicker paint in pinks, dull reds and dusty yellows, with gray-blue describing the shadows under the jaw and in the folds of the ear.*

there are often reflected highlights. These tend to be pale and cool, often with a marked bluish tinge, varying according to the light source being reflected, which mix with the "actual" color of the skin. On a dark skin they contrast sharply; on a pale skin they are less obvious, but arc still just as important.

Skin varies in transparency, so its color is partly determined by the amount of blood showing through. It may be thin and transparent on the face, particularly the nose and lips, or rough and opaque on the back of the hand. Stretching of the skin squeezes underlying blood away so the color pales – the skin over a clenched fist is an example. Veins underlying the skin will appear bluish, for instance on the temples and neck, and a man's face may have a bluish shadow where it has been clean-shaven. In the true shadows, you may see a variety of purples, blue-grays and cool browns, which can be made by mixing white and raw umber with the necessary amounts of violet or ultramarine.

In acrylics, glazing is an effective method of gradually building up the colors on the painting itself by adding layer upon layer of thin paint washes. As long as the white ground continucs to show through, thc paint will retain a certain luminosity appropriate to the rendering of skin. The same is true for washes in watercolor, although the fewer used the better, otherwise the paint looks overworked and muddy. You could try partial mixing – keeping little patches of unmixed color lying mosaic-like over the surface. An effective way of breaking up color is to add little dabs of one color (say a cool, bluish "skin tone") over another, warmer one, or vice versa. Pastels lend themselves to broken color, since it is difficult to use them in any other way, and are thus excellent for suggesting the vibrant luminosity of skin.

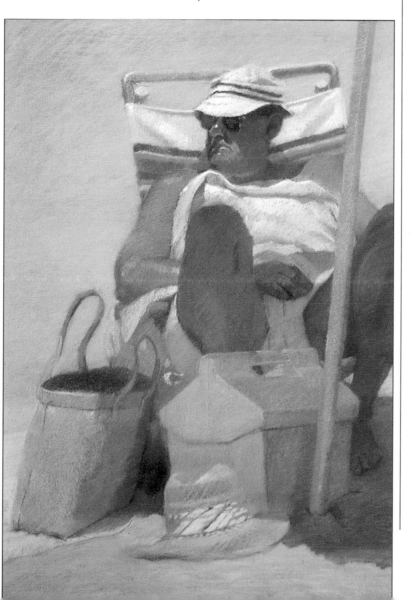

RIGHT: Beach Series Number 5 *by Sally Strand, pastel, 24 x 36 inches. People at leisure, in informal poses such as this, are the artist's special interest, and she observes and paints the colors of skin and clothing with both daring and accuracy. A wide range of hues has been used for the color in the man's sunburned skin, from deep pinks, mauves and reds on the legs and shadowed side of the face, through the more conventional "flesh pink" of the shoulders to the brilliant cherry red of the nose. We can almost feel the heat of the sun.*

THE ARTIST'S EYE
LIFE STUDIES

Drawing the human figure has been a basic discipline of art training for centuries and is still regarded as a uniquely important skill. No other single subject presents such complexity of form and surface. The life model provides a versatile structure – a simple change of pose confronts the artist with a completely new set of relationships of form, light and shade, surface texture, and color values.

Perhaps because of the academic associations, students do not always find it easy to discover something new and exciting in life drawing. These examples show how color can give a startling new vitality to this established discipline, and a fresh modern character to the resulting images.

There are two basic approaches to life drawing in color. One is to select a color range that can be used as an equivalent for the tonal scale. In this way, the figure is "modeled" with light and shade in the traditional manner, but using color relationships. Alternatively, existing hints of color in the flesh tones and lights and shades can be pulled out and emphasized, developing expressive color interactions. A strong paper color helps you to make an emphatic visual statement.

The standing and reclining figures also display a remarkably sensitive quality of line drawing that derives quite naturally from the fluid contours of the human body.

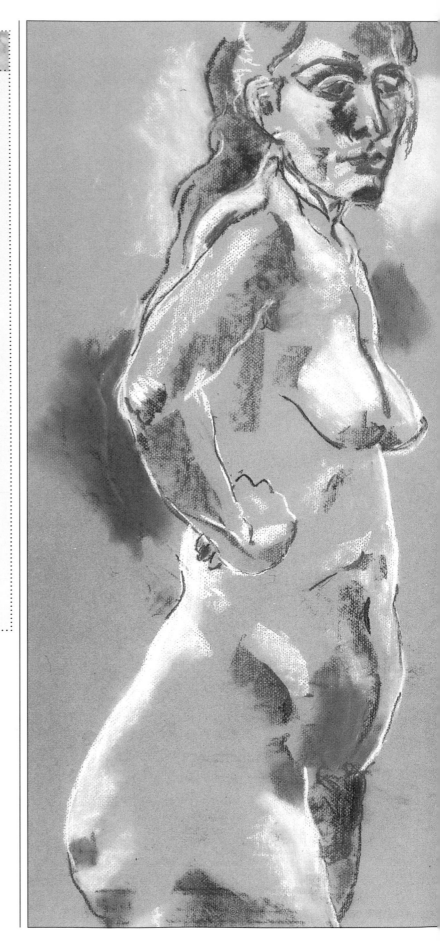

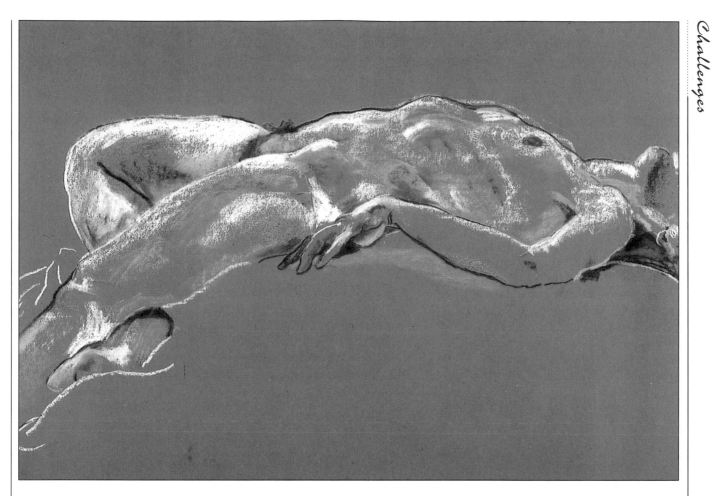

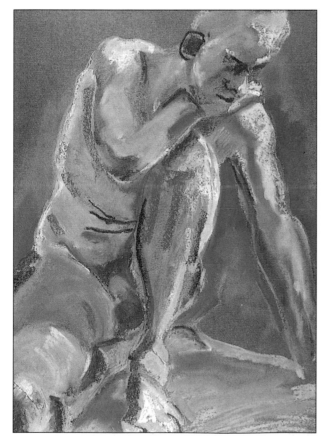

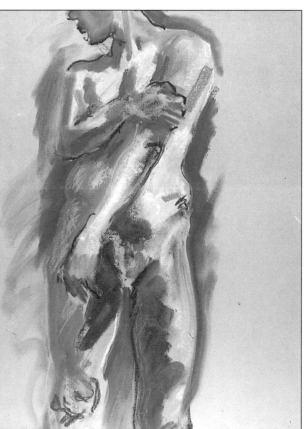

MOVEMENT

*M*any drawings have a sense of movement that comes from the movement of your hand as you make marks with the drawing tools. Certain subjects naturally suggest mobility – notably human figures and animals – that can lend a dynamic force to the drawing even when the model is in a static pose. The problems of rendering actual movement – as of a figure crossing a room, dancing, or performing any definite action – have been tackled in various ways by different artists. There are a number of visual conventions which you can use to convey a sense of movement, depending on the context suggested by the subject and the qualities of picture surface you want to achieve.

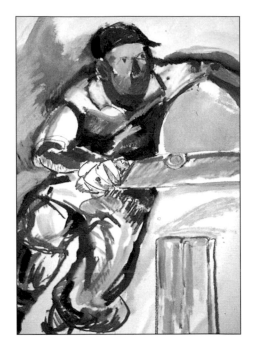

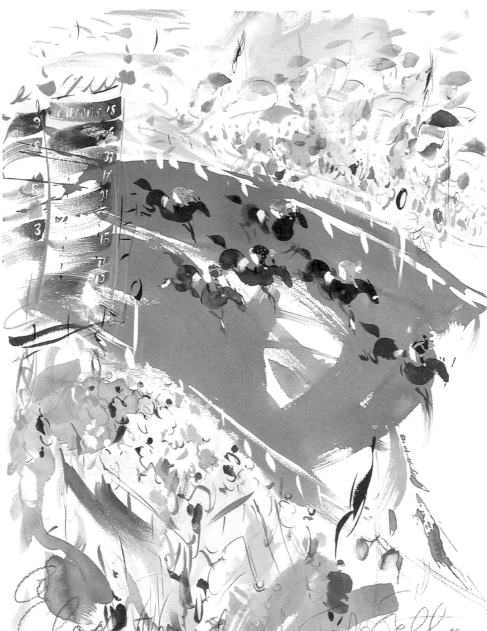

ABOVE: *Linda Kitson precisely conveys the sudden spurt of energy of a cricketer breaking into a run. The forward thrust of the pose is captured in the vigorously brushed line, the shifting weight of the body emphasized by the transitions through heavy patches of dark and light color. The whole image is given its sense of speed and energy by the loose brush drawing technique.*

LEFT: *Jake Sutton's watercolor relays the excitement of a crowded race track as the race nears its finish. The horses and riders are just vivid dashes of color leading through the image, the busy activity of the crowd merely suggested, but these elements are so aptly though minimally described, the whole impression is remarkably illustrative of the atmosphere.*

The visual attraction of movement is its quickness and fluidity – the choreographed rhythms of a dancer, the accidental grace of a cat washing itself, the constantly changing patterns of people walking along a busy street. If you could slow these things down enough to see what is really going on, the unique, attractive characteristic of the activity would already be lost.

Making a drawing of a subject in motion is a matter of memory as well as observation, since even as you begin to mark down what you see, the subject has moved on. This changeability is confusing. You have to develop an almost instinctive process of allowing the evidence of your eyes to be translated easily into drawn marks. In this way you form the solution directly by the activity of drawing not by thinking about how to draw. One way of breaking yourself in more slowly to this process is to ask someone to model repeated movements for

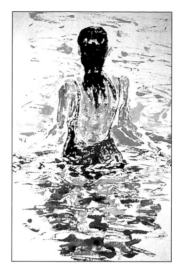

BELOW: *The movement in this pose is given emphasis by the way the light and dark contrasts are blocked across the squared shape created by the bending figure with arm outstretched. A more fluid rhythm is set up along the curving patterns of the striped towels, and Sally Strand takes the opportunity to introduce vivid color accents, offsetting the warm flesh tints and neutral background tone.*

ABOVE: *Pauline Turney uses the rippling quality of printed-off color to capture the image of a swimmer breaking surface. White patches flickering through the colors highlight the wet figure and its reflection on the water.*

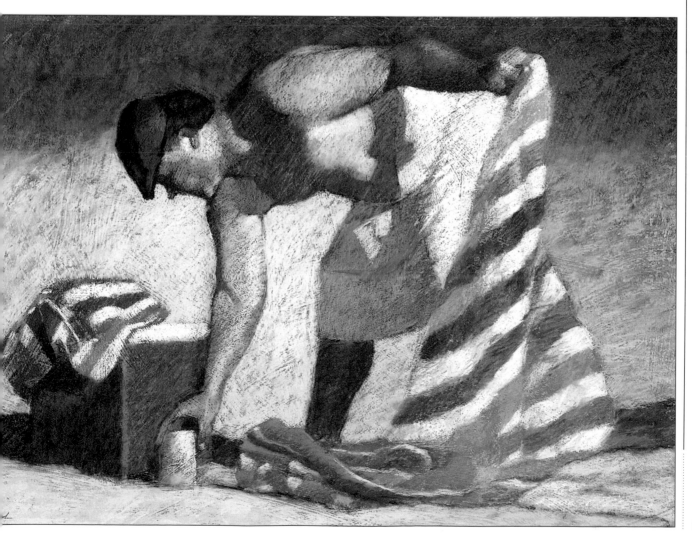

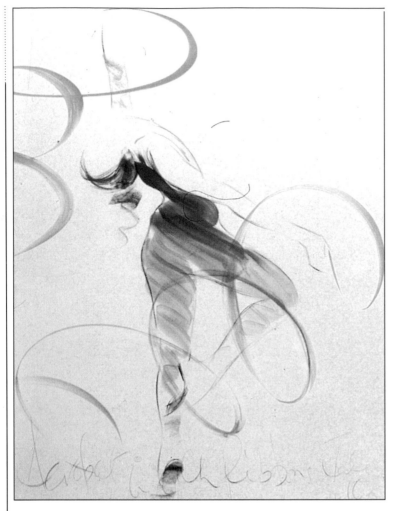

ABOVE: *Jake Sutton picks out the essence of acrobatic movement in a single figure study. He chooses the most expressive lines of the figure and uses these as the central axis of the image. The whirling ribbons flying out in all directions suggest a continuous motion of which this image represents only one split-second element. By simplifying the form of the figure, he produces an anonymous but entirely characteristic portrayal of the acrobat.*

you, so that you gain a sense of the patterns of line and form of which the motion is composed. Animals tend to make repetitive movements, though sometimes you have to wait a while for the same sequence to occur again. Confined animals often follow set patterns of movement, so if you don't object to the ambience, the zoo can be a useful place for studied observation of moving forms.

Because it is difficult to track movement visually, it is tempting to use photography to "freeze" the motion – but freeze is exactly what it does, and although photographs can make useful reference, they are not a solution to this problem. Serial images, such as the famous sequences of human and animal motion produced over a century ago by photographer Eadweard Muybridge, give information about stages of movement. But there is still the question of how to interpret a series of still images in a way that describes the whole motion pictorially. One way is to "telescope" the movements into a series of connected or overlapping forms.

It is often useful to create a framework for the drawing within which you can plot moving elements of the image and play them off against fixed reference points, including vertical and horizontal stresses. The flat planes of the walls and floor in a room, for example, form a natural "grid" for plotting the way a figure moves within the space.

LINEAR MOVEMENT

The calligraphic quality of line drawing is particularly appropriate to rendering movement. Sometimes you can obtain a vivid impression of mobility from a simple outline. An important feature of modern calligraphy is an emphasis on variations between thick and thin line (think of the fluid quality of italic handwriting) but this is also a useful device in drawing. The qualities of a line that alternately swells and tapers as it traces out a form suggest a changing balance of weight and direction that implies movement.

The technique described as "nervous" line, or repeated lines, takes a different approach, using broken lines or interwoven tracings to sketch out the form. This sort of technique successfully conveys limited movement – the gradual shifts of position of a seated person relaxing in a chair, small hand and arm movements made during conversation, and so on. It can also set up rhythms and tensions in the drawing that could be used in illustrating athletic or dance movements. Another linear technique that produces interesting results employs dashes and scribbled marks to build up a sense of mass and movement.

In all these techniques, color qualities can also be exploited to add to the sense of weight and direction in the image. A strong color, such as a bright red or blue, gives more dynamic emphasis than a lighter yellow, say, or a subtle mixed hue. In linear drawing of movement, the figurative color values of the subject can be subordinated to a more abstract sense of color that gives the drawing its own vitality. Colored lines crossing or running into each other where shapes are formed relating to different elements of the subject strengthen the internal rhythms of the drawing.

DIRECTION AND MASS

A composition depicting two or more figures offers the opportunity to introduce movement by setting up directional tensions between the figures. You might place them in such a way that the pattern of their bodies and limbs forms a series of flowing curves leading a viewer's eyes around the image. They could be angled to create oppositions.

Ideas of movement based on arranging the composition to convey action can be worked out in quick sketches. Brush drawing is a particularly useful technique for describing motion in this way, because of the fluid line and medium. Another device is to offset sharp-focus rendering against softer, even slightly blurred areas of the image, and contrast directional marks with solidly weighted shapes. This is particularly useful for including a sense of movement within the broad framework of an image – a street or beach scene, for examples, which combines static elements with subjects in motion. An architectural background composed of geometric blocks is a very effective foil for directional movement.

To convey the sense of movement in the drawing is thus a matter of technical variation. When working with pastels, crayons or colored pencils, you can rub the colors with your fingers, "draw negatively" with an eraser into the colored marks, or spread the color with a solvent to soften and vary the drawn textures. If using paint, you can apply soft washes or use dry-brush techniques as well as calligraphic movements of the brush tip to develop the complexity of the forms.

ABOVE: *Gestural drawing is frequently used to describe figures in action. The rhythmical brushstrokes in this drawing not only capture the movement of the cellist but also express the pulse of the music.*

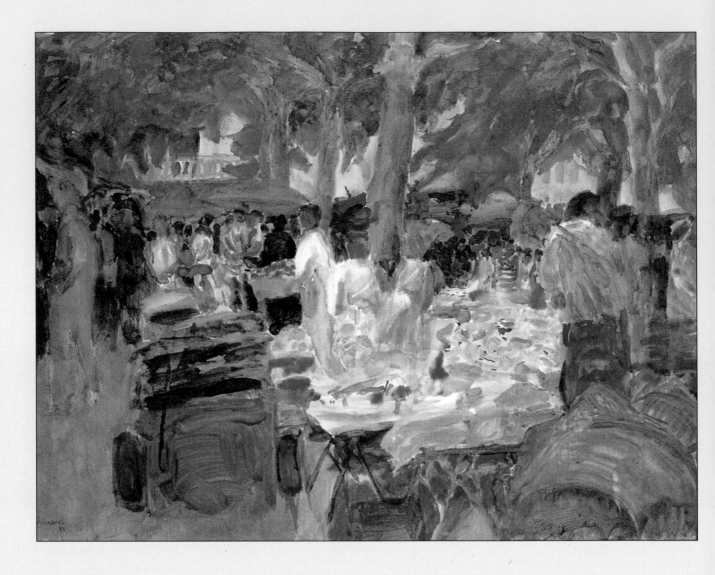

THE PERSONAL
STATEMENT

"*How do you see this tree? Is it really green? Use green then, the most beautiful green on your palette. And that shadow, rather blue? Don't be afraid to make it as blue as possible.*" This remark, attributed to Paul Gauguin, was astonishingly bold for its time. Even now we can appreciate it as an encouragement to release the sensations of color from strict boundaries of "realism." It is also important to understand that Gauguin was not endorsing a purely abstract use of color, but suggesting that a different kind of realism was to be found through artists allowing their perceptions of color to be felt and expressed uninhibitedly.

BELOW: *A color sketch of a fallen tree in pencil, gouache and watercolor, catches the strong balance of form and color by emphasizing tonal contrast but also introducing many subtle color accents. Working on a neutral-toned paper, Kate Gwynn gradually develops the range of hue and tone, using the buff background tone and application of neutral grays as a foil for strong touches of color, such as the vivid light mauve interspersed with greens and yellows through foreground and background. The bold use of pure black gives the image structure and impact.*

As a method for developing a personally expressive approach to color work, Gauguin's philosophy is a useful model. It is a way of putting yourself and your responses to color into your drawing without going so far as inventing a personalized language of color. It provides the opportunity to allow yourself a bold statement that has a referential framework. You can find what interests you most about a subject and focus on that element, then exaggerate it. This principle can be applied to all the different aspects of color already discussed – the relationships of pure hues and tonal values, color accents, surface detail and the color key of your drawing.

All drawing is a contrivance – if your only purpose was to reproduce a picture of a subject, you could simply take a color photograph. It is the choices and interventions that have to be made in translating real objects into a drawn image that motivate the activity. There are, however, degrees of objectivity; also within your range of decisions about picture-

ABOVE: *This simple symmetrical image isolates the form of a flowering tree and reinterprets its colorful effect in terms of abstract dabs and dashes of bright gouache color. Judy Martin later developed this idea into a series of fully abstract paintings.*

making are methods of deliberate manipulation that, in giving mood, drama or emphasis, represent the kind of reality you have seen in the subject.

ADJUSTING THE COLOR BALANCE

The colors and tones in a drawing or painting give body to the structure of the image. In representational work you are most concerned with how the real color values contribute to the illusion of form and space, with identifying and recording them in what appears to be a "correct" relation. At a certain point, however, your attention is also taken by the internal dynamics of the drawing and how it works within specific parameters. A drawing is a record of something you have seen and of the process by which you have described it. You may find that you want to focus more on working up the balance of the image in its own terms, if necessary allowing it to become somewaht detached from its model

in the real world so that it can be developed more strongly in terms of the drawing processes.

This may involve adjusting the emphasis of both the color values and the gestural quality of the marks you have used to convey those values. Take as an example a subject that has a basic solidity and static form and a naturally controlled color key, such as a townscape view containing blocks of neutral color and relatively muted hues. You may render this quite faithfully in terms of what you see, but then find that the drawing is lacking in some way – perhaps it fails to catch some quality of light or color accent that would give it more life. You then need to study it more closely to see whether there are hints of color that could be played up, whether the apparent "flatness" of walls, streets and sidewalks could be given some

ABOVE: *A gouache figure study by Stan Smith uses the strong shafts of light falling through a slatted blind as a semi-abstract pattern of pale tone across the shadowy form and interior. The two elements work together because both are loosely defined, developing the mood of the image rather than its descriptive aspects.*

LEFT: *Kate Gwynn takes a calculated risk in slashing the vivid red of the glider wings right across the width of the image, but this contrasts well with the muted colors below.*

ABOVE: *An abstracted landscape in mixed media by Vincent Milne spreads a dominant block of yellow over more than half of the picture area. The slanted horizon line gives subtlety to a basically simple composition and the heavy paint and pastel textures activate the surface.*

internal activity, perhaps simply in terms of a more vigorous approach to mark-making within the drawing. Adjusting the balance of line and mass may activate the image, especially if the color stresses are rhythmically linked between the two elements. It is possible to give quite strong emphasis to such surface qualities in a drawing without losing the coherent sense of structure that is also a crucial part of such a subject.

Adjusting the balance of color and tonal values may also provide a more dynamic overall impression of the subject. A drawing that turns out rather flat – a still life that loses the distinctiveness of the forms or a landscape without sufficient sense of distance – might be enlivened by alterations to the tonal key. Perhaps the darks need to be made darker, the highlights more vivid; or perhaps the middle register of tonal values needs more definition and contrast. Alternatively, you might find that a more dramatic mood is created by limiting the color values, by

making a very strong statement using a restricted color range that complements the subject.

DOMINANT COLOR

A powerful effect of color intensity comes from allowing a single color to dominate the drawing. There is a natural "overbalance" of color type in some subjects – greens in landscape being perhaps the most obvious example. In an interior, warm reds, yellows or oranges or, alternatively, cooler blue and purple hues may occur due to the lower light levels and the particular quality of a natural or artificial light source. These naturally created color biases help to set the mood or key of an image.

The idea of allowing one color to dominate has been exploited by artists from Van Gogh on to produce both expressionistic and abstracted imagery. There are ways of using close tonal values and strong color intensity that redefine the sense of form. In a drawing with a contained

sense of space, such as a small interior or a figure study, the sense of closeness created by the broad spread of a single, dense color value can contribute particularly effectively to the interpretation of the subject.

This approach can be exploited with any color by selecting a few closely matched tones. Using a wider variety of hues and tonal values of a single color, or a couple of related colors, you can create more emphatic modeling and play up qualities of light and shade while maintaining an overall color character.

There are two main ways of employing a dominant color. One is to block in solid areas of close-toned color values to form the basic ground of the image, and the other is to interweave lots of hues and tones of the same color family to create a very busy surface texture that reads as solid form. A good way of trying out the effect of a composition expressed in terms of a single dominant color is to choose a piece of strongly colored paper and work mainly with line and calligraphic linear marks, in color, to sketch in basic detail of contours, highlights and deep shadows. Apply this technique to picking out essentials of form and definition, allowing the color of the paper to hold the main balance of the image. This will give an overall impression of the color balance without requiring a lot of time-consuming work in building a colored ground with drawing materials. You can use scraps of paper to create color thumbnail sketches, too, to try the different effect of each color from a given range.

BELOW: *Natural subjects such as fruit and flowers invariably contain their own color harmonies. In assembling a still life, the artist can choose to extend or counterpoint the natural color range. Jane Strother makes a strong composition by contrasting the warm, pale color of the grapes with rich dark tones.*

HARMONY AND DISCORD

*A*s you gain experience of color interactions, you may wish to manipulate the relationships to give more emphasis to the effects of harmony or contrast. Look back to the color wheel on page 16 and identify the harmonies between adjacent colors on the wheel and the tonal variations within individual hues. You will also be able to see the potential for clashes and contrasts between colors that are not similar in hue or tone. Thinking of the abstract relationships of colors may stimulate ideas for stressing different aspects of their interactions that will increase the harmonies or develop color tensions in your drawings.

It is also useful to look at paintings and at the color schemes and combinations in designed objects, such as fabrics and ceramics. These provide information about other people's experiences of color

ABOVE: *The relationship of colors within a composition can significantly alter the balance of the image, and is itself dependent on the quality of color and* *texture in the drawing medium. Quick pastel sketches are used here to try out varied densities of color and tone in a simple still life.*

relationships and the ways they have used them to demonstrate the physical, decorative and abstract properties of color. Because these are finished statements, contrived to answer the requirements of a particular context, they are directly instructive. You should not feel hesitant about borrowing someone else's solution if you can make it work for you in specific terms. Remember, however, that the artist has put deliberate thought and intention into creating his or her own color expression, and this deserves a thoughtful response, which will enable you to decide how that experience may serve your own intentions.

Natural color schemes are a valuable source of interesting and sometimes unexpected color combinations – the muted hues of weathered stonework, the brilliant variations of color in garden plants and

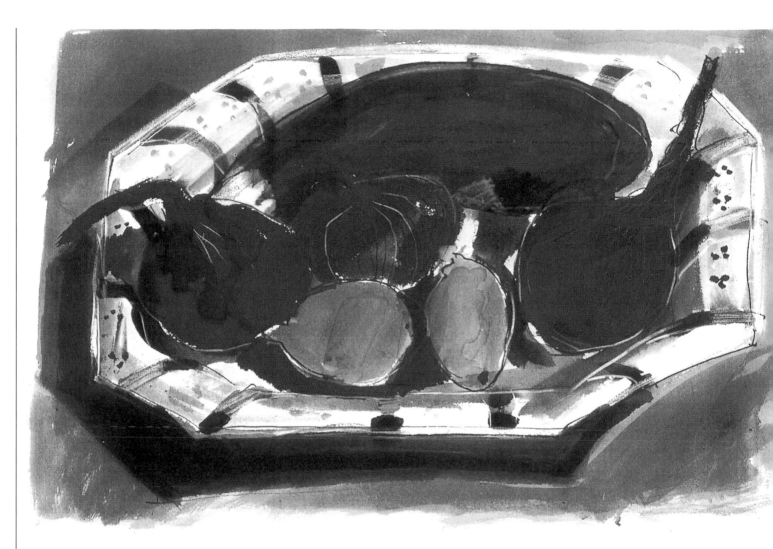

flowers, the related moods of landscape and sky showing peculiar luminosities and tonal contrasts. You will probably use these elements to describe the objects themselves, but you can also extract from them a more general sense of color relationships that can be adapted to other subjects. In this way you will introduce a lively sense of invention, but one that still has a basis in reality.

We tend to seek harmony almost instinctively; the relationships of pure hues and the balance of lights and darks are elements we naturally wish to organize harmoniously. In drawing, we do this by making links between colors in different areas of the picture; by using a line of pure color to balance a heavy mass of color and tone; by shading blues into blue-greens, yellows into oranges, softening any harsh edges between unrelated tones and colors. We can also see, though, how strong, well-defined touches of contrast can emphasize

the more fluid gradations of color and tone, and this is a way of devising a balance that creates harmony.

It is surprisingly difficult to strike a discordant note in color work, not only because our instinct is to create a pleasing balance, but also because we are very tolerant of even quite extreme interactions within unusual color combinations. The world is very colorful, and much of the color information we absorb daily, almost without thought, is designed to be eye-catching and stimulating – particularly in consumer packaging, advertising and media design. This has given us a sophisticated familiarity with color that subtly acts upon our own approaches to using it in image-making. There is also a purely subjective aspect to color preferences, one person's idea of a harmonious combination of colors sometimes seeming strange and unpleasing to another.

The concept of discordant color therefore lies more in trying to strike an unexpected note in a given context than in identifying forms of color behavior that would create a sense of harshness or unease. Reversing tonal values is one such possibility – a brilliant light value in purple shadow on a rich dark red, for example, or tiny touches of intense mid-blue enhancing the brilliance of warm golds and yellows in a mixed hue. Also the interplay of warm and cool colors could be employed in the purple-red contrast by setting a pale blue-purple against vermilion, but also by playing a light mauve-pink against a cold bluish-red.

The texture and shape of the drawn marks also contribute to the type of color interaction that a combination of individual hues will seem to make. If you place a vivid scribble of one color on a flat ground of another color, the effect is slightly different according to whether you use a fluid, curving motion or a jagged, broken line. Similarly, the quantity of one color against another has an influence. Try, for example, making the curved or jagged scribbles first in a pale color on a dark ground, then in the reverse color relation. Such elements are components of a descriptive mood, affecting our sensations of color values.

LEFT: Diane's Pink Gown *by Doug Dawson, pastel, 15 x 18½ inches. The most obvious way to create harmony in a painting is to use cool or pale colors, but here all the colors are bright and hot – almost clashing. But the picture works beautifully, first because all the reds, pinks and browns are closely related, and second because the tones have been very carefully controlled. Notice the bright pink highlights on the shadowed left arm and shoulder, which separate the deep pink from the red-brown of the door. The blue of the curtain and the paler blue of the sky seen through the window have been "tied" to the rest of the picture by areas of pink repeated from the dress.*

CREATING A MOOD

*M*any of the projects and examples of finished works illustrated in previous chapters have included a sense of mood and atmosphere, as well as conveying the more straightforwardly descriptive qualities of the subject. This demonstrates that the mood of an image is not a separate element to be integrated with the form of the composition, but is already potentially there in each aspect of the color work in a drawing. A relatively simple way to create a

BELOW: *There is a tranquil mood to this watercolor sketch by Ian Ribbons, deriving partly from the gentle color influences conveying clear light, partly from the frontal view of the subject which makes the main axis of the composition divide the image area horizontally.*

RIGHT: *Sally Strand allows the mood of her chosen subject to speak for itself, by focusing on the undisturbed self-absorption of a mother and her sleeping child. The gentle atmosphere is enhanced by depicting both faces in shadow against the strong summery light woven across the skin tones and beachwear of the figures.*

sense of drama is to exaggerate the inherent qualities of an ordinary scene by heightening tonal contrasts, intensifying color values, giving some shapes and forms a more powerful presence than others. Any such methods of creating an unexpected imbalance in the weights, textures and rhythms of the drawing seize the viewer's attention in a way that a harmonious and completely balanced image does not.

It is worthwhile pointing out the obvious here – that certain subjects have a particularly striking mood or atmosphere that any successful drawing must convey. A street market, for example, is a colorful and active subject, so there is no point in trying to devise a way of representing it more subtly. But you might choose to play up the activity by, for example, stressing the vividness of the color relationships and allowing free rein to the calligraphic qualities of your drawing technique. There are also

RIGHT: *David Bomberg's pastel radiates shimmering light, the sense of form and space emerging subtly from the masses of grainy color. The mood and tone are set by the warm color of the paper, the pastel work maintaining a high key overall.*

occasions when you might wish to counterpoint the mood that a subject seems to suggest by altering its emphasis. An open landscape, for example, generally has a peaceable atmosphere, but if you were to depict it with a deep blue-gray sky threatening stormy weather instead of a clear, sunny one, the whole scene would have a quite different mood.

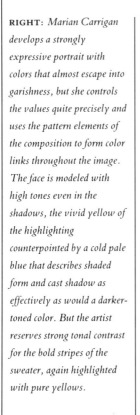

RIGHT: *Marian Carrigan develops a strongly expressive portrait with colors that almost escape into garishness, but she controls the values quite precisely and uses the pattern elements of the composition to form color links throughout the image. The face is modeled with high tones even in the shadows, the vivid yellow of the highlighting counterpointed by a cold pale blue that describes shaded form and cast shadow as effectively as would a darker-toned color. But the artist reserves strong tonal contrast for the bold stripes of the sweater, again highlighted with pure yellows.*

Qualities of mood are also rather subjective, and no single color quality or technique works in only one particular way. Active mark-making, such as hatching or scribbling, will in one context enhance the energy conveyed by the subject, but in a different context may create a relatively coherent surface texture. The following are some general principles and suggestions for developing mood and atmosphere in color drawing, but take time also to study the illustrations throughout this book and analyse how the mood of any particular image is made to work in terms of overall composition, the color detail and the drawing technique.

COLOR INTENSITY

Pure hues with high color intensity have an exciting, active visual quality. This has been notably used in expressionistic styles of drawing and painting, where strong color values are often emphasized to create a more emotive image. In a portrait or figure drawing, for example, playing up the accents of strong color creates a more aggressive or dynamic representation than a naturalistic rendering of subtle skin tints and hints of reflected color.

WARM AND COOL CONTRASTS

Warm colors tend to have more vitality and seem nearer to the view than cool colors, which by comparison are passive and recessive. As in the open spatial quality of landscape, blues and greens in an interior view are less enveloping than hot reds and oranges. Remember, however, that these are relative color qualities and dependent on the interactions of hues and tones.

COLOR KEYS

High-key schemes of color can suggest a cheerful or expansive mood. Low-key treatments more suitably correspond to a sober, melancholic or threatening atmosphere. This aspect of color moods is particularly related to color intensity and the degree of tonal contrast. The inertia of some dense pure hues or dark values of particular colors can give a comfortable sense of quietness to a low-key color range where these values predominate.

TONAL CONTRAST

The different ways of emphasizing tonal contrast to create mood depend upon relative areas of light and dark values. You can develop a mysterious mood by suffusing a drawing with darkness, offset against a single focal area of light, such as a window, lamp or open door. In this context, shadow areas can be made richly colorful because they play a major role. Or you can weave a complex pattern of light and shade which suggests a particular time of day or a languid or active mood. Cast shadows creating a linear pattern need to be carefully looked at for the edge qualities between tonal changes, the definition of interlocking shapes and the relative color values.

SURFACE QUALITIES

Both the color relationships and the physical quality of drawn marks activate the surface area of a drawing. Bright colors and vigorous linear drawing have a more dynamic presence than softly gradated shading of blended hues. These elements can be manipulated to enhance a "loud" or "quiet" atmosphere, developing the sense of energy and aggression or gentle calm in the overall mood.

POINTS OF REFERENCE

Focal points are created in terms of both the compositional structure of the drawing and the particular areas of interest within the subject. An accent or patch of strong color among neutral or dark ones naturally draws the eye. In a similar way, a figure within an interior or landscape is a point of identification for the viewer. These two

LEFT: *Ian Ribbons chooses a sombre palette for his ink and watercolour sketch of polo players. The turbulence of the action is expressed through vigorous line work overlaid with loosely brushed colour. The dark tones concentrate the focus of the image around the knot of horsemen.*

aspects of image-making can be made to work together, for instance by giving the figure the most colorful presence in the drawing or by setting up an intriguing opposition, putting the figure in shadow.

TESTING SENSATIONS

You can establish ways of conveying different moods in a subject by making a series of sketches or quick drawings. In these, you can make adjustments to the color key, tonal relationships and compositional balance of the image, also using different drawing techniques to suit the impression you want to create. As this is a basically interpretive area of drawing, it is not always necessary to work from the subject itself. You might wish to investigate several potentially different moods in a subject you have already successfully captured in one way in a finished drawing. This is an area where the perceptual skills developed from objective study can be extended independently in terms of your experience of drawing and color interaction.

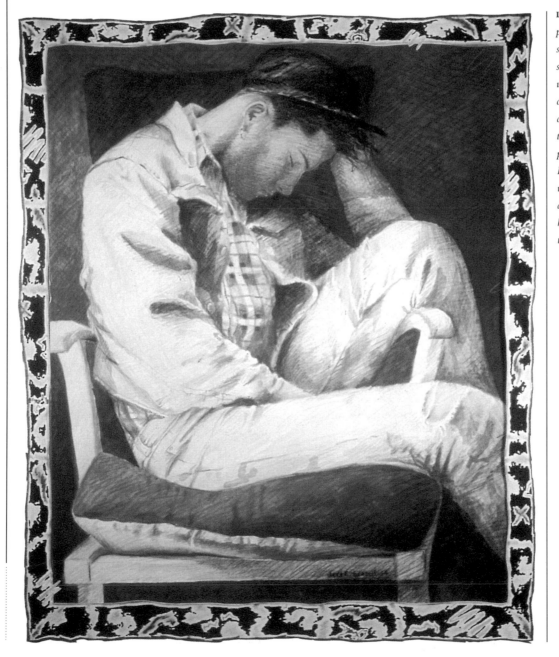

LEFT: *Sometimes it is in the pose and framing of the subject that the artist most strongly expresses the mood, with the color work complementing the narrative content. This is the case in this watercolor and colored pencil portrait by Derek Brazell, and the color work with its warm light and soft, deep shadows is perfectly keyed to the quiet mood of the image.*

"UNREAL" AND UNMIXED COLORS

Once you have experience of working with color and have understood the capabilities of your materials and techniques, there is no reason why you should always work within a frame of reference originally based on local color. It can be exciting to try out "unreal" colors, but related to real form.

A way of investigating this more abstract use of color is to maintain the basic structure of the composition and apply color in strictly pictorial terms. You might, for example, choose to use pure color values to differentiate particular elements – vertical and horizontal surfaces, shadows and

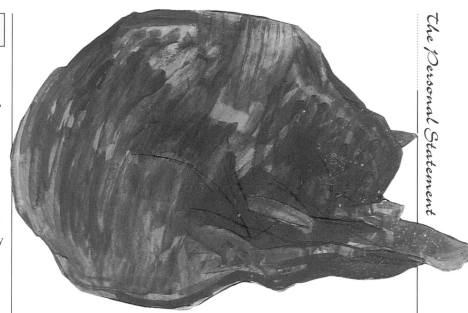

ABOVE AND LEFT: *These cat studies by Judy Martin investigate different ways of describing the form with color. Both examples on this page rely on the contour, first using charcoal and acrylics to describe the massed shape of the body (above), then using a monoprint technique to sketch in overlaid layers of textured color (right).*

highlights, solid forms and the spaces between them. Your experience of color can be used to create an effective orchestration of color relationships, in terms of hue, intensity and tonal value, that gives the drawing subtlety and coherence. The general principle of tying color values to the structures of form and space, though no longer in the "real" terms of local colors and tones, enables you to develop a logic of picture-making – without this the result could be a disastrous confusion.

Since there is no precise model for the final image, this may be a hit and miss affair at first, producing as many failures as successes. But, as with any drawing process,

once you have gained experience of how to make the component elements convey your intentions, you will gradually acquire the skill required to make the image work in its own terms.

This exploration of "unreal" colors can be used to good effect in painting. The problem of how to avoid muddying can sometimes be solved simply by using your colors straight from the tube, but obviously this can only be effective in some areas of a painting or the result would be garish and untrue to nature. Also, many beginners seem to make muddy messes even in this way! It is, of course, the combination of colors that is the crucial factor. In oils, the

unmixed use of dark transparent paints – ultramarine, alizarin crimson and viridian – usually seems to result in a gloomy, depressing picture, whereas mixing these colors with just a little white not only lightens them but also enormously enriches their quality.

A picture that has bold areas of pure color is Frances Treanor's pastel, *Bunch of Flowers* (opposite), in which the cool background is done in a single turquoise color which has been loosely applied in strokes forming little fan shapes over the entire surface. Letting the color of the paper show through is a technique much used in pastel, where colors cannot be mixed on a palette as they can with oils. If a single unmixed color is used for a large area such as this, it is important to break it up in a way that echoes the treatment of the rest of the picture, otherwise the separate areas will not relate to one another. If the turquoise background had been painted uniformly, the vase and flowers would look as if they had been cut out and placed on the background.

BELOW: *Val d'Entre Conque by Frederick Gore. One way to avoid muddying colors is to keep mixing to a minimum, but in inexperienced hands this can result in a garish and unharmonious picture. Here extremely skillful use has been made of cadmium red, cadmium yellow and ultramarine, largely unmixed and straight out of the tube.*

NARRATIVE AND INVENTION

Few artists work only in terms of recording the literal appearance of their subjects. Many, in fact, use the cues taken from the real world to develop a highly personal style of imagery including narrative elements and invented forms and subjects. This is nothing new: consider the religious, social and political themes incorporated in the works of master painters across the centuries, as well as the strands of folklore and literature that have provided subject matter for painting and sculpture. In modern times, the Expressionist, Surrealist and Abstract schools of painting have vastly extended the range of pictorial invention. Personal expression is no longer limited.

The once-famous response to the drawing styles of artists such as Picasso, Klee and Miró – that "a child of six could do it" – always carried the wrong emphasis. It is not a matter of capability, but of choice. A child uses particular techniques and observations

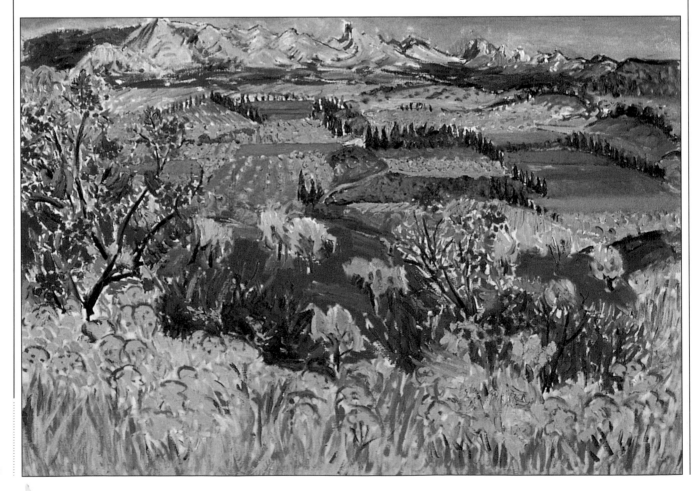

LEFT: Bunch of Flowers *by Frances Treanor, pastel, 26 x 38 inches. This lively pastel is made up of large and small areas of pure color which, combined with the bold treatment, give it a strong feeling of vigor and excitement. No muddy colors here, although the very dark paper the artist has used has been left to show in shimmering patches throughout the picture surface.*

because of a limited experience of life and art, but practicing artists choose their means of expression from among a broad range of perceptual experiences and visual skills. A trained artist who draws people as stick figures has a more complex reason for doing so than not being able to draw "correctly."

The point of bringing up this old argument again is to illustrate the fact that just as drawing only what you see restricts your means of expression, so does the idea of working only out of what goes on in your own head, like an inexperienced child. Many artists have moved into pure abstraction via a highly traditional academic training in drawing and painting, including figure work, landscape, still life and the other established subject areas. Some art students have come to grief by jumping straight into abstraction and finding that, because they

have no grounding of experience in visual interpretation, before long there is nowhere to go. Self-expression, paradoxically, works best if there is a certain amount of discipline in perceptual and technical skills.

The experience gained by following some of the exercises and projects illustrated in the previous pages – those basic skills of drawing and color rendering – provides you with a resource that can be applied to any personal idea you have for image-making. Anything can cause an image to form in your mind's eye – a newspaper report, the theme of a poem, play or opera, an event which has actually happened to you or to someone you know, a historical occasion, a fairy-tale. Alternatively, you might want to explore pure color as a pictorial phenomenon without reference to landscapes, figures and so on. If you cherish a personal vision, there is only one way to make it real – pick up your drawing tools and make a start.

ABOVE: *Simon Lewty's drawing, in ink, crayon and acrylic on heavy paper, is like a complex map of the artist's concept of subject and image. He mixes abstract, stylized and cartographic forms to develop an internal narrative combining verbal and visual elements.*

RIGHT: *This riotous carnival image in exotic color weaves a touch of the sinister and macabre into the brightly colored proceedings. The free-and-easy movement of the forms suggested by the flow of the composition, and the expressive brushwork is set against the harsher impressions of the snarling leopard mask and totem figures. The scheme of color contrives a brilliant illumination of pure hues that is simultaneously enlivening and unsettling, in keeping with the overall image.*

MIXED PAINT COLORS

*W*e touched on mixtures of the primary colors in Chapter 1, and explained that when two primary colors are mixed the result is a secondary color. For example, blue and red, both primaries, make purple, but this does not tell us which blue and which red make the best purple for our needs. We have also seen that when complementary colors such as red and green are mixed, we get a muddy gray, so obviously we must avoid near-complementaries for our purple. Cobalt blue has a hint of green in it, and when mixed with red it produces a grayish-purple. To make a purer purple you'll need to choose a less green blue, preferably one with a hint of purple. Ultramarine is the best bet. Next we must consider the red. A bright orange-red, such as cadmium scarlet, will muddy the blue, as orange and blue are complementaries, so this won't produce a satisfactory purple. The best red is the one nearest to purple: alizarin crimson is a good choice, and magenta or rose even better. Some blue and red mixtures are initially very dark, but a small addition of white will bring out the character without destroying the hue.

The more transparent a paint is, the better it mixes because the pigment particles in the mixture do not get hidden behind each other so thoroughly. This is another reason why the opaque cadmium red is less good at mixing than the transparent alizarin, magenta or rose. Cobalt blue is also slightly less transparent than ultramarine, so it is not such a good mixer.

To mix the brightest possible green from other colors in your palette, you should choose the greenest blue you have – perhaps phthalocyanine blue or Prussian blue. Cobalt blue, although a little greener than ultramarine, is less good for rich greens as it is more opaque. Cerulean has low tinting power, but it is useful for making cool, bluish greens. There are many yellows to choose from: cadmium yellow and yellow ocher both make warm greens, and lemon yellow the cooler, bluer ones. As with the purples described above, a little white may need to be added to lighten some blue and

yellow mixtures. A vibrant, rich olive green can also be made by mixing cadmium yellow or yellow ocher with lamp black. Some artists use black mainly for this purpose, as this kind of green cannot really be made from a blue and yellow mixture.

Orange is easy to make by mixing cadmium red and cadmium yellow. Using the bluer reds, such as alizarin or magenta or the bluer yellows such as lemon yellow produces quieter, less orange hues, again because blue and orange are complementaries.

So far we have discussed the various secondary colors in terms of their brightness and intensity, but "muddy" or subtle colors also have their uses. Bright, clean colors can be offset and enhanced by areas of darker or more muted color, while too many pure colors of different hues can often fight with one another so that the brilliance of each is lessened.

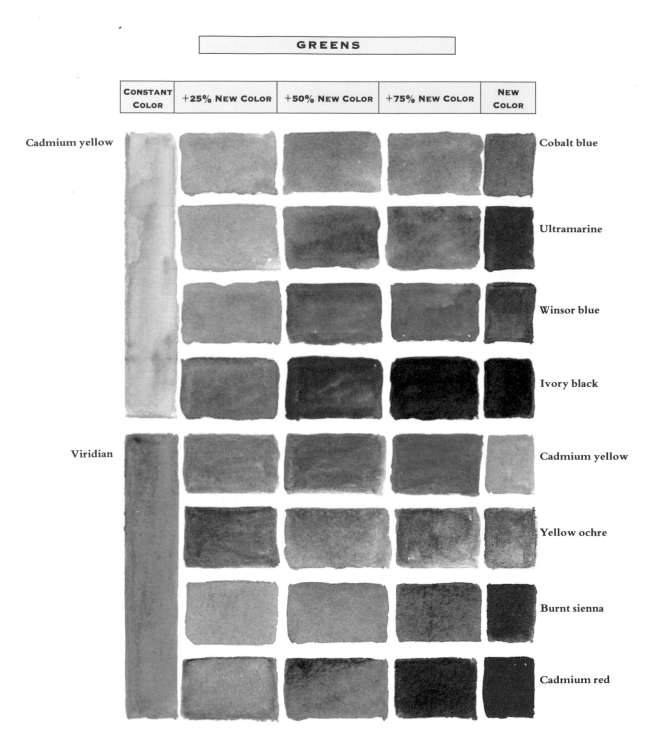

GREENS

	CONSTANT COLOR	+25% NEW COLOR	+50% NEW COLOR	+75% NEW COLOR	NEW COLOR	
Cadmium yellow						Cobalt blue
						Ultramarine
						Winsor blue
						Ivory black
Viridian						Cadmium yellow
						Yellow ochre
						Burnt sienna
						Cadmium red

ABOVE: *Greens. The variety of greens that can be mixed is almost limitless. In the top part of the chart we show a single yellow, cadmium, mixed with a range of blues to produce greens. Varying the proportion of blue and yellow in each mixture increases the choice still further. Tube greens can be modified with other colors on your palette. Here we show viridian-based mixtures, but you can try the same exercise with other greens, such as sap green or terre verte.*

PINKS, PURPLES AND BROWNS

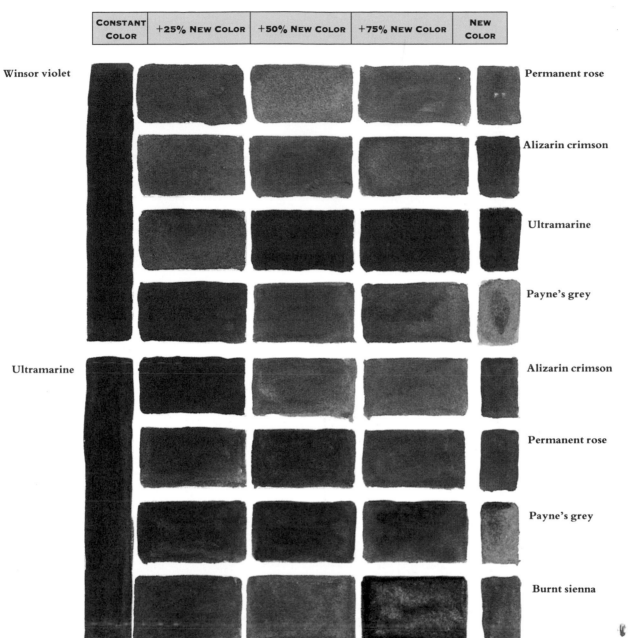

	CONSTANT COLOR	+25% NEW COLOR	+50% NEW COLOR	+75% NEW COLOR	NEW COLOR	
Winsor violet						Permanent rose
						Alizarin crimson
						Ultramarine
						Payne's grey
Ultramarine						Alizarin crimson
						Permanent rose
						Payne's grey
						Burnt sienna

ABOVE: *Pinks, purples and blues. Really brilliant violets and magentas cannot be mixed from other pigments, which is why flower painters like to have a good selection of these colors, which they can then modify as necessary. However, it is possible to use these brilliant colors as a base for mixing more subtle, muted shades. Here, Winsor violet and French ultramarine have been modified with other palette colors to demonstrate the vast range of pinks, purples and blues that can be created.*

ORANGES AND BROWNS

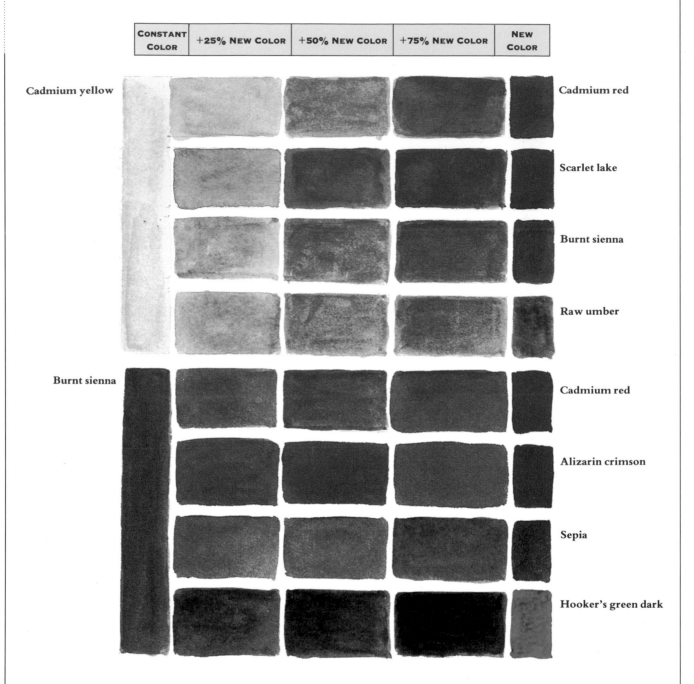

	Constant Color	+25% New Color	+50% New Color	+75% New Color	New Color
Cadmium yellow					Cadmium red
					Scarlet lake
					Burnt sienna
					Raw umber
Burnt sienna					Cadmium red
					Alizarin crimson
					Sepia
					Hooker's green dark

ABOVE: *Oranges and browns. The purest and most brilliant orange is made from cadmium red and cadmium yellow, which gives almost exactly the same color as that sold in the tube under the name of cadmium orange. Rich red-browns can be made by modifying an earth color such as burnt sienna with various reds; dark browns are achieved by mixing earth colors with greens or grays.*

GREYS AND NEUTRALS

	CONSTANT COLOR	+25% NEW COLOR	+50% NEW COLOR	+75% NEW COLOR	NEW COLOR	
Payne's grey						Cadmium red
						Raw umber
						Viridian
						Winsor blue
Winsor violet						Lemon yellow
Ultramarine						Raw umber
Hooker's green dark						Alizarin crimson
Burnt sienna						Ultramarine

ABOVE: *Grays and neutrals. Payne's grey, used in the upper half of this chart, is a good base for the cooler neutral colors, such as those found in cloudy skies. Another method of achieving interesting grays and neutral shades is by mixing two complementaries (red and green, violet and yellow, blue and orange) or near complementaries such as blue and brown. Pastelists often make use of this, toning down a too-bright area of color by overlaying strokes of its complementary.*

PAINT IDENTIFICATION CHART

HOW TO USE THIS CHART

Owing to the constraints of space, this chart deals only with artists' quality brands of oils, watercolors and acrylics.

The colors listed are those referred to in this book and their approximate equivalents.

Similar composition or similar color value determines equivalent color, but don't expect an exact match from brand to brand.

In each of the brands, names of colors will vary. In addition to terms such as "light," "dark" and "deep," accompanying a color name, there may also be rearrangements of words. Allow for this when you see the chart.

The dots indicate whether a manufacturer produces the color.

	WINSOR & NEWTON	OIL	WATERCOLOR	ACRYLIC	ROWNEY	OIL	WATERCOLOR	ACRYLIC	GRUMBACHER	OIL	WATERCOLOR	ACRYLIC
WHITES	Titanium white	●		●	Titanium white	●		●	Superba (titanium)	●		●
	Chinese white		●		Chinese white		●		Chinese white		●	
BLUES	French ultramarine	●	●		French ultramarine	●	●	●	French ultramarine	●	●	
	Ultramarine			●	French ultramarine	●	●	●	Ultramarine blue	●	●	
	Cobalt blue	●	●	●	Cobalt blue	●	●	●	Cobalt blue	●	●	●
	Cerulean blue	●	●	●	Coeruleum	●	●	●	Cerulean blue	●	●	
	Prussian blue	●	●		Prussian blue	●	●		Prussian blue	●	●	
	Phthalo blue			●	Monestial blue	●	●	●	Thalo blue	●	●	●
	Winsor blue	●	●		Monestial blue		●	●	Thalo blue	●	●	
REDS	Alizarin crimson	●	●		Crimson alizarin	●	●		Alizarin crimson	●	●	●
	Cadmium red	●	●		Cadmium red	●	●	●	Cadmium red	●	●	
	Permanent rose	●	●		Rowney rose	●	●		Thalo red rose	●		
	Carmine	●	●		Carmine (alizarin)	●	●		Thalo crimson		●	●
	Vermilion	●	●		Cadmium scarlet	●	●		Vermilion (hue)	●	●	
	Crimson lake	●	●		Crimson alizarin	●	●		Alizarin crimson	●	●	●
	Naphthol crimson			●	Vermilion (hue)			●	Grumbacher red			●
	Venetian red	●	●		Venetian red	●	●	●	Venetian red	●		
	Light red	●	●		Light red	●	●		English red light	●	●	
	Burnt sienna	●	●	●	Burnt sienna	●	●	●	Burnt sienna	●	●	
YELLOWS	Lemon yellow	●	●		Lemon yellow	●			Zinc yellow	●		
	Cadmium yellow	●	●		Cadmium yellow	●	●	●	Cadmium yellow	●	●	●
	Naples yellow	●	●		Naples yellow	●			Naples yellow	●	●	
	Yellow ocher	●	●	●	Yellow ochre	●	●	●	Yellow ochre light	●	●	●
	Raw sienna	●	●	●	Raw sienna	●	●	●	Raw sienna	●	●	
GREENS	Viridian	●	●		Viridian	●	●		Viridian	●	●	
	Winsor emerald	●	●		Rowney emerald	●		●	Permanent bright green	●		
	Winsor green	●	●		Monestial green	●	●	●	Thalo green	●	●	
	Phthalo green			●	Monestial green			●	Thalo green	●	●	
	Cadmium green	●			Cadmium green	●			Permanent green light	●		
	Chrome green	●			Chrome green	●			Permanent green dark	●		
	Hooker's green		●	●	Hooker's green		●	●	Hooker's green		●	
	Permanent green light			●	Bright green			●	Thalo yellow green		●	
	Terre verte	●	●		Terre verte (hue)	●	●		Green earth	●	●	
VIOLETS	Winsor violet	●	●		Permanent mauve	●	●		Thio violet	●	●	
	Magenta	●			Permanent magenta	●	●		Thio violet	●	●	
	Dioxazine purple			●	Permanent violet			●	Grumbacher purple			●
BROWNS	Raw umber	●	●	●	Raw umber	●	●	●	Raw umber	●	●	
	Burnt umber	●	●	●	Burnt umber	●	●	●	Burnt umber	●	●	
BLACKS	Lamp black	●	●	●	Lamp black	●	●		Lamp black	●	●	
	Ivory black	●	●	●	Ivory black	●	●	●	Ivory black	●	●	
	Mars black	●		●	Mars black	●		●	Mars black	●		
	Payne's grey	●	●	●	Payne's grey	●	●	●	Payne's grey		●	

HOLBEIN	OIL	WATERCOLOR	ACRYLIC	LEFRANC & BOURGEOIS	OIL	WATERCOLOR	ACRYLIC	SCHMINCKE	OIL	WATERCOLOR	ACRYLIC	
Titanium white	●		●	Blanc de titane	●		●	Titanweiß	●		●	**WHITES**
Chinese white		●		Blanc de chine		●		Perm. chin. weiß		●		
Ultramarine light	●	●	●	Outremer No2 clair	●	●		Ultramarin hell	●	●	●	**BLUES**
Ultramarine deep	●	●		Outremer No1 foncé	●	●	●	Ultramarin dunkel	●			
Cobalt blue	●	●	●	Bleu de cobalt	●	●	●	Kobaltblau	●	●	●	
Cerulean blue	●	●		Bleu céruleum	●	●		Cöwnblau	●	●		
Prussian blue	●	●		Bleu de prusse	●	●	●	Preußischblau	●	●		
Transparent blue	●			Bleu hortensia		●		Phthaloblau	●	●		
Indigo		●		Bleu hoggar	●	●	●	Phthaloblau	●	●		
Crimson lake	●	●		Laque garance cromoisie	●			Alizarin krapplack	●	●		**REDS**
Cadmium red	●	●	●	Rouge de cadmium	●	●	●	Kadmiumrot	●	●	●	
Alps red	●		●	Rouge grenat	●			Rublinlack dundeu	●			
Carmine	●	●		Carmin d'alizarine	●	●		Karmin	●	●		
Vermilion	●	●		Vermilion français	●			Zinnoberton	●			
Crimson lake	●	●		Laque garance cramoisie	●	●		Alizarin krapplack	●			
Flame red			●	Rouge breughel	●	●	●	Zinno berrot		●	●	
Venetian red	●			Ocre rouge	●	●	●	Engwshrot hell	●	●	●	
Light red	●	●		Rouge anglais	●			Engwshrot hell	●	●	●	
Burnt sienna	●	●	●	Terre de sienna brûlée	●	●	●	Siena gebrannt	●	●	●	
Lemon yellow pale	●			Jaune de strontiane	●			Zincgelb	●			**YELLOWS**
Cadmium yellow	●	●	●	Jaune de cadmium	●	●		Kadmiumgelb	●	●	●	
Naples yellow	●	●		Ton jaune de naples	●	●	●	Neapelgelb dunkel	●	●		
Yellow ochre	●	●	●	Ocre jaune	●	●	●	Lichter ocker natur	●	●	●	
Raw sienna	●	●		Terre de sienna naturelle	●	●	●	Siena natur	●	●	●	
Viridian	●	●		Vert émeraude	●	●	●	Chromoxidgrün feurig	●	●		**GREENS**
Emerald green nova	●	●		Ton vert véronèse	●	●	●	Vert paun veronese	●			
Transparent green	●			Vert armor	●	●	●	Phthalogrün	●	●	●	
Permanent green deep	●	●		Vert aubusson	●	●		Phthalogrün	●	●		
Cadmium green	●	●	●	Vert de cadmium	●			Kadmiumgrün	●			
Compose green	●	●	●	Vert anglais	●		●	Chromgrün	●			
Hooker's green		●	●	Vert de hooker	●			Hookersgrün		●		
Permanent green light	●	●		Vert lumière			●	Permanentgrün hell			●	
Terre verte	●	●		Terre verte	●	●		Böhmische grüne erde	●	●	●	
Transparent violet	●			Violet d'egypte	●	●	●	Echtviolett	●	●	●	**VIOLETS**
Rose violet	●		●	Violet de bayeux	●	●	●	Echt-rotviolett	●	●	●	
Permanent violet		●		Violet d'egypte	●	●	●	Echtviolett	●	●	●	
Raw umber	●	●	●	Terre d'ombre naturelle	●	●	●	Umbra natur	●	●	●	**BROWNS**
Burnt umber	●	●	●	Terre d'ombre brûlée	●	●	●	Umbra gebrannt	●	●	●	
Lamp black	●	●	●	Noir froid	●			Lampenschwarz	●	●		**BLACKS &**
Ivory black	●	●		Noir d'ivoire	●	●		Elfenbeinschwarz	●	●		**GRAYS**
Mars black			●	Noir de mars	●		●	Schwarz	●			
Payne's grey	●	●		Gris de payne		●		Paynesgrau	●	●		

INDEX

PICTURE CREDITS

···